WITHDRAWN

Painting and the Novel

By the same author

Fiction and the Colonial Experience
The Wounded Spirit: A Study of 'Seven Pillars of Wisdom'

For
Sheldon and Jeannie
Peter and Maria

Jeffrey Meyers *Painting and the Novel*

MANCHESTER UNIVERSITY PRESS

BARNES & NOBLE · BOOKS

© 1975 Jeffrey Meyers

Published by
Manchester University Press
Oxford Road, Manchester M13 9PL

ISBN 0 7190 0591 4 (*hardback*)
ISBN 0 7190 0605 8 (*paperback*)

Published in the U.S.A. 1975 by
Harper & Row Publishers, Inc.
Barnes & Noble Import Division

ISBN 0 06 494792 0

Printed in Great Britain
by Unwin Brothers Limited
The Gresham Press, Old Woking, Surrey
A member of the Staples Printing Group

Contents

Illustrations

PLATES

Acknowledgements

The author and publishers gratefully acknowledge permission to reproduce items from the collections named above.

Parts of this book have appeared in the *London Magazine*, *Art International*, *Apollo*, *Modern Language Review*, *Journal of Aesthetics and Art Criticism*, *D. H. Lawrence Review* and *Mosaic*. The author and publishers are grateful to the editors of these journals for permission to reprint.

The publishers are indebted to Edward Arnold (Publishers) Ltd, London, for permission to quote from E. M. Forster, *Where Angels Fear to Tread*; to Lawrence Pollinger Ltd and the estate of the late Mrs Frieda Lawrence for permission to quote from D. H. Lawrence, *The White Peacock*, *The Rainbow*, *Women in Love* and *The Collected Letters of D. H. Lawrence*, published by William Heinemann Ltd, London, and Viking Press Inc, New York; to Rupert Hart-Davis, division of Granada Publishing Ltd, London, for permission to quote from Mark Gertler, *Selected Letters*, ed. N. Carrington; to Penguin Books Ltd, Harmondsworth, for permission to quote from R. Baldick's translation of J. K. Huysmans, *A Rebours*; to Mr George Scott Moncrieff and Chatto & Windus Ltd, London, and Random House Inc, New York, for permission to quote from the English translation of Marcel Proust, *Remembrance of Things Past*; to William Collins Sons & Co. Ltd, London, and Harvill Press, New York, for permission to quote from G. T. di Lampedusa, *The Leopard*, translated by A. Colquhoun; to J. M. Dent & Sons Ltd, London, for permission to quote from Dostoyevsky, *The Idiot*, translated by E. Morton, in Everyman's Library; to Martin Secker & Warburg Ltd, London, and Alfred A. Knopf Inc, New York, for permission to quote from Thomas Mann, *Doctor Faustus*, translated by H. T. Lowe-Porter; to Phaidon Press Ltd, London, for permission to quote from E. and J. de Goncourt, *French Eighteenth Century Painters*, translated

by R. Ironside; and to Princeton University Press for permission to quote from Erwin Panofsky, *The Life and Art of Albrecht Dürer* (copyright 1943, © 1955 by Princeton University Press; Princeton Paperback, 1971).

Introduction

'A characteristic symptom of the spiritual condition of our century', writes Baudelaire, 'is that all the arts tend, if not to act as a substitute for each other, at least to supplement each other, by lending each other new strength and new resources.'[1] Aesthetic analogies express this inherent relationship of the arts, and add a new dimension of richness and complexity to the novel by extending the potentialities of fiction to include the representational characteristics of the visual arts. The novel is essentially a linear art which presents a temporal sequence of events, while painting fixed reality and produces a simultaneity of experience. Evocative comparisons with works of art attempt to transcend the limitations of fiction and to transform successive moments into immediate images.

Comparisons with works of art in the modern novel are similar to the literary use of metaphor, symbol, archetype or myth, for they evoke a new depth of meaning through suggestive allusion. Aesthetic analogies can intensify ordinary life and elevate the significance of commonplace reality. Art throws life into relief, as it were, focusing the familiar and clarifying the vague, for as Proust writes, 'Painting can pierce to the unchanging reality of things, and so establish itself as a rival of literature.'[2]

Through numerous specific allusions we know what visual images the novelists had in mind when making their analogies. Their visualisation was based on paintings they knew well, and determined by their memories and impressions. Yet the novelists demand a knowledge more specialised and a memory more precise than even the most cultured and careful reader can command. By reproducing the paintings visually, by describing them verbally, by interpreting them inconographically, by looking at them with the same attention and intensity as the novelists, we can attempt to see what they saw and make that ideal correspondence between their visual images while writing and those in our minds while reading.

This correspondence concerns the widest implications of perspective—the way an author shapes his vision of the world and enforces his way of seeing on

1

the reader. Virginia Woolf observes that 'painting and writing have much to tell each other; they have much in common. The novelist after all wants to make us see.'[3] And in a letter to a painter she says, 'I rather think you've broached some of the problems of the writers too, who are trying to catch and consolidate and consummate (whatever the word is for making literature) those splashes of yours.'[4] Through a careful examination of the paintings the novelists used as sources of inspiration we can see how the paintings are transformed by their imagination and can understand how their creative process works.

Stendhal employed Guercino's *St William of Aquitaine* in *Le rouge et le noir* (1830) and George Sand used Holbein's *Dance of Death* in *La mare au diable* (1846) to portray character and emphasise themes, but modern novelists are pre-eminent in the use of this technique. *Painting and the Novel* considers three groups of related novels—social, aesthetic and ideological—published between 1860 and 1960. Hawthorne is the first English-language novelist to use aesthetic analogies, but his approach to art is rather naive. He seeks imaginative inspiration in Guido Reni's sentimental idealisation of Beatrice Cenci, but remains completely uncritical about the blatant faults of the painting and exhibits the same defects as Reni. *The Marble Faun*, an obviously weak novel, is included to provide a contrast to the more sophisticated techniques developed by later writers like Henry James. For James studies and learns from Hawthorne, and adopts the 'international theme' of Americans alienated in Europe that becomes dominant in his own work. James finds in Bronzino's morbid Mannerism and Veronese's splendid materialism an accurate reflection of the ambiguous value of wealth in *fin-de-siècle* London and Venice.

When Forster writes his Italian novels at the turn of the century the example of James, whom he later discusses in *Aspects of the Novel*, is paramount. Forster expresses the spirit of San Gimignano and Florence through Ghirlandaio and Giotto, and he exploits the satiric and ironic aspects of their religious subjects. He defines his characters through their responses to the paintings and reveals their approach to life through their approach to art. Though Lawrence writes extensively about Italy and could say, with James and Forster, 'Italy has given me back I know not what of myself, but a very, very great deal',[5] his greatest books are rooted in England; in his first novel and then in his best one, he uses English paintings as the thematic centre of his work. In *The White Peacock* the obscure work of Greiffenhagen portrays a Pre-Raphaelite and Theocritan lyricism that represents an unobtainable kind of love. In *The Rainbow* Fra Angelico's paradisal angels, which link the generations of Brangwens, symbolise a quest for the connection between the material and spiritual worlds and helps the characters develop a 'visionary awareness'. And Lawrence sees in Mark Gertler's *Merry-Go-Round* an expression of the decadence of modern society, dominated by the chaos and violence of war, that he describes in *Women in Love*.

French writers have studied the relation between painting and literature since the eighteenth century, and the important tradition of Diderot, Stendhal, Fromentin, the Goncourts, Baudelaire and Zola culminates in the aesthetic novels of Huysmans, Proust and Lampedusa. Count Robert de Montesquiou is the model for both Huysmans' Des Esseintes and Proust's Charlus; and Huysmans' sensibility and luxury, his refined taste and lapidary prose, his decadence and neurasthenia are all reflected in Proust's novel. Des Esseintes' box of purple bonbons also seems to foreshadow Marcel's *madeleine*: 'he would place one of these bonbons on his tongue and let it melt; then, all of a sudden, and with infinite tenderness, he would be visited by dim, faded recollections'.[6] Huysmans uses Gustave Moreau's *Salome* to symbolise a perverse fantasy that allows an escape from the hideous vulgarity of the contemporary world. In Proust, Mantegna and Botticelli transform aesthetic perceptions into moral truths; and Vermeer embodies the perfections of an Impressionist painting, and provides a moral touchstone that helps to evaluate the characters. The influence of Proust is present in Lampedusa's use of symbolic *objets d'art* to illustrate and prophesy the love of Tancredi and Angelica. Like Guido Reni, Greuze exhibits a rather banal hypocrisy, but Lampedusa significantly places Greuze in the context of a decadent cultural tradition that is analogous to feudal Sicily; and *Le fils puni*, which mirrors the death of Prince Fabrizio, reveals the ironic triumph of *bourgeois* over aristocratic values.

Dostoyevsky has a profound ideological effect on both Mann and Camus. Adrian's dialogue with the devil in *Doctor Faustus* is modelled directly on Ivan's discussion with Satan in *The Brothers Karamazov*. And Prince Myshkin's humane ideas about executions influence Camus' attack on capital punishment in 'Réflexions sur la guillotine' (1957) and *Resistance, Rebellion and Death* (1961), as well as the theme of guilt and redemption in *The Fall*.

The paintings in Dostoyevsky, Camus and Mann express the traditional values of a period of high culture and religious faith that contrast with modern nihilism. Dostoyevsky was deeply moved by the ghastly Holbein which reinforces the analogy between Christ and Myshkin and dramatises a crisis of faith by casting doubt on the divinity of Christ. Camus replaces the drama we normally find in fiction with the tension of a moral and philosophical argument; and the Van Eyck portrays the salvation of mankind that is, ironically, denied in the guilt-ridden world of *The Fall*. In Mann, Dürer relates Nazism to the era of Faust and Luther by expressing an archetypal Germanic demonology, and visualises the themes of artistic sterility and apocalyptic destruction.

Though an awareness of the paintings that form the symbolic core of the work contributes to an understanding of all the novels, the function of the pictures in Hawthorne, Forster, the early Lawrence, Huysmans and Lampedusa is *relatively* less important than in James, the later Lawrence, Proust, Dostoyevsky, Camus and Mann, where a thorough knowledge of their aesthetic models is essential for

a full comprehension of their works. *Painting and the Novel* analyses the novels in conjunction with the paintings, considers the differences between the two forms of art and shows how one can explain the other. This approach leads to new interpretations of the novels. For a thorough knowledge of the visual qualities of the paintings as well as the artist, his time and the whole cultural tradition in which they were created—the biblical sources and saints' legends; the biographies of the secular subjects (Beatrice Cenci and Mohammed II); the history (the restoration of Giotto and Nazi theft of Van Eyck); the critical reputation (Ruskin's ideas on art influenced Hawthorne, James, Forster, Lawrence and Proust); and especially the reasons why the authors were attracted to the paintings, their response to them in their journals, letters and essays, and even their personal feelings about the artist (Lawrence's attitude toward Gertler)—all these elucidate the themes, characters, structure and imagery of some of the most famous and difficult novels in modern European literature.

NOTES TO INTRODUCTION

[1] Charles Baudelaire, *The Life and Work of Eugène Delacroix* (1863), quoted in Jean Seznec, *Literature and the Visual Arts in Nineteenth Century France* (Hull, 1963), 3. Valéry, Mallarmé, Apollinaire, Rilke, Stevens and Auden, as well as Baudelaire, were profoundly influenced by the visual arts.

[2] Marcel Proust, 'John Ruskin', *A Selection from his Miscellaneous Writings*, ed. and trans. Gerard Hopkins (London, 1948), 64.

[3] Virginia Woolf, *Walter Sickert: A Conversation* (London, 1934), 22.

[4] Letter to Jacques Raverat, 3 October 1924, quoted in Quentin Bell, *Virginia Woolf*, II (London, 1972), 106.

[5] D. H. Lawrence, *Sea and Sardinia* (London, 1956), 122.

[6] J.-K. Huysmans, *Against Nature*, trans. Robert Baldick (London: Penguin, 1966), 110.

Part I

1 Guido Reni
and *The Marble Faun*

> Hawthorne was a good deal bored by the importunity of Italian art, for which
> his taste, naturally not keen, had never been cultivated.
>
> [Henry James, *Hawthorne*]

The philistine and provincial Nathaniel Hawthorne fulminates against nudity in
art, dislikes Fra Angelico, calls Titian 'a very good-for-nothing old man',[1]
recommends that the frescoes of Cimabue and Giotto be 'reverently' covered
with whitewash, and condemns Rome for its bad food, ugly streets, poisonous
air, dead atmosphere, despotic police and vicious inhabitants. Hawthorne's
farewell to Rome is rather different from Gibbon's, and he writes in his journal:

> I bitterly detest Rome and shall rejoice to bid it farewell forever; and I fully
> acquiesce in all the mischief and ruin that has happened to it, from Nero's
> conflagration downward. In fact, I wish the very site had been obliterated
> before I saw it.[2]

Despite Hawthorne's bitter maledictions *The Marble Faun* (1860), which
includes unassimilated chunks from his assiduous but unperceptive journal,
became famous as a guidebook; and Henry James observes that the novel 'is part
of the intellectual equipment of the Anglo-Saxon visitor to Rome, and is read by
every English-speaking traveller who arrives there'.[3]

Though the Gothic–aesthetic *Marble Faun* reads like Edgar Poe lost in an
endless museum, Hawthorne has a profound mistrust not only of Rome and the
'unspeakable corruption' of its Church but also of the art that it produced—the
'nastiness' at the foot of the Cross. Hilda, who begins as a painter, becomes a
copyist. After the failure of her creative impulse she loses the 'faculty of
appreciating these great works of art which heretofore had made so large a
portion of her happiness . . . and [she] sometimes doubted whether the pictorial
art be not altogether a delusion'.[4] And the sculptor Kenyon also announces,
'Imagination and the love of art have both died out of me.'

It is ironic that Hawthorne, the first novelist in English to draw extensive
thematic parallels between fictional characters and famous paintings, lacks (as
we have seen) aesthetic taste and sophistication. He praises the 'touching'
spirituality of the aptly named 'Sodoma',[5] and has a compulsive fascination with

6

the spurious and sentimental art of Guido Reni:

> [Beatrice Cenci's] spell is indefinable, and the painter has wrought it in a way more like magic than anything else. It is the most profoundly wrought picture in the world; no artist did it, nor could do it again. Guido may have held the brush, but he painted better than he knew. I wish, however, it were possible for some spectator, of deep sensibility, to see the picture without knowing anything of its subject or history; for, no doubt, we bring all our knowledge of the Cenci tragedy to the interpretation of it I hated to leave the picture, and yet was glad when I had taken my last glimpse, because it so perplexed and troubled me not to be able to get hold of its secret.[6]

Since the Cenci tragedy is not manifested in the Reni portrait, Hawthorne brings all his knowledge of the story to its interpretation. And it is clear from his description of *Beatrice Cenci* (plate I) that Hawthorne primarily seeks imaginative inspiration in the illustrated anecdote, and values the eloquence of its history or secret more than its composition or technique. The kind of art Hawthorne likes (apart from the work of Americans) has a rather obvious 'moralizing strain' and can 'compress and define a character or story, and make it patent at a glance' (96).

Hawthorne interprets Reni's Beatrice as an 'angel fallen, yet sinless'. Just as Beatrice's sin and crime are omitted from her pitiful portrait, so Miriam's guilt is never explained except by analogy with Beatrice, and her responsibility in Donatello's murder of the model is deliberately left obscure. Hawthorne is attracted to Miriam's passionate nature but gives her few opportunities to express it, apart from her possession of a guilty secret and her knowledge of evil. Donatello, the faun of the title, is an Italian pagan, and he has to discover evil by enacting it directly. Hilda and Kenyon, the two New England puritans, come into contagious contact with evil through Miriam and Donatello, but remain essentially untouched: Hilda is protected by her powerful purity and Kenyon by his defensive withdrawal. Reni's Beatrice suggested to Hawthorne the theme of the knowledge of evil, and the question of whether it is possible to remain innocent after experiencing evil, or to be good without experiencing it. Hawthorne approaches these ideas in *The Marble Faun* but does not resolve them, because the *real* evil remains a mystery in Miriam's past, and in the destruction of the model (more a diabolical spirit than a real man), as in the murder of Beatrice's father, a lesser evil is cancelled by the extinction of a greater one.

Hawthorne is clearly fascinated by the Cencian theme of incest, which he could not bring himself to discuss in the novel, but which is an excellent example of a taboo so loathsome that it defiles even the unwilling participant and thus perfectly expresses the theme of unintentional guilt. The repressed theme of incest is partially responsible for the rather diffuse action of the novel, which, as

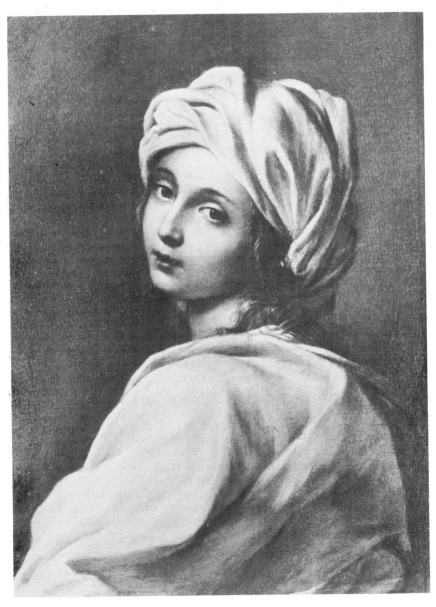

(I) 'Guido Reni,' *Beatrice Cenci*

James remarks, 'struggles and wanders, is dropped and taken up again, and towards the close lapses into an almost fatal vagueness'.[7] But *The Marble Faun* is both structured and inspired by the five focal chapters in which Reni's *Beatrice Cenci* and *The Archangel Michael* (plate II) are interpreted by the characters whose lives they reflect and reveal.

In his preface to *The Cenci* (1819) Shelley discusses the (fashionably Byronic) incestuous passion that precipitated the tragedy:

> [Francesco Cenci] had an implacable hatred toward his children, which showed itself towards one daughter under the form of an incestuous passion, aggravated by every circumstance of cruelty and violence [Beatrice] was evidently a most gentle and amiable being, a creature formed to adorn and to be admired, and thus violently thwarted from her nature by the necessity of circumstance and opinion.

Francesco Cenci imprisoned Beatrice and her stepmother Lucrezia in Aquila castle in 1595, and after enduring his sexual 'cruelty and violence' for several years she planned her father's murder with the help of her lover and her brother. Cenci was assassinated in 1598 and his body thrown from the balcony of the castle to suggest an accident; but the facts were revealed, and the family was arrested, brought back to Rome and thrown into the Castel San Angelo. Beatrice at first denied all guilt, even under torture, but she was finally forced to confess. In 1599 Beatrice and Lucrezia were beheaded, and her brother was drawn and quartered, after Pope Clement VIII refused to pardon them; and the Pontiff's mercenary motives were revealed when he confiscated the extensive family property after their deaths.[8]

Just as Donatello (who also has a history of guilt in *his* family) re-enacts the murder of Francesco Cenci by throwing the model-monk off the Tarpeian Rock, so Miriam's frightful unnamed and unnamable crime is not, as Male writes, 'the murder of her father'[9] but rather the incest with her father: 'the ever-increasing loathsomeness of a union that consists in guilt, cemented with blood, which would corrupt and grow more noisome, for ever and for ever' (132). The parallel of Beatrice and Miriam's incest is confirmed by Simpson's statement that 'Almost certainly [Hawthorne] had read Melville's *Pierre*, in which a central motif is actual or possible incest and in which the implicated young woman is said to resemble a copy of the same Beatrice portrait'.[10]

Hawthorne frequently emphasises the mixed Jewish–Oriental background of the 'reckless and passionate' Miriam, and when the dove-like Hilda passes through the Jewish Ghetto to deliver Miriam's sealed packet to the Cenci palace (where Beatrice was born), she is exposed to

> the foulest and ugliest part of Rome. In that vicinity lies the Ghetto, where thousands of Jews are crowded within a narrow compass, and lead a close, unclean and multitudinous life, resembling that of maggots when they overpopulate a decaying cheese. [279]

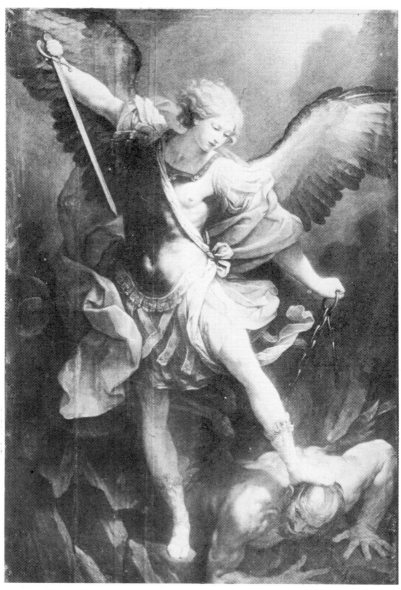

(II) Guido Reni, *The Archangel Michael*, 1635

The corrupt inbreeding of this 'close, unclean' Jewish life (the model-monk is Miriam's cousin) is the closest Hawthorne comes to identifying the unmentionable, but as Frederick Crews writes, 'incest [is] in Hawthorne's mind if not in the minds of the characters' and he 'exploits a rather slender story for its vague and bizarre incestuous overtones'.[11]

According to tradition, Reni painted Beatrice in prison just before her execution, so that the pathos of the portrait was heightened by the extraordinary circumstances of its creation. Hawthorne, who visited the dungeon of the Castel San Angelo, an 'artificial cavern remote from light and air', was deeply moved by the experience, and he writes that Beatrice

> spent a whole year in this dreadful pit, her trial having dragged on through that length of time. How ghost-like she must have looked when she came forth! . . . And how rejoiced she must have been to die at last, having already been in a sepulchre so long![12]

It is extremely ironic, therefore, that the work on which Reni's 'fame in modern times is mainly based'[13] and 'of which, for more than a century, copies have been made by the million in colours, and in the form of engravings and photographs'[14] is neither of Beatrice Cenci nor by Guido Reni. Ricci states that 'as early as 1836 Artnau . . . repudiated Reni as the painter' and 'Burckhardt finally declared that the famous head was not even beautiful and that all its fascination comes from the legend which has grown up around it.'[15] Sweetser denied the attribution to Reni in 1878, and the following year Bertolotti conclusively proved that Reni did not come to Rome until 1608, nine years after the execution of Beatrice.[16]

It is now somewhat difficult to see how Reni, with all his affectation, vapidity and bathos, once ranked just after Raphael;[17] but the force of the legend persisted, and the dubious attribution did not diminish the nearly universal admiration of the painting that became a mirror to which authors brought their own image of Beatrice. The Cenci tragedy, personified in the portrait that transformed the incest, parricide, passion, prison and torture of the haggard Beatrice into the sexually exciting image of a violated virgin, had an enormous attraction not only for Hawthorne but also for Shelley, De Quincey, Stendhal, Dickens, Landor and Swinburne.[18] Shelley was profoundly affected by the saccharine portrait, and he describes it in some detail in the preface to his tragedy.

> The portrait of Beatrice is . . . one of the loveliest specimens of the workmanship of Nature. There is a fixed and pale composure upon the features: she seems sad and stricken down in spirit, yet the despair thus expressed is lightened by the patience of gentleness. Her head is bound with folds of white drapery from which the yellow strings of her golden hair escape, and fall about her neck. The moulding of her face is exquisitely delicate; the eyebrows are distinct and arched: the lips have that permanent

meaning of imagination and sensibility which suffering has not repressed
and which it seems as if death scarcely could extinguish. Her forehead is
large and clear; her eyes, which we are told were remarkable for their
vivacity, are swollen with weeping and lustreless, but beautifully tender and
serene. In the whole mien there is a simplicity and dignity which, united
with her exquisite loveliness and deep sorrow, are inexpressibly pathetic.

In his essay on Shelley's *Cenci* De Quincey speaks of 'the glory of that
suffering face immortalised by Guido';[19] and even Stendhal remarks that the Reni
has 'the sensibility of Mozart'.[20] Stendhal's 'Cenci' (1837) is more sentimental
than ironic: his lachrymose Beatrice is six years younger than her actual age, and
the large and appealing eyes of her portrait 'have the startled air of a person who
has just been caught in the act of shedding large tears'.[21] Dickens' description is
closest to Hawthorne's, and he also emphasises the poignant and tragic eyes of
the sacrificial Beatrice:

> The portrait of Beatrice Cenci in the Palazzo Barberini is a picture almost
> impossible to be forgotten. Through the transcendent sweetness and beauty
> of the face, there is something shining out, that haunts me The head is
> loosely draped in white; the light hair falling down below the linen folds.
> She has turned suddenly towards you; and there is an expression in the
> eyes—although they are very tender and gentle—as if the wildness of a
> momentary terror, or distraction, had been struggled with and overcome,
> that instant; and nothing but a celestial hope, and a beautiful sorrow, and a
> desolate earthly helplessness remained.[22]

In *The Marble Faun* Hawthorne uses *Beatrice Cenci* and *The Archangel
Michael* both to differentiate and to link Miriam and Hilda. When Miriam visits
her friend's studio she discovers Hilda's surreptitious copy of the portrait and
admires it extravagantly:

> The eyes were large and brown and met those of the spectator, but evidently
> with a strange, ineffectual effort to escape. There was a little redness about
> the eyes, very slightly indicated, so that you would question whether or no
> the girl had been weeping It was the very saddest picture ever painted
> or conceived; it involved an unfathomable depth of sorrow, the sense of
> which came to the observer by a sort of intuition. It was a sorrow that
> removed this beautiful girl out of the sphere of humanity, and set her in a
> far-off region, the remoteness of which—while yet her face is so close
> before us—makes us shiver as at a specter. [53]

The motif of eyes, with their 'strange, ineffectual effort to escape', is important
in the novel, for the violent expression in Miriam's eyes inspires Donatello's
crime and their murderous compact, and reveals her guilt to Hilda. Beatrice's
depth of sorrow comes to Hawthorne not 'by a sort of intuition' but from the full
knowledge of the Cenci tragedy that he brings to the portrait. While Shelley

emphasises the nobility of Beatrice's character, which transcends the crime that surrounds her:

> She, who alone in this unnatural work,
> Stands like God's angel ministered upon
> By fiends
> Though wrapped in a strange cloud of crime and shame,
> [Beatrice] lived ever holy and unstained [V, i, iv];

Hawthorne stresses her isolation from normal human life, which is caused by her incest.

When Miriam asks Hilda to interpret the painting, the copyist replies:

> It is infinitely heartbreaking to meet her glance, and to feel that nothing can be done to help or comfort her; neither does she ask help or comfort, knowing the hopelessness of her case better than we do. She is a fallen angel, fallen, and yet sinless. [54]

This passage foreshadows the confessional theme in the novel: Kenyon's selfish unwillingness to allow Miriam to ease her conscience when she seeks his 'help or comfort', Hilda's direct accusation of Miriam after she has accidentally witnessed the model's murder, and Hilda's own confession in St Peter's; and it also links *Beatrice Cenci* with the portrait of the sinless and the fallen angels in *The Archangel Michael*.

But when Hilda is questioned by Miriam she expresses an ambivalence about Beatrice's incest, retracts her original judgement, and asserts that Beatrice's 'was a terrible guilt, an inexpiable crime, and she feels it to be so Her doom is just!' The wounded Miriam, whose expression has become almost exactly like the portrait, compares Hilda to St Michael and exclaims, 'Oh, Hilda, your innocence is like a sharp steel sword!' Miriam defends Beatrice (and herself) against Hilda's harsh judgement and explains, 'Beatrice's sin may not have been so great: perhaps it was no sin at all, but the best possible virtue in the circumstances. If she viewed it as a sin, it may have been because her nature was too feeble for the fate imposed upon her.' Miriam's attitude to Beatrice, though more honest than Hilda's, is also ambivalent. She first states that Beatrice's sin was not great, next that it was no sin, then that it was a virtue, and finally (returning to her first premise) that it was a sin only because she was too weak to deal with incest in any other way. Both Beatrice and Miriam are guilty and innocent at the same time, for their sin is mitigated by overpowering circumstances. And Hawthorne himself is ambivalent about Beatrice because he emotionally endorses Miriam's views and intellectually endorses Hilda's, and he never resolves the conflict between them.

When Miriam visits Hilda's studio for the second time, after the murder, she finds that *Beatrice Cenci* is still on the easel, 'resolving not to betray its secret of grief or guilt'. Hilda glances in the mirror, sees Beatrice's expression depicted in

her *own*—not in Miriam's—face, and thinks, 'Am I, too, stained with guilt?' But Hawthorne hastens to deny this ('No, thank heaven!') by adopting the view of Beatrice first proposed by Hilda in the previous scene and by suggesting

> a theory which may account for its unutterable grief and mysterious shadow of guilt, without detracting from the purity which we love to attribute to that ill-fated girl. Who, indeed, can look at that mouth—with its lips half-apart, as innocent as a baby's that has been crying—and not pronounce Beatrice sinless? It was the intimate consciousness of her father's sin that threw its shadow over her, and frightened her into a remote and inaccessible region, where no sympathy could come. It was the knowledge of Miriam's guilt that lent the same expression to Hilda's face. [152]

The excessive adjectives, the sentimental and tearful simile, and the 'intimate consciousness' of her father's incest which negates Beatrice's parricide, reveal Hawthorne's pathetic partiality, and the purity that he 'loves to attribute' to Beatrice despite her 'guilt'.

Miriam's contagious crime is caught and expressed on the face of Hilda, who attempts to shed this vicarious guilt by abandoning her friend, though Miriam points out that she now needs her help more than ever. Hilda pretends to deny her *noli me tangere* St Michael role ('If I were one of God's angels, with a nature incapable of stain . . . I would keep ever at your side'), but she actually assumes it. Miriam tells the merciless Hilda, 'You have no sin, nor any conception of what it is; and therefore you are so terribly severe!' And the scene ends with unintentional irony when, after Hilda's accusation that Miriam is responsible for the model's murder, Miriam tries to comfort *Hilda*: 'This is a terrible secret to be kept in a young girl's bosom. What will you do with it, my poor child?'

In *The Marble Faun* the incest theme—expressed in the stain, the tears and the contaminated purity—makes guilt a vital component of passion, so that the murder of the model releases the sexual feelings of the Semitic Miriam and the Latin Donatello in a kind of Mediterranean *Liebestod*: 'She pressed him close, close to her bosom, with a clinging embrace that brought their two hearts together, till the horror and agony of each was combined into one emotion, and that a kind of rapture' (130). For this reason the innocent Hilda, who has no passion and is much closer to the idealised *Beatrice Cenci* than Miriam, refuses to reveal her 'guilt' by confessing to the priggish Kenyon, whose intimacy with Hilda allowed him, in a revealing phrase, 'the free enjoyment of all but the deeper recesses'.

Hawthorne exploits the traditional connection between *Beatrice Cenci* and *The Archangel Michael* when he links the two paintings in the novel, for as Barbiellini states, 'if we look attentively at the head of the angel and that of the devil we soon discover in the first the physiognomy of Beatrice and in the second one that of Clement VIII, who is crushed under the foot of the girl'.[23] The subject

of *The Archangel Michael* (1635) has its source in Revelation 12: 7-9, but the dynamic conflict in the Bible is missing from the painting:

> And there was war in heaven: Michael and his angels fought against the dragon; and the dragon fought and his angels, and prevailed not; neither was their place found any more in heaven. And the great dragon was cast out, that old serpent, called the Devil, and Satan, which deceiveth the whole world: he was cast out into the earth, and his angels were cast out with him.

Michael's left leg and right arm, reinforced by the shining sword, form a white diagonal that cuts across the painting and ends at the head of the devil. The victorious angel wears a red cape, blue corselet with grey epaulet sleeves and skirt, and jewelled sandal straps; his reddish blond hair is flowing, his wings are spread, and he carries the binding chains in his left hand. The human half of the devil—bald, bearded and muscular—reflects the orange glow of fire as he attempts to struggle out of the rocky depths of hell, but Michael conquers the winged and serpent-tailed demon and forces him into the inferno.

The relation of innocence to evil, of holiness to 'crime and shame', is illustrated by Reni's sketch of St Michael. Hilda discovers this 'winged figure with a drawn sword, and a dragon, or demon, prostrate at his feet' in Kenyon's studio, and calls it 'the most beautiful and the divinest figure that mortal painter ever drew'. When Hilda points out that the difference between the sketch and the painting is that in the former St Michael turns his eyes away from the demon in painful disgust, Miriam criticises the drawing for precisely this reason: 'The expression suits the daintiness of Michael's character, as Guido represents him. He could never have looked the demon in the face!'[24] (106). Just as the guilty Miriam was identified with Beatrice, so the unrealistically innocent Hilda is now associated with the dainty Michael who refuses to recognise evil. These parallels are reinforced when Kenyon sees a resemblance between the face of the squirming demon (which looks like Clement VIII) and Miriam's model. This evil spectre, who pursues Miriam through catacomb and gallery and is murdered by Donatello, is not only the dead monk laid out in the Church of the Cappucini, where the original *Archangel Michael* hangs, but also the vile and insane suitor. This mad cousin, chosen for Miriam by her powerful family, was involved in the 'mysterious and terrible event' that cast suspicion on Miriam, and caused her to feign suicide and to disappear into artistic anonymity.

After the murder of the model-monk, the four friends meet in the Cappucini Church to compare the sketch with the finished painting of the saint. *The Archangel Michael*, which illustrates the ostensible theme of *The Marble Faun*—'the triumph of goodness over the evil principle'—is described by Kenyon, who naturally shares Hilda's enthusiasm:

> What an expression of heavenly serenity in the Archangel's face! There is a degree of pain, trouble and disgust at being brought in contact with sin, even

for the purpose of quelling and punishing it; and yet a celestial tranquility pervades his whole being. [137][25]

But Miriam criticises the painting (which foreshadows Hilda's walk through the Ghetto) of the well dressed angel balanced rather daintily and distantly on the devil's head, and she proposes her own quite personal and superior iconography:

> I could have told Guido better. A full third of the Archangel's feathers should have been torn from his wings; the rest all ruffled, till they looked like Satan's own! His sword should be streaming with blood, and perhaps broken halfway to the hilt; his armor crushed, his robes rent, his breast gory; a bleeding gash on his brow, cutting right across the stern scowl of battle! He should press his foot hard down on the old serpent, as if his very soul depended upon it, feeling him squirm mightily and doubting whether the fight were half over yet, and how the victory might turn! And, with all this fierceness, this grimness, this unutterable horror, there should still be something high, tender, and holy in Michael's eyes, and around his mouth. But the battle never was such child's play as Guido's dapper Archangel seems to have found it. [138][26]

The 'high, tender and holy eyes' recall those of *Beatrice Cenci* and reflect the frightening possibility of the triumph of evil, for Miriam is 'afraid the victory would fall on the wrong side' and that the devil would push the angel into hell. But Miriam's criticism of the painting applies equally to *The Marble Faun*, for there is no real conflict of good and evil in the novel. The 'evil' of Beatrice and Miriam is incest, but since incest is not portrayed either in the paintings or in the novel, the evil does not actually exist. Hawthorne, fascinated by an evil he is unable to express, censors the Cenci story and presents a serene and sentimental Beatrice, a vague and 'mysterious' Miriam, and an innocent but repellent Hilda.

Though Hilda, in the guise of the saint, had refused confessional consolation to Miriam, the mosaic copy of *The Archangel Michael* in St Peter's ironically affords Hilda the opportunity for an emotional release that is analogous to Miriam's sexual passion:

> The moral of the picture, the immortal youth and loveliness of Virtue, and its irresistible might against ugly Evil, appealed as much to Puritans as to Catholics. Suddenly, and as if it were done in a dream, Hilda found herself kneeling before the shrine, under the ever-burning lamp that throws its rays upon the Archangel's face. She laid her forehead on the marble steps before the altar, and sobbed out a prayer. [254]

The theme of *The Marble Faun* is not only the awakening of the moral faculties after the fortunate fall and the banishment from Eden by the angel with the flaming sword, but also the refusal of Hilda and Kenyon to recognise the relation of good and evil. Their innocence is closely related to Hawthorne's inability to portray the theme of incest, so that the 'evil' in the novel is presented

indirectly, obliquely—almost, one might say, guiltlessly—and moral distinctions are blurred. Beatrice's parricide is justified by her father's incest, just as Donatello's crime is cancelled by the model's evil designs, for Miriam explains that in Roman times 'Innocent persons were saved by the destruction of a guilty one, who deserved his doom'. At the end of the novel the puritan Hilda and Kenyon, who are happily engaged though still somewhat confused about the inexplicable complications of Miriam's dark past, remain completely untouched by Catholic corruption and by Jewish incest. They reveal a simplistic ignorance of the existence of evil and never understand the paradox that Milton expresses in *Areopagitica*: 'Good and evil we know in the field of this World grow up almost inseparably: and the knowledge of good is involved and interwoven with the knowledge of evil.' In *The Marble Faun* Hawthorne exhibits the same defects as Guido Reni, who ignores Beatrice's crime and Satan's strength, and impoverishes his art by effectively eliminating the 'contact with sin'.

NOTES TO CHAPTER ONE

[1] Nathaniel Hawthorne, *Passages from the French and Italian Notebooks* (1872), *Works*, ed. G. P. Lathrop, x (London, 1883), 331.

[2] *Ibid.*, 5–6.

[3] Henry James, *Hawthorne* (1879), (London: Macmillan, 1967), 151.

[4] Nathaniel Hawthorne, *The Marble Faun* (New York: Signet, 1961), 242.

[5] See Giorgio Vasari, 'Giovanni Bazzi', *Lives of the Most Eminent Painters, Sculptors and Architects*, trans. Gaston de Vere, VII (London, 1912–14), 245–7, for a negative account of 'Sodoma's' morals and demeanour.

[6] Hawthorne, *Notebooks*, 89-90, 505. Spencer Hall's 'Beatrice Cenci: Symbol and Vision in *The Marble Faun*', *Nineteenth Century Fiction*, XXV (1970), 85–95, deals with Hawthorne's use of painting, but Hall does not reproduce and analyse Reni's works, nor relate Cenci's incest to the meaning of the novel.

[7] James, 155.

[8] Shelley calls the Pope:
　　　. . . *a marble form,*
　　A *rite, a law, a custom, not a man.* [V, IV]

[9] Roy Male, *Hawthorne's Tragic Vision* (Austin, 1957), 168.

[10] Claude Simpson, 'Introduction' to *The Marble Faun* (Columbus, Ohio, 1968), xl.

[11] Frederick Crews, *The Sins of the Fathers: Hawthorne's Psychological Themes* (New York, 1966), 227–8.

[12] Hawthorne, *Notebooks*, 137. Donatello, who recreates the role of the assassin–lover, expiates his crime in the 'sepulchral' Castel San Angelo: 'that immense tomb of a pagan emperor, with the archangel [Michael] at its summit' (83).

[13] Moses Sweetser, *Guido Reni* (Boston, Mass., 1878), 34.

[14] Corrado Ricci, *Beatrice Cenci*, II (London, 1926), 281.

[15] *Ibid.*, II, 286. See Jacob Burckhardt, *Le Cicerone* (1855), trans. Auguste Gerard, II (Paris, 1872), 798: 'La soi-disant *Beatrice Cenci*, n'est pas même une jolie tête; elle n'a de charme que par la légende qui s'attache à ce nom.'

[16] See Antonino Bertolotti, *Francesco Cenci e la sua famiglia* (Florence, 1877). Since Hawthorne gives no indication that he was aware of such heresy, and would have refused to recognise it even if he he had been, I shall continue to refer to the painting as Reni's *Beatrice Cenci*.

[17] Reni's prestige remained unchallenged until the 1840s, when Ruskin's attacks marked the beginning of the decline of his enormous reputation. See John Ruskin, *Modern Painters, Works*, ed. E. T. Cook and Alexander Wedderburn (London, 1903–12), III, xxxv, and IV, 212.

[18] See Walter Savage Landor, *Beatrice Cenci: Five Scenes* (London 1851); and Algernon Charles Swinburne, 'Les Cenci' (1883), *Studies in Prose and Poetry, Complete Works*, ed. Edmund Gosse and Thomas Wise, xv (London, 1926), 319–29.

[19] Thomas De Quincey, 'Notes on Gilfillan's *Literary Portraits*: Shelley' (1846), *Collected Writings*, ed. David Masson, xi (London, 1897), 376.

[20] Stendhal, *Journal*, 24 September 1811.

[21] Stendhal, 'The Cenci', *The Abbess of Castro and Other Tales*, trans. C. K. Scott Moncrieff (London, 1926), 173.

[22] Charles Dickens, *Pictures From Italy* (London, 1846), 211-12. Dickens' passion for his sister-in-law, Catherine Hogarth, may have stimulated his interest in the theme of incest.

[23] Amadeo Barbiellini, *The History of Beatrice Cenci* (Rome, 1909), 47.

[24] After he murders the model, the guilty Donatello rejects Fra Angelico for the same reason that Miriam scorns *The Archangel Michael*: 'His angels look as if they had never taken a flight out of heaven: and his saints seem to have been born saints, and always to have lived so' (225).

[25] See Reni's rather pompous description of the creation of *The Archangel Michael*, quoted in Sweetser, 64–5: 'I wish I had had the wings of an angel, to have ascended into Paradise, and there to have beheld the forms of those beatified spirits, from which I might have copied my Archangel; but, not being able to mount so high, it was vain for me to search his semblance here below; so that I was forced to make an introspection into my own mind, and into that Idea of beauty which I have formed in my imagination.'

[26] The difference between Reni's original and the mosaic copy in St Peter's provided the distinction between the sketch and the finished portrait in the novel. See Hawthorne, *Notebooks*, 505–6: 'There is something finical in the copy, which I do not find in the original. The sandalled feet are here those of an angel; in the mosaic they are those of a celestial coxcomb, treading daintily, as if he were afraid they would be soiled by the touch of Lucifer.'

Kenyon is attracted to the *Laocoön* for the same reason that he praises Miriam's version of St Michael, for the sculpture impressed him 'as a type of the long, fierce struggle of man, involved in the knotted entanglements of Error and Evil' (281).

Bronzino, Veronese
 and *The Wings of the Dove*

> My heart is sore pained within me: and the terrors of death are fallen upon
> me. Fearfulness and trembling are come upon me, and horror hath
> overwhelmed me. And I said, Oh that I had wings like a dove! for then I
> would fly away, and be at rest.
>
> [Psalms 55: 4–6]

In *Aspects of the Novel* E. M. Forster speaks of 'the wonderful rare heroine . . .
who is consummated by Milly Theale', and then gives a harsh but essentially just
description of James' characters:

> They are incapable of fun, of rapid motion, of carnality, and of nine-tenths
> of heroism. Their clothes will not take off, the diseases that ravage them are
> anonymous, like the sources of their incomes, their servants are noiseless or
> resemble themselves, no social explanation of the world we know is
> possible from them, for there are no stupid people in their world, no barriers
> of language, and no poor. Even their sensations are limited. They can land in
> Europe and look at works of art and each other, but that is all. Maimed
> creatures can alone breathe in Henry James' pages.[1]

Yet *The Wings of the Dove* (1902) clearly succeeds as a novel despite these
serious limitations, and despite James' tortuous style, which stands as an
implacable obstacle between the reader and the life of the book, his tediously
procrastinated revelations (even James confessed that the novel was 'too
inordinately drawn out'[2]), and the fact that some of the most significant scenes in
the book (Kate Croy's visit to Merton Densher's rooms, Lord Mark's revelations
to Milly, Densher's last interview with Milly, and the death of Milly) are merely
alluded to but not actually rendered. One of the most important ways in which
James transcends these deadening mannerisms, vivifies his 'maimed creatures'
and places them in a complex perspective is to bring the characters into
significant conjunction with works of art. James expresses Milly's relation to
Lord Mark at Matcham through an analogy to Bronzino's *Lucrezia Panciatichi*
(1540) (plate III) and defines Milly's relation to Densher in Venice through an
analogy with Veronese's *The Marriage Feast at Cana* (1563) (plate IV).

In his discussion of how James transforms recollected images into prototypes
of fictional creations[3] (a device that James inherited from Hawthorne[4]), Austin
Warren denigrates this technique: 'The obvious errand of these [aesthetic]
analogies is honorific; they belong to the high and honored world of "culture".

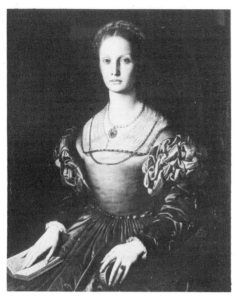

(III) Bronzino, *Lucrezia Panciatichi*, 1540

But in the decorative and the ''beautiful'', James' taste (like his taste in poetry) was conventional.'⁵ But James' taste for Bronzino, Veronese, Titian, Van Eyck and Memling cannot be accurately categorised as 'conventional', and his employment of analogies with art is far more complex than an exhibition of 'honorific' culture.

In his comparison of painting and the novel in *Picture and Text* James insists that 'The forms are different, though with analogies; but the field is the same—the immense field of contemporary life observed for an artistic purpose'.⁶ And James writes significantly in 'The Lesson of Balzac' about the need for visual reality: 'The most fundamental and general sign of the novel, from one desperate experiment to another, is its being everywhere an effort at *representation*—this is the beginning and end of it To the art of the brush the novel must return, I hold, to recover whatever may still be recoverable of its sacrificed honor.'⁷ In *The Wings of the Dove* the first meeting of Milly and Densher (whose mother copied famous pictures in great museums) takes place amidst the Titians and Turners of the National Gallery; and James frequently attempts to make the reader *see* by imitating the representational characteristics of the pictorial arts, and by 'composing, as painters call it' the complex elements of his novel.

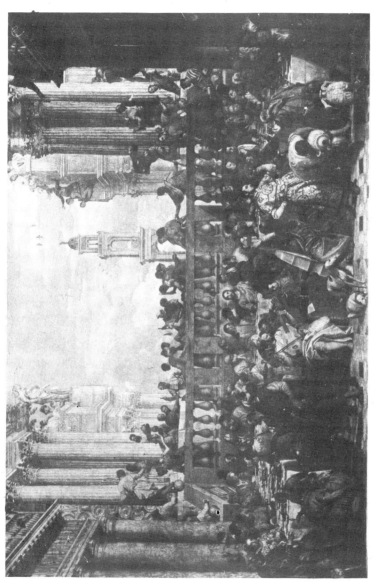

(IV) Veronese, *The Marriage Feast at Cana,* 1536

James compares the uninquisitive Susan Stringham to a porcelain monument or a Byzantine mosaic at Ravenna; and Densher sees an opportunity 'before him like a temptress painted by Titian'. Kate's 'sketch' of her predatory Aunt Maud Lowder had 'a high color and a great style: at all of which [Densher] gazed a minute as at a picture by a master'; and Kate agrees with Densher: 'You're right about [Milly] not being easy to know. One *sees* her, with intensity—sees her more than one sees almost anyone; but then one discovers that that isn't knowing her and that one may know better a person whom one doesn't "see", as I say, half so well.'[8]

We see Milly twice in the novel before the great recognition scene at Matcham where we come to *know* her. While touring in the Alps to recover her health (Europe is the great American sedative) she is described as a 'striking apparition' in a rich black frock, with a sickly complexion and splendid coils of brilliantly coloured hair: a 'slim, constantly pale, delicately haggard, anomalously, agreeable angular young person, not more than two-and-twenty in spite of her marks, whose hair was somehow exceptionally red even for the real thing, which it innocently confessed to being'. Her face, with 'rather too much forehead, too much nose and too much mouth, together with too little mere conventional color and conventional line, was expressive, irregular, exquisite, both for speech and for silence' (71, 80).

Milly is next seen in a symbolic relation to the landscape when she climbs into the higher Alpine meadows and then descends precipitously to the dangerous edge of 'a slab of rock at the end of a short promontory' that pointed into dizzy gulfs of air, in order to see a view of great extent and beauty. Her companion, Susan Stringham, fears for the life of the invalid, whose state, beauty and mystery 'all unconsciously betrayed themselves to the Alpine air'. But Milly 'wouldn't have committed suicide; she knew herself unmistakably reserved for some more complicated passage; this was the very vision in which she had, with no little awe, been discovered' (83-5).

This Alpine vision of her fate is subtly linked to another epiphany (about her own mortality) in the Bronzino scene when, later in the novel, Milly remembers:

> She had not been so thoroughly alone with [Lord Mark] since those moments of his showing her the great portrait at Matcham, the moments that had exactly made the high-water mark of her security, the moments during which her tears themselves, those she had been ashamed of, were the sign of her consciously rounding her protective *promontory*, quitting the blue gulf of comparative ignorance and reaching her *view* of the troubled sea. [290][9]

In the Matcham scene Lord Mark first experiences his (not entirely disinterested) love for the fabulously wealthy Milly, and in the later scene when she remembers the '*mark* of her security' she unintentionally humiliates him by refusing his proposal. Lord Mark's complex mixture of protectiveness and vindictiveness

leads him to tell Milly of Kate and Densher's plot against her, and to destroy her tenuous will to live when he destroys the love that sustains it.

When Milly first visits Lord Mark at Matcham,[10] which had for her 'an almost extravagantly grand Watteau-composition', he asks her, 'Have you seen the picture in the house, the beautiful one that's so like you?' He then leads her on a slow and devious progress 'through innumerable natural pauses and soft concussions' to the wonderful Bronzino that 'appeared deep within'. This ritualistic 'complicated passage' gives Mark the opportunity to tell Milly, ' "Do let a fellow who isn't a fool take care of you a little." ' The thing somehow, with the aid of the Bronzino, was done.'[11]

Through a series of 'opening vistas' Milly achieves a kind of 'apotheosis' at the sight of the picture that seemed 'to mark civilization at its highest'.

> She found herself, for the first moment, looking at the mysterious portrait through tears. Perhaps it was her tears that made it just then so strange and fair—as wonderful as he had said: the face of a young woman, all magnificently drawn, down to the hands, and magnificently dressed; a face most livid in hue, yet handsome in sadness and crowned with a mass of hair rolled back and high, that must, before fading with time, have had a family resemblance to her own. The lady in question, at all events, with her slightly Michaelangelesque squareness, her eyes of other days, her full lips, her long neck, her recorded jewels, her brocaded and wasted reds, was a very great personage—only unaccompanied by a joy. And she was dead, dead, dead. Milly recognized her exactly in words that had nothing to do with her. 'I shall never be better than this.'
>
> He smiled for her at the portrait. 'Than she? You'd scarce need to be better, for surely that's well enough. But you *are*, one feels, as it happens, better; because splendid as she is, one doubts if she was good.' [144]

James was drawn to Bronzino's *Lucrezia Panciatichi* for two reasons.[12] First, James could be described as the Bronzino of the novel, for his own strained elegance of form is analogous to the Mannerism of the painting. James must have felt a strong affinity in values and feeling with the ceremonious and self-consciously aristocratic poet–painter, a contemporary of Cellini and Vasari at the court of the Medicis.[13] But more important, James saw in the portrait the suggestion of both richness and sadness—even a hint of disease. As Wylie Sypher writes, Mannerist figures

> appear passive, suffering mutely from internal and unintelligible strain. They hold their distance even while they dramatically approach our world through an unnaturally extended hand or foot; if these people are agitated, they nevertheless have the still repressed air we see in portraits by Bronzino. It is customary to speak of the hauteur of Bronzino's people as 'distinguished'; but their very lifeblood has congealed.[14]

And McComb emphasises the 'increasingly Spanish gravity' of Bronzino's

figures: 'there is no longer any gaiety, humor, intimacy, but only this all-pervading, incredibly sad elegance'.[15]

The most striking aspects of the portrait are the cold, melancholy look of almost Byzantine severity, and the luxurious red silk gown with violet undersleeves and white guimpe. Lucrezia's splendid red hair is parted in the middle and coiled tightly around her head. She has a fine marble forehead, and full, strong features; and the skin on the long column of her neck is whiter than the pearls that adorn it. A fine golden chain rests on her breast and carries the inscription *Amour dure sans fin*, and there is another chain around her waist. Her slim fingers extend elegantly along the arm of her chair and spread across the open pages of a devotional book bound in red leather. Lucrezia's pallor suggests Milly's fatal disease which the 'love' of the motto enables her to endure, and this loyal love lasts beyond the 'end' and is sufficiently strong to dominate Densher and Kate *after* Milly's death.

Bronzino's portrait style, which influenced artists like Velazquez and Van Dyck and had its 'effect in determining the character of Court painting all over Europe',[16] is decorative, sharply observed and severely disciplined; and his erect and immobile subject, though magnificently detached, has a chilly worldliness. Lucrezia Pucci, the wife of Bartolomeo Panciatichi, poet, *littérateur*, ambassador and patron of Bronzino, was later forced to test her motto, for she and her husband (who wrote amorous *canzone* in the form of penitential psalms) were accused of heresy, 'flung into prison in Florence and compelled to make a public recantation'.[17]

Milly, the 'princess' who leads a kind of 'court life without the hardships', looks at the mysterious portrait of her 'pale sister' through tears because it sparks a sudden premonition—and acceptance—of her own mortality. For she prophetically tells Susan just before she sees the painting, 'Since I've lived all these years as if I were dead, I shall die, no doubt, as if I were alive.' (By contrast, Kate's 'doom was to live fast'.) The joyless, bloodless Lucrezia is literally dead, and when the moribund Milly observes, 'I shall never be better than this', she means that she will never be more lively than Lucrezia. Lord Mark, though he senses Milly's weakness, misunderstands her remark, doubts that Lucrezia was good and claims that Milly is *morally* superior.

Lord Mark is not the only one to notice the similarity between Milly and the painting: 'Les grands esprits se rencontrent.' Kate observes 'the likeness is so great' and expresses what Milly must have thought: 'Then I'm not original.' Lady Aldershaw 'looked at Milly quite as if Milly had been the Bronzino and the Bronzino only Milly'; and her husband amuses Kate by grunting, 'Humph—most remarkable'. These responses to the painting sink Milly into 'something quite intimate and humble', for 'she had in a manner plunged into it to escape from something else'. Her mood is intimate because the portrait is revealing, humble because it seems too grand a model; and as she seeks to escape

from death she is menacingly confronted with it and can take no pleasure from the comparison. Since Milly is both modest and selfless, she thinks the Bronzino is more appropriate to the extremely good-looking (but penniless) Kate; and the portrait allows her to establish a second moment of intimacy: 'Milly spoke with her eyes again on her painted sister's—almost as if under their suggestion.'

Milly's benign deception, which gives Kate the first sure indication of her friend's illness, provides a strong contrast to Kate's fatal treachery. In order to spare Susan the pain of unnecessary worry Milly asks Kate to accompany her on a visit to her doctor, Sir Luke Strett; and her request for absolute silence echoes an earlier conversation when Susan and Aunt Maud (who objected to people doing as they liked) discussed Kate and Densher. James calls Milly's tactics 'the wisdom of the serpent', and the reference to Matthew 10: 16, 'Behold, I send you forth as sheep in the midst of wolves: be ye therefore wise as serpents, and harmless as doves', emphasises the contrast of her weakness and Kate's strength and suggests that Milly's relation to Kate is analogous to Kate's relation to Aunt Maud (a kid to a vulture).

The chapter on the rich and courtly Veronese painting also illuminates the contrast of the material and spiritual, of power and love. When the scene shifts to Venice, Densher is rather awed by the aggravated grandeur of Milly's *palazzo*, but Susan intends to bring out all the glory of the place.

> 'It's a Veronese picture, as near as can be—with me as the inevitable dwarf, the small blackamoor, put into a corner of the foreground for effect. If only I had a hawk or a hound or something of that sort I should do the scene more honor. The old housekeeper, the woman in charge here, has a big red cockatoo that I might borrow and perch on my thumb for the evening.' These explanations and sundry others Mrs Stringham gave, though not all with the result of making him feel that the picture closed him in. What part was there for *him*, with his attitude that lacked the highest style, in a composition in which everything else would have it? . . .
>
> 'Why, we're to have music—beautiful instruments and songs Besides, you're in the picture.'
>
> 'Oh—I!' said Densher, almost with the gravity of a real protest.
>
> 'You'll be the grand young man who surpasses the others and holds up his head and the wine-cup'. . . .
>
> The way smooth ladies, travelling for their pleasure and housed in Veronese pictures, talked to plain, embarrassed working-men, engaged in an unprecedented sacrifice of time and of the opportunity of modest acquisition! [329–30]

There is some unfortunate confusion among critics about which Veronese painting James is discussing. Cargill writes that 'Susan has mixed up this picture [*The Marriage Feast at Cana*] with 'The Feast of Levi' for which Paolo Veronese had to appear before the Tribunal of the Inquisition to explain that the dwarfs and fools in it were not meant to disparage religion';[18] and Holland also believes that

James describes both paintings.[19] Yet there is no reason why James should have Susan 'mix up' the pictures (Cargill does not suggest that James is himself confused) and a study of the enormous and complex *Marriage Feast at Cana* reveals all the details mentioned by James.

The inevitable dwarf, with a cockatoo perched on his fist, stands in the left foreground with one hand on the right corner of the white tablecloth. Just left of the dwarf the blackamoor is offering a goblet of wine at the end of the oblong table which seats, among other notables, François I, Mary Tudor, Sultan Suleiman I, Vittoria Colonna and Charles V. The pedigree hounds in the centre foreground form the lower point of the triangle that leads upwards to Christ. The musicians with their beautiful instruments are directly behind the dogs: Titian in a cardinal's scarlet on the double-bass, Veronese opposite him playing the viola, and the bearded Tintoretto and Jacopo Bassano (with the flute) between them. A fool in motley stands between the musicians and the distant and isolated Christ, who is seated next to the Virgin and Apostles. Standing to the right of Titian and to the left of the servant who decants the miraculous wine, Veronese's brother Benedetto, dressed in a splendid white brocade, tastes the wine that has just been created from water: 'This beginning of miracles did Jesus in Cana of Galilee, and manifested forth his glory; and his disciples believed in him' (John 2: 11).

Though scholars have not agreed about its meaning, *The Marriage Feast at Cana* has been continuously praised since the sixteenth century. Vasari calls it 'a marvellous work for its grandeur, the number of figures, the variety of costumes, and the invention; and, if I remember right, there are to be seen in it more than one hundred and fifty heads, all varied and executed with great diligence'.[20] Reynolds gives a detailed description of the painting in his *Discourses*;[21] Rossetti calls it 'the finest picture in the world';[22] and Cézanne observes, 'One sees nothing but a great coloured undulation It's magnificent to bathe a boundless and immense composition like this in the same clear and warm light Isn't it transfigured, miraculous, alive in another world, and yet a real world?'[23]

Though Ruskin admits that 'The whole value of the miracle, in its serviceable tenderness, is at once effaced when the marriage is supposed, as by Veronese and other artists of later times, to have taken place at the house of a rich man',[24] he nevertheless affirms 'the chief purpose of it is, I believe, to express the pomp and pleasure of the world, pursued without thought of the presence of Christ'.[25] But James, who writes of 'the absence of a total character at all commensurate with its scattered variety and brilliancy', rejects this interpretation and states, 'Mr Ruskin, whose eloquence in dealing with the great Venetians sometimes outruns his discretion, is fond of speaking *even* of a Veronese as a painter of deep spiritual intentions. This, it seems to me, is pushing matters too far.'[26] And James' interpretation is confirmed by Berenson, who writes of the painting, commissioned for the rectory of San Giorgio Maggiore: 'Paolo's chief employers

were the monasteries. His cheerfulness, and his frank and joyous worldliness, the qualities, in short, which we find in his huge pictures of feasts, seem to have been particularly welcome to those who were expected to make their meat and drink of the very opposite qualities.'[27] *The Marriage Feast at Cana,* then, is a kind of religious Satyricon, a sybaritic scene extending out of the frame into endless, elegant feasting, which allowed Veronese to indulge his taste for majestic ensemble and ostentatious luxury.[28]

Densher is more than a little overwhelmed by Susan's grandiose conception, and though she puts him 'in the picture' as a pleasure-loving wine taster, he feels 'closed in' and is unable to relate to it either aesthetically (he 'lacked the highest style') or economically (a 'plain, embarrassed working-man'). But when Milly abandons her black dress and makes her last public appearance in the novel, Densher feels quite secure and exalted in the noble 'golden grace of high rooms, chambers of art in themselves'.

> Milly, let loose among them in a wonderful white dress, brought them somehow into relation with something that made them more finely genial; so that if the Veronese picture of which he had talked with Mrs Stringham was not quite constituted, that comparative prose of the previous hours, the traces of insensibility qualified 'by 'beating down', were at last almost nobly disowned. [334]

The recreation of the Veronese painting in the novel, like the analogy with the Bronzino, allows the characters to come into a more intimate relation with each other; and at the end of the book, when Densher thinks of 'that night when she was in white, when she had people there and those musicians', he remembers that Milly committed Sir Luke to his care: 'It was beautiful for both of us—she *put us in relation*' (375).

James uses the motif of pearls to link the Bronzino with the Veronese painting and to illustrate the themes of the novel. Milly's habitual dress (like Lucrezia's) is a dark gown embellished by priceless lace and a long chain of lustrous pearls that represent 'the value of her life, and the essence of her wealth'. When Milly appears in the Veronese scene Kate remarks:

> 'Pearls have such a magic that they suit everyone.'
> 'They would uncommonly suit you,' [Densher] frankly returned.
> 'Oh yes, I see myself.'

And he thinks, 'pearls were exactly what Merton Densher would never be able to give her. Wasn't *that* the great difference that Milly tonight symbolised?' (338). The pearls remind Densher of his poverty and make him think of how he could adorn Kate if he had Milly's money. And in the final chapter the revelation in Milly's last letter is 'like the sight of a priceless pearl cast before his eyes—his pledge given not to save it—into the fathomless sea'. This allusion to the murder of Desdemona in *Othello*:

Like the base Indian, threw a pearl away,
Richer than all his tribe [V, II),

emphasises Densher's evil destruction of the woman who loved him, the 'pearl of great price' in Matthew 13: 46. If Densher is the worldly wine taster, then Milly is the Christ-like dove arrayed in her sacrificial robes of white.

Though James, like Thomas Mann, sees the splendid but decaying Venice as the most melancholy and funereal of cities—'Nowhere else is the present so alien, so discontinuous, so like a crowd in a cemetery, without garlands for the graves'[29]—Kate ironically declares, 'We're making her want to live.' When Kate perceives the depth of Milly's response to Densher the plot that was first conceived in the Bronzino chapter is executed in the Veronese one. And when Densher finally understands—'Since she's to die I'm to marry her? . . . So that when her death has taken place I shall in the natural course have money?'—Kate takes up the unnatural aspects of 'natural' and insists that money determines freedom: 'You'll in the natural course have money. We shall in the natural course be free.' Though Kate thinks that Milly's 'freedom, fortune and fancy were her law' and that her own bitter, caged freedom is 'hideously relative to tiers and tiers of others', Milly is also relentlessly confined by her riches, and is both a sacrificial victim and an innocent cause of evil. Kate, Densher and Milly are all locked in a struggle for wealth and power that must inevitably destroy them.

At his painful moment of *éclaircissement* Densher, who begins to lose faith in Kate (and perhaps in himself as well) secures Kate's agreement to come to his rooms as the sexual reward for his trying 'hard to propose to a dying girl'. Their plot succeeds only too well until the jealous and suspicious Lord Mark appears in Venice and tells Milly that Densher has been deceiving her. Densher then admits to Kate that 'We've played our dreadful game, and we've lost' and tries to rescue Kate by a desperate proposal of marriage. But his delay is fatal; and as James explains in his *Notebooks*, when she is finally ready to marry, 'he has really fallen in love with the dead girl. Something in the other woman's whole attitude in the matter—in the ''game'' he consented in a manner to become the instrument of, something in all this revolts him and puts him off. In the light of how exquisite the dead girl was he sees how little exquisite is the living.'[30]

When Densher makes the bitter discovery that Milly has left him all her money, he renounces the destructive legacy and offers Kate the ironic freedom to choose between marrying him without the money or taking the money without him. Only then does Densher, who has tasted the rich cup of life and wanted more as he tasted more, reject the morbid equation of money and life, and attempt to return to his belief (when he asked Kate to 'take me just as I am') that one can lead a decent and even happy life without a great deal of money. But Densher has learned too little and too late; and Kate's final confession, 'We shall never be

again as we were!', which ironically recalls her earlier declaration 'that I love you as I shall never in my life love anyone else', reveals how profoundly they have betrayed themselves and degenerated from idealism to corruption.

The paintings by Bronzino and Veronese give the characters of *The Wings of the Dove* a new depth and significance by placing them in the context of a rich and courtly decadence, provide a visual focus and structure for two crucial scenes of the novel, and render in pictorial art the dominant themes of the book: the Bronzino suggests the morbid ambiguity of aristocratic wealth and the Veronese the triumph of materialism over spirituality.

NOTES TO CHAPTER TWO

[1] E. M. Forster, *Aspects of the Novel* (London, 1927) 205–6.

[2] Quoted in Leon Edel, *Henry James: the Master, 1901-1919* (London, 1972), 121.

[3] Austin Warren, 'Henry James', *Rage for Order* (Chicago, 1948), 149: 'For years James had traveled diligently in France and Italy, written conscientious commentaries on cathedrals, châteaux, and galleries. Now people remind him of art, become indeed works of art. His heroines, almost without exception, are thus translated. The auburn-haired Milly Theale is a Bronzino; Aurora Coyne becomes "an Italian princess of the *cinque cento:* Titian or the grand Veronese might . . . have signed her image". Nan, the modernist and un-British daughter of *The Sense of the Past*, recalls "some mothering Virgin by Van Eyck or Memling". For Maggie there is evoked some slim draped statue from the Vatican, "the smoothed elegant nameless head, the impersonal flit of a creature lost in an alien age". Mme de Vionnet's head could be found on "an old precious medal, some silver coin of the Renaissance", while her daughter is a "faint pastel in an oval frame . . . the portrait of an old-time princess".'

[4] Marius Bewley, '*The Marble Faun* and *The Wings of the Dove*', *The Complex Fate* (London, 1952), 46, convincingly argues that 'Hawthorne's Dove [Hilda] seems to have been the only and the perfect artistic model' for Milly.

[5] Warren, 150. F. O. Matthiessen, 'James and the Plastic Arts', *Kenyon Review*, V (1943), 533–50, and Viola Hopkins, 'Visual Art Devices and Parallels in the Fiction of Henry James', *PMLA*, LXXVI (1961), 561–74 are good general essays, but they do not discuss James' use of Bronzino and Veronese.

[6] Henry James, *Picture and Text* (New York, 1893), 65.

[7] Henry James, 'The Lesson of Balzac', *The Question of Our Speech* (Boston, Mass., 1905), 93, 109. For an anthology of James' writings on art see Henry James, *The Painter's Eye*, ed. James Sweeney (London, 1956), which also contains a superb photograph of James studying a painting in a gallery.

[8] Henry James, *The Wings of the Dove* (London: Penguin, 1972) 52, 222.

[9] After their meeting in the National Gallery Kate and Densher look at each other 'as people look who have just rounded together a dangerous corner' (197).

[10] It is quite possible that James is punning on 'match 'em' as well as on Susan 'shepherd string 'em', the protective *duenna* who leads Milly through Europe. Critics have mentioned the evangelical echoes of Lord Mark and Sir Luke, and the fact that croy is a crow and teal a duck; but the characters' names have other significant associations. The overbearing Maud Lowder is obviously 'louder'; 'cate' is a dainty delicacy; Luke Strett is a 'strut' or support; and the frequently obtuse Merton is 'denser' (Kate is 'tired of his density').

[11] Milly tells Kate that Sir Luke will also 'take care of me for ever and ever'; but 'Kate Croy, whatever happened, would take care of Kate Croy' (151, 272).

[12] The painting was first identified in a note by Miriam Allott, 'The Bronzino Portrait in *The Wings of the Dove*', *Modern Language Notes*, LXVIII (1953), 23–5.

[13] A modern equivalent of the Bronzino is Sargent's fine portrait, *Henry James at 70* (1913) in the National Portrait Gallery, London. See James' essay 'John Singer Sargent', *Picture and Text* (New York, 1893), 92–115.

[14] Wylie Sypher, *Four Stages of Renaissance Style* (New York: Anchor, 1956), 113.

[15] Arthur McComb, *Agnolo Bronzino: His Life and Works* (Cambridge, Mass., 1928), 6.

[16] Bernard Berenson, *Italian Painters of the Renaissance* (London, 1952), 72. .

[17] Michael Levey, 'Prince of Court Painters: Bronzino', *Apollo*, LXXVI (May 1962), 169. See Luigi Passerini, *Genealogia e storia della famiglia Panciatichi* (Florence, 1858), 70–1.

[18] Oscar Cargill, *The Novels of Henry James* (New York, 1961), 377 n. 17. John Ruskin, *Guide to the Principal Paintings in the Academy at Venice* (1877), *Works*, ed. E. T. Cook and Alexander Wedderburn, XXIV (London, 1903–12), 187–90, prints, with his commentary, the transcription of Veronese's trial in 1573.

[19] Lawrence Holland's comment in *The Expense of Vision: Essays on the Craft of Henry James* (Princeton, N.J., 1964), 313, is rather confusing and superficial: 'When Densher agrees to stay in Venice, he agrees to perpetuate the fraud which is Milly's betrayal, fixing himself squarely in the picture at *The Supper in the House of Levi*, there to hear the call to repentance. Yet the same action, staying in the picture in Venice, fixes him squarely as the admiring young man with the wine cup, still sampling the sacred wine in *The Marriage Feast at Cana.*'

[20] Giorgio Vasari, 'Michele Sammichele', *Lives of the Most Eminent Painters, Sculptors and Architects*, trans. Gaston de Vere, VII (London, 1912-14), 239.

[21] See Sir Joshua Reynolds, *Discourses on Art*, ed. Robert Wark (San Marino, Cal., 1959), 157 n.

[22] Quoted in Percy Osmond, *Paolo Veronese: His Career and Work* (London, 1927), 49.

[23] Quoted in *ibid.*, 51.

[24] Ruskin, *Giotto and His Works in Padua* (1853), *Works*, XXIV, 86.

[25] Ruskin, *Modern Painters* (1843-60), *Works*, VII, 335-6.

[26] Henry James, 'Venice: an Early Impression' (1872), *Italian Hours* (London, 1909), 58. In 'The Grand Canal' (1892), *Italian Hours*, 36, James writes that Tintoretto's *Marriage at Cana* also 'sacrifices the figure of our Lord, who is reduced to the mere final point of a clever perspective, and [expresses] the free, joyous presentation of all the other elements of the feast'.

[27] Berenson, 29. Berenson also states that 'he was as much the greatest master of the pictorial vision as Michelangelo was of the plastic, and it may be doubted whether, as a mere painter, Paul Veronese has ever been surpassed'.

[28] See Marcel Proust, *Cities of the Plain*, trans. C. K. Scott Moncrieff, II (London: Chatto & Windus, 1971), 118: 'You shall fill all our glasses, they will bring in marvellous peaches, huge nectarines, there against the sunset; it will be as gorgeous as a fine Veronese.'

[29] Henry James, 'The Grand Canal', *Italian Hours*, 32.

[30] *The Notebooks of Henry James*, ed. F. O. Matthiessen and Kenneth Murdock (New York, 1947), 173.

Ghirlandaio
 and *Where Angels Fear to Tread*;
 Giotto
 and *A Room with a View*

I

> Pictures are not easy to look at. They generate private fantasies, they furnish
> material for jokes, they recall scraps of historical knowledge Long
> years of wandering down miles of galleries have convinced me that there
> must be something rare in these coloured slabs called 'pictures'.[1]

The tone of Forster's essay 'Not Looking at Pictures' is similar to his ironic and
satiric use of art in his two Italian novels. In these books the English characters
learn to see life through the medium of art, which revives both their visual and
their sensual feelings, and awakens their 'fantasies' about painting as well as
their capacity to love. Italian art expresses the beauty of San Gimignano and of
Florence, and stands for the human world of colour, form and emotion that is
either denied or discovered by the English travellers. The English usually have a
reverential regard for art, so that the 'jokes' are reserved for Forster, whose
secular humanism deflates the religious content of the paintings—the vision of
Santa Fina and ascension of St John. But Forster also values the personal and
prosaic qualities of Renaissance art as well as the aesthetic, and he mentions the
mother of Fina and the 'friends' of John. The 'scraps of historical knowledge'
belong pre-eminently to Karl Baedeker; and Forster contrasts two distinct
approaches to art: the expert and sterile, sanctified by the German's guidebooks,
and the emotional and intuitive, employed by those liberated English who have
abandoned themselves to the experience of the exquisite peninsula.

Though the effect of Forster's wit and playfulness is frequently humorous, the
themes of both novels are serious and even sombre; and Forster uses the
paintings of Ghirlandaio and Giotto in a subtle way to suggest the symbols,
reveal the characters and emphasise the themes of his books. The subject and
content of the paintings provide numerous allusions and analogies to the
substance of the novels, and the characters are often defined by their response to
the paintings. And Ghirlandaio and Giotto are also used as aesthetic models for

significant scenes so that the visual element matches and heightens the psychological significance of the action.

In the opening paragraphs of *Where Angels Fear to Tread* (1905) the crypto-philistine Philip Herriton, who adores Italians but never contemplated having one as a relative, advises his widowed sister-in-law Lilia, who is leaving for Italy with her friend Caroline Abbott, about what pictures to see. He then warns her: 'don't go with that awful tourist idea that Italy's only a museum of antiquities and art. Love and understand the Italians.' When Lilia impetuously follows this suggestion and falls in love with Gino Carella, the handsome though impoverished son of a dentist in Monteriano, Philip is despatched as a Jamesian ambassador to bring her back to her senses and to her stultifying life in Sawston (the town of saws, or platitudes).

Monteriano is based on San Gimignano, and the numerous towers, the Rocca, the Church of Sant' Agostino and the Collegiate Church actually exist. The town is described to Sawston first in the lively letters of Lilia, whom Philip censures as appallingly ignorant and with a false taste in art, but who nevertheless admires the Church of Santa Deodata and its wonderful frescoes (Caroline is 'very busy sketching'), and then through the dry and solemn facts of Baedeker (mentioned seven times in the novel), who also recommends 'the charming *Frescoes'. But in the 1874 edition of *Northern Italy* Baedeker warns the Anglo-Saxons of the problems to be encountered among the Latin races: 'With Italian sellers the pernicious custom of demanding considerably more than will ultimately be accepted is almost the invariable rule; but a knowledge of the custom, which is based entirely on the presumed ignorance of one of the contracting parties, tends greatly to mitigate the evil.'[2] Armed with such insight, Sawston is well prepared for Monteriano.

The famous frescoes are discussed in the novel when Philip, who 'catches art from Burne-Jones to Praxiteles', and his sister Harriet, who 'crawled like a wounded creature through the streets [of Florence], and swooned before various masterpieces of art',[3] approach Monteriano. Having failed to prevent Lilia's marriage to Gino, they now intend to rescue the baby who has survived Lilia in childbirth. (The duel over the baby and the 'pressure of a rescue party' have been foreshadowed in the earlier fight over the custody of Lilia's daughter Irma, and in the despatch of her ineffectual suitor, Mr Kingscroft.)

> One of the towers, rough as any other, was topped by a cross—the tower of the Collegiate Church of Santa Deodata. She was a holy maiden of the Dark Ages, the city's patron saint, and sweetness and barbarity mingle strangely in her story. So holy was she that all her life she lay upon her back in the house of her mother, refusing to eat, refusing to play, refusing to work. The devil, envious of such sanctity, tempted her in various ways. He dangled grapes above her, he showed her fascinating toys, he pushed soft pillows beneath her aching head. When all proved vain he tripped up the mother and

flung her downstairs before her very eyes. But so holy was the saint that she never picked her mother up, but lay upon her back through all, and thus assured her throne in Paradise In the full spring of the Renaissance, a great painter came to pay a few weeks' visit to his friend the Lord of Monteriano. In the intervals between the banquets and the discussions of Latin etymology and the dancing, he would stroll over to the church, and there in the fifth chapel to the right he has painted two frescoes of the death and burial of Santa Deodata. That is why Baedeker gives the place a star. [87–8]

Santa Deodata (given to God) is in fact Santa Fina (1238–53), whose terrible bodily ailments expiated the sins of other people and who was renowned for the perfect resignation with which she accepted physical suffering. In her childhood she was suddenly attacked by diseases and 'for five years she was obliged to lie on one side without turning; that side became a mass of corruption, and she was eaten by worms and mice'.[4]

Eight days before her death, as she lay alone and untended, Gregory appeared to her, and said, 'Dear child, on my festival God will give you rest' The neighbours declared that when her body was removed from the board on which it had rested, the rotten wood was found to be covered with white violets Many miracles were reported as having been wrought through her intercession. In particular she is said, as she lay dead, to have raised her hand and to have clasped and healed the injured arm of her friend Beldia.[5]

The frescoes of Domenico Ghirlandaio (who is called Giovanni da Empoli in the novel), *St Gregory Announces the Death of Santa Fina* (plate v) and *The Funeral of Santa Fina* (1475), are on opposite walls of the saint's chapel in the Collegiate Church. In the first painting the emaciated Fina, with the high forehead and long blonde hair so admired in Renaissance Italy, lies on a plank bed on the bare floor, attended by her mother and Beldia. Her rigid posture is emphasised by the horizontal lines of the long wooden table, with a copper pot, pomegranates and wine, and by the panelled ceiling, supported by decorated columns. The Tuscan landscape appears through the door and window on both sides of St Gregory (who was also noted for his endurance of suffering while chained to a rock in the middle of the sea), who appears in papal raiment surrounded by six winged angels to bless Fina and announce the end of her agonies. The diagonal from Gregory to the heads of the two nurses reiterates the fixed gaze of the three women who stare upwards at the vision. The grey walls and ceiling, the muted crimson in the sleeves of the two nurses, the reds around the cherubs and the pink in Fina's simple dress help to create the atmosphere of harmony and intimacy. And Van Marle writes that (like Forster) 'Ghirlandaio has not insisted on the loathsome details with which the young girl's legend describes her sufferings, as for example how she was pestered with rats and even

(V) Ghirlandaio, *St Gregory Announces the Death of Santa Fina*, 1475

had her ear eaten by them. A sweet little mouse on Fina's arm is the only allusion to this part of her story.'[6]

When late in the novel Philip follows Caroline into the church and is convinced by her that Gino should keep his baby because he loves it—the Herritons attribute their own lack of genuine feeling to the Italians and find it difficult to recognise 'that wicked people are capable of love'—there is a more detailed description of this fresco. Caroline instinctively leads Philip to the famous chapel, and as she praises him for the first time he smiled with pleasure and

> his eyes rested agreeably on Santa Deodata, who was dying in full sanctity, upon her back. There was a window open behind her, revealing just such a view as he had seen that morning, and on her widowed mother's dresser there stood just such another copper pot. The saint looked neither at the view nor at the pot, and at her widowed mother still less. For lo! she had a vision: the head and shoulders of St Augustine were sliding like some miraculous enamel along the roughest wall. It is a gentle saint who is content with half another saint to see her die. In her death, as in her life, Santa Deodata did not accomplish much. [129]

It is clear that Philip idealises Caroline as a gentle yet prosaic saint, for 'he was content to observe her beauty and to profit by the tenderness and the wisdom that dwelt within her'; and though he worships her, 'her remarks had only an aesthetic value'. But Caroline, ironically, is thinking about Gino, though she says she will never speak to him again; and when Philip declares, 'you are wonderful', she alludes to his emotional paralysis and replies, 'I can't bear—she has not been good to you—your mother'. Just as Santa Fina 'did not accomplish much', so 'their discourse, splendid as it had been, resulted in nothing'.

Ghirlandaio's fresco, like Donizetti's opera that the English visitors see in Monteriano, provides an aesthetic model for *Where Angels Fear to Tread*, for the novel is composed of a series of operatic and dramatic scenes ('The vista of the landing and the two open doors made [Gino] both remote and significant, like an actor on the stage'), and the English regard Italy as a 'pageant' and a 'spectacle'. When Philip sees Gino and Caroline just after they have bathed the baby and at the crucial moment when she realises that she loves Gino, they form a composition like the Ghirlandaio fresco—with a similar view and a similar copper pot—that is at once theatrical, aesthetic and religious.

> There she sat, with twenty miles of view behind her, and he placed the dripping baby on her knee. It shone now with health and beauty; it seemed to reflect light, like a copper vessel [used to bathe the baby]. Just such a baby Bellini sets languid on his mother's lap, or Signorelli flings wriggling on pavements of marble, or Lorenzo di Credi, more reverent but less divine, lays carefully among flowers, with his head upon a wisp of golden straw. For a time Gino contemplated them standing. Then, to get a better view, he knelt by the side of the chair, with his hands clasped before him. So they were when Philip entered, and saw, to all intents and purposes, the Virgin and Child, with Donor. [122]

This wonderfully subtle moment, like the scene with Connie and the partridge chicks in *Lady Chatterley's Lover*, expresses the important theme of unfulfilled maternity—Gino is the 'donor' of the child as well as of the painting—which unites the three women in the novel. The frustrated Caroline bursts into tears and rushes out of the room because she had hoped that Gino would propose to her. It was her passionate though repressed love for Gino that made Caroline encourage Lilia to marry him and then, when that marriage failed, to return to undo the 'evil'. Caroline is a remarkably complex character, and though she appears to be merely 'good, quiet, dull and amiable', even Philip realises that she 'cared about life, and tried to live it properly'. Through her self-sacrifice she is, more than any of the other characters, 'purified and ennobled' by Italy (where people drink wine and are beautiful); and her gradual 'unbending before the shrine' and realisation of her love for Gino, who can recognise and express his emotions ('This cruel, vicious fellow knew of strange refinements'), is the most interesting and moving aspect of the book. Caroline's friend Lilia, who had surprisingly left

her fatherless nine-year-old daughter for an entire year with his 'beastly family' whom she despised, hoped to compensate for the loss of her child and to bind herself to the unfaithful Gino by bearing his child. And the malicious energy of the peevish spinster Harriet derives, at least in part, from her maternal frustration. These women represent three progressive stages of love: Harriet is completely repressed; Caroline is awakened but unfulfilled; and Lilia is happy for a few months before her disillusionment with Gino and her death in childbirth.

The 'sweetness and barbarity' of the saint's life, portrayed in the fresco, is not only an aesthetic model for certain scenes in Forster's novel but also a thematic source that relates the characters to a single image. For, like Fina, Lilia dies an exemplary and expiatory death, liberating Caroline and Philip, as she had freed herself from 'the idleness, the stupidity, the respectability, and the petty unselfishness' of Sawston. Caroline's rescue of Philip, the fictional equivalent of Fina's miraculous cure of Beldia's paralysed arm, is also presented in a dramatic, aesthetic and religious composition similar to the 'Virgin and Child, with Donor'. For the 'goddess' Caroline again assumes the role of the Virgin and lifts Philip into her arms in the traditional *pietà* pose of the *mater dolorosa*: 'Her eyes were open, full of infinite pity and full of majesty, as if they discerned the boundaries of sorrow, and saw unimaginable tracts beyond. Such eyes he had seen *in great pictures* but never in a mortal' (150). As the servant Perfetta ironically ascends the stairs with the milk for the dead baby, the saint-like Caroline admonishes the men: 'there is to be no revenge. I will have no more intentional evil.' Philip, deeply moved by the example of this good woman, 'underwent conversion. He was saved.' In a moment of sacramental communion Gino nourishes Philip with the baby's milk.

Ghirlandaio's fresco records the life of a saint who struggled against the devil, and the novel's theme is an ambiguous and ironic reversal of the painting. Gino is twice called the 'devil', but he is also the agent of self-discovery for the principal characters. Like Fina, first Lilia, then Caroline *Abbott* and finally *Fra Filippo* are tempted by the attractive but unfaithful Gino, who is associated with the powers of evil. Lilia provides the first and fatal example, succumbs to the cruel and dissolute devil with slabs of shining hair—yet who is also 'majestic' and 'part of Nature'—and she dies as a result of it. Caroline too falls in love with the attractive Italian and nearly marries him (Gino tells his friend that he finds Caroline *simpatica*). But Gino's temptation of Philip, who distrusts emotion, is the most subtle and complex, for both men have a homosexual element in their nature, and their sado-masochistic connection builds up to a crescendo of pain through a series of hints and touches: 'Though you become as David and Jonathan, you need never enter his home, nor he yours.' After his marriage to Lilia, Gino agrees with his friend Spiridione, 'Sono poco simpatiche le donne. And the time we waste over them is much.' When Forster describes Gino's

procreative 'desire that his son should be like him, and should have sons like him, to people the earth', he calls this the 'strongest desire that can come to a man' and then adds the revealing qualification—'if it comes to him at all'. At the opera Philip is enchanted by the light caress of Carella's arm across his back; in the café Gino lays a sympathetic hand on Philip's knee; when Philip tells Gino of the baby's death he touches him on the shoulder for consolation; and when Gino twists his arm and he strikes Gino down, Philip passes his arm around him and is filled with pity and tenderness. Philip tells Caroline that after the baby's funeral Gino nursed him, for 'I was the only person he had to be kind to'. He is bound to Gino 'by ties of almost alarming intimacy' and confesses, 'I love him too!'[7]

The legend of Santa Fina also provides a major symbol in the novel, for when the saint died the rotten wood of the bed was covered with violets and masses of violets were seen flowering suddenly on all the towers of the town. When Philip first arrives in Monteriano his caustic interrogation of Caroline is suddenly interrupted by a long and lyrical description in water imagery of the violets that seem to symbolise Italy.

> The trees of the wood were small and leafless, but noticeable for this—that their stems stood in violets as rocks stand in the summer sea. There are such violets in England, but not so many. Nor are there so many in Art, for no painter has the courage. The cart-ruts were channels, the hollows lagoons; even the dry white margin of the road was splashed, like a causeway soon to be submerged under the advancing tide of spring His eyes had registered the beauty, and next March he did not forget that the road to Monteriano must traverse innumerable flowers. [23]

When the English make their tragic descent through that same wood with the stolen baby, the infant is contrasted to the shining image of the Virgin and Child and identified with 'Harriet, and the darkness, and the poor idiot [a kind of Greek messenger who understands everything but can explain nothing and has visions of saints] and the silent rain, which filled him with sorrow and with the expectation of sorrow to come It was as if they were travelling with the whole world's sorrow, as if all the mystery, all the persistency of woe were gathered to a single fount' (139–40). In this fast and perilous descent from light into darkness, from Paradiso into Inferno, the sacred wood becomes menacing, is associated with Dante's *selva oscura* and *via smaritta*, and prepares for the fatal accident. Baedeker mentions Dante's reference to the town's Ghibelline tendencies (Dante had visited San Gimignano on 8 May 1300 as ambassador for the Guelph League), Gino proudly recites the opening lines of *La Divina Commedia*, and Philip thrice alludes to *La Vita Nuova* ('Here beginneth the New Life').

In the final scene of the novel the symbolic violets, which renew the miracle every March, form part of the cluster of images that Philip associates with the paradisal aspects of Italy and that are an exact contrast to the infernal images of

doom: 'That laughter in the theatre, those silver stars in the purple sky, even the violets of a departed spring, all had helped [to bring them together], and sorrow had helped also, and so had tenderness to others.' This scene is the culmination of Philip and Caroline's moments of understanding and connection, in the train, the theatre and the church, which bring Philip to the point of proposing to Caroline—when she unexpectedly confesses her love for Gino. Though this love is doomed to frustration she rightly prefers to live with it rather than with Philip, for she realises that he is 'dead', without passion. At this moment Caroline embodies the perfect resignation of Santa Fina, and like the saint transcends 'degradation' and is transformed by the moral beauty of a love that cannot be realised in this world. In that terrible moment of discovery even Philip manages to think not of himself but of her. 'As she spoke she seemed to be transfigured For her no love could be degrading: she stood outside all degradation. This episode, which she thought so sordid, and which was so tragic for him, remained supremely beautiful.'

The characters and themes of *Where Angels Fear to Tread* are repeated three years later in *A Room with a View*, where Gino becomes George, Philip is Cecil, Caroline is Lucy and Harriet is Charlotte. In the later novel, however, George and Lucy achieve a fulfilment in love, analogous to the divine love portrayed in Giotto's painting, that is denied to Philip and to Caroline.

<div align="center">II</div>

The second chapter of *A Room with a View* (1908), 'In Santa Croce with no Baedeker', focuses on Giotto's fresco *The Ascension of St John* (plate VI), and the significance of the painting reverberates throughout the novel. For just as Giotto presents, in the characters grouped around St John, two distinct ways of viewing experience, so Forster reveals his characters' approach to life through their approach to art. One character complains of the Italians, 'From the cab-driver down to—to Giotto, they turn us inside out': images lead to ethics. In the course of the novel the heroine, Lucy Honeychurch, moves from a separation to an integration of art and life, and her development is measured by her change from a purely aesthetic object to a mature woman awakened through art to self-knowledge.

In the first chapter the expansive and far-sighted Emersons, father and son, quite naturally have rooms with a view that open out towards experience and quite sincerely offer them to Lucy and her *duenna* Charlotte Bartlett, who want and need them. Charlotte's rude and reluctant acceptance immediately places the characters in opposing camps and establishes a series of contrasting values: instinct–convention, passion–intellect, classical–medieval, truth–lies, sunlight–shadow. Views, violets, music and water symbolise the first group, while snobbery, hypocrisy, repression and sterility define the second.

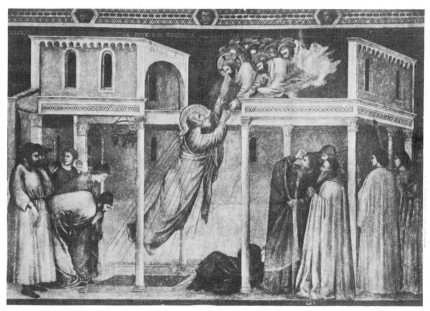

(VI) Giotto, *The Ascension of St John the Evangelist, c.* 1311–14

In Santa Croce these polarities are both intensified and weakened, for Lucy is again exposed to the sincere yet 'strange standpoint' of Mr Emerson, but begins her shift from the values of Charlotte to those of George Emerson. In order to prepare herself for the expedition to Santa Croce Lucy took up 'Baedeker's *Handbook to Northern Italy*, and committed to memory the most important dates of Florentine history. For she was determined to enjoy herself on the morrow.'[8] This *non sequitur* exposes the contrast between facts and pleasure, between looking at art with the serious spectacles of Baedeker (or even of Ruskin) or with a direct and intuitive vision. Like the views and violets and kisses, Baedeker, the Bible of tourism, carries its own (negative) values, and identifies the travellers who carry the coupons of Cook and who see Italy as a museum of dead things. Late in the novel, when Lucy tries to run away from George, abandons her quest for self-knowledge and joins 'the vast armies of the benighted', she prepares for Greece by borrowing a dictionary of mythology and buying a Baedeker.

The bourgeois novelist Eleanor Lavish, who like Cecil Vyse loudly proclaims her unconventionality, undertakes to lead Lucy to the church and to emancipate her from Baedeker, takes the red book from her and then disappears with a friend—throwing the lost Lucy into the orbit of the Emersons. Santa Croce, which Baedeker calls a 'cruciform basilica' and Forster an 'ugly barn',

'contained frescoes by Giotto, in the presence of whose tactile values she was capable of feeling what was proper. But who was to tell her which they were? She walked about disdainfully, unwilling to be enthusiastic over monuments of uncertain authorship or date' (25). The ironic reference to 'tactile values', that quality celebrated—particularly in respect to Giotto—by Bernard Berenson in his work on the Italian painters of the Renaissance which appeared between 1894 and 1907, places Lucy in a cage of conventional response from which she is liberated by the end of the novel, and prepares us for Mr Emerson's iconoclastic response to the painting.

' "If you've no Baedeker," said the son, "you'd better join us." ' They lead the way to the Peruzzi Chapel, where the Reverend Eager (who with Charlotte and Cecil represents 'medievalism') is suggesting a second way to look at art and is directing his parishoners, *ex cathedra*, 'how to worship Giotto, not by tactile valuations, but by the standards of the spirit Observe how Giotto in these frescoes—now, unhappily, ruined by restoration—is untroubled by the snares of anatomy and perspective.' The provocative Mr Emerson then interrupts the lecture with his own very secular and literal interpretation of Giotto: 'as for the frescoes, I see no truth in them. Look at that fat man in blue! He must weigh as much as I do, and he is shooting into the sky like an air-balloon!' This deflating observation drives Mr Eager and his flock, who carry the compound stigma of prayer books and guidebooks, out of the chapel, leaving George Emerson, who disagrees with his father, the last word on the fresco:

> It happened like this, if it happened at all. I would rather go up to heaven by myself than be pushed by cherubs; and if I got there I should like my friends to lean out of it, just as they do here Some of the people can only see the empty grave, not the saint, whoever he is, going up. It did happen like that, if it happened at all. [28–29]

The tradition of the saint's ascension derives from the apocryphal 'Acts of St John', which states '(evidently in view of the saying that this particular disciple "should not die", John XXI, 23) that St John at the end of his days in Ephesus simply disappeared: his body was never found'.[9] In his iconography for *The Ascension of St John* (1311–14) Giotto 'followed the Golden Legend, where the translation takes place suddenly in the presence of the whole assemblage. "When he had finished his prayer (in the grave which he had caused to be dug for him in front of the altar) he was surrounded by so strong a light that no one could look at him, and when the light disappeared they found no man in the grave".[10] In his 'Life of Giotto' Vasari remarks that the Peruzzi Chapel contains 'two marvellous stories of St John the Evangelist—namely, when he brings Drusiana back to life, and when he is carried off to heaven'.[11] And these frescoes, which were praised by Dante, Boccaccio and Petrarch, by Ghiberti, Poliziano and Leonardo, also get two stars from Karl Baedeker: 'This church

may be termed the pantheon of modern Italy In the Capella Peruzzi (the 4th), God the Father with the Madonna, St Roch, and St Sebastian, attributed to Andrea del Sarto; the **frescoes on the walls, representing the history of (r.) John the Baptist, and (l.) St John the Evangelist, are among the finest of Giotto's works.'[12] The interest in this church was heightened by the accidental discovery in 1849 of Giotto's frescoes, which Mr Eager calls 'ruined by restoration', beneath a layer of whitewash.

An early Christian basilica surrounds the ascending Evangelist, and the literal-minded men on the left stare with amazement into the empty grave as John slowly rises ('by himself') between two columns and is received by Christ and the Apostles ('his friends'), who reach out towards him in a gesture of love and bathe him in celestial light. On the right, one man has thrown himself on the ground and hides his face, another shields his eyes and a third clasps his hands in prayer.

Forster's interest in and attitude towards this painting were undoubtedly influenced by the essay on Giotto by his close friend Roger Fry, which first appeared in the *Monthly Review* of 1901. Fry calls the Santa Croce frescoes Giotto's 'maturest and most consummate works' and declares, 'It is difficult to avoid the temptation to say of Giotto that he was the greatest artist that ever lived.'[13] Fry also provides the best aesthetic description, which negates Mr Eager's patronising 'spirituality' and seems closest to George's enthusiastic affirmation:

> The shadow of the building is made use of to unify the composition and give depth and relief to the imagined space. It is also an example of that beautiful atmospheric tonality of which I have already spoken. In the figure of St John himself, Giotto seems to have the freedom and ease which we associate with art of a much later date. There is scarcely a hint of archaism in this figure. The head, with its perfect fusion of tones, its atmospheric envelopment, seems already nearly as modern as a head by Titian. Even the colour scheme, the rich earthy reds, the intense sweet blues of the figures relieved against a broken green-grey, is a strange anticipation of Cinquecento art. It seems as though Giotto in these works had himself explored the whole of the promised land to which he led Italian painting.[14]

And Sirén addresses himself to the realistic criticism of Mr Emerson: 'The artist has not wished to give any ethereal sublimation of the subject, but has tried rather to make the miracle credible on a material basis. Every figure, heavenly as well as earthly, has its full volume and a movement that can be accounted for on an organic basis.'[15]

Giotto's painting, an organising principle in the novel, establishes the values of Lucy, Miss Lavish and Charlotte, the Emersons and Mr Eager; teaches Lucy how life can be enhanced by art (in Rome she sees George, without shadows, 'on

the ceiling of the Sistine Chapel, carrying a burden of acorns'); how to dispense with the baneful benediction of Baedeker and to express her own, as opposed to official, opinion (she likes Della Robbia's babies½* better than Giotto**); and, urged by Mr Emerson, how to move from darkness towards the light that is expressed in her name: 'Let yourself go. Pull out from the depths those thoughts that you do not understand, and spread them out in the sunlight and know the meaning of them' (32).

In the fourth chapter Lucy becomes aware of 'the sadness that is often Life, but should never be Art' and crosses some spiritual boundary. She buys several photographs in Alinari's, including *The Ascension of St John,* but drops them when she faints into George's providential arms after seeing a man stabbed. When George throws the blood-stained photographs into the Arno and declares, 'I shall want to live', he makes the exemplary choice of life over art, just as Cecil chooses art over life. Art, however, is not dismissed from life (as when Mr Eager petulantly strikes a reproduction of Fra Angelico's angels and tears it) but is integrated into life, for the photograph of the ascension of St John (to *his* room with a view) reappears as a unifying symbol in George's house as well as in Lucy's.

Like Lucy, Cecil is related to the Emersons through Italian Renaissance painting, for he meets them in the National Gallery as they admire the art of Luca Signorelli. Cecil winces with superiority as Mr Emerson mispronounces the names of the Italian painters (George understands Giotto, though he does not know which saint is in the painting) just as the pedantic Mr Eager 'improves' Mr Emerson's translation of 'Non fate guerra al maggio'. Cecil's attempt to score off the local landlord by telling the undesirable Emersons about a house to let backfires when George returns to Lucy's world of music and violets and kisses her for the second time, a kiss that is infinitely superior to Cecil's frigid osculation.

Like Baedeker and the violets, the 'compositional' scenes of *Where Angels Fear to Tread* reappear in *A Room with a View.* George's kisses, prompted by the example of the driver Phaeton, take place in the context of an aesthetic landscape: the view over the Sussex weald is compared to pictures in a gallery, and the Italian view is similar to the one that Alessio Baldovinetti was fond of introducing into his paintings. Lucy, who is strongly influenced by the cascade of violets, admits that 'It makes such a difference when you see a person with beautiful things behind him'. Lucy feels that Cecil belongs in a drawing room with no view at all, but Cecil sees her in a landscape of fantastic rocks: 'she had turned and stood between him and the light with immeasurable plains behind her'. And when Mr Beebe, who loved the art of the past, sees Freddy and Mrs Honeychurch surrounding Lucy as she plays the piano he is reminded of a particular genre of painting, 'the *Santa Conversazione,* in which people who care for one another are painted chatting together about noble things' (201).

Lucy's aesthetic association of George and the Sistine Chapel links him with Freddy, whom Beebe describes as Michelangelesque; and the friendship of Freddy and George, sealed in the bathing scene, also helps to bring George back into Lucy's life. By contrast, Beebe, who has revealed his true colours and become solidly unsympathetic at the end of the novel, is described in an architectural metaphor as a 'black column' of clerical darkness;[16] and medieval Cecil is likened to a Gothic statue of a fastidious saint who guards the portals of a French cathedral.

Cecil too likes to compare Lucy to 'a woman of Leonardo da Vinci's, whom we love not so much for herself as for the things that she will not tell us. The things are assuredly not of this life; no woman of Leonardo's could have anything so vulgar as a "story" ' (95). This comparison reveals a good deal about Cecil, who sees Lucy as a purely aesthetic object ('not so much for herself') who has no inner life of her own (he thinks she soars up to reach *him*) and must live up to the expectations implied in the Leonardo analogy and the landscape of fantastic rocks. When Lucy criticises Mr Eager it appears to Cecil 'as if one should see the Leonardo on the ceiling of the Sistine', but this incongruity suggests that Lucy belongs in the camp of Michelangelo with George and Freddy and that the 'Leonardo' qualities are falsely imposed on her by Cecil. When she is angry after he has spitefully ruined her plans to house the Miss Alans, he 'felt again that she had failed to be Leonardesque'. He plans to rescue his 'Leonardo' through marriage but Lucy refuses to be a work of art. When she finally breaks off her engagement to Cecil and criticises his protective attempt to 'wrap yourself up in art and books and music, and would try to wrap up me' he is surprised to find that 'From a Leonardo she had become a living woman, with mysteries and forces of her own, with qualities that even eluded art' (183).

The paradox of Lucy's own art and life—'that she should play so wonderfully and live so quietly'—is finally resolved, as Mr Beebe predicts, when 'the water-tight compartments in her break down, and music and life mingle'. When she leans on the parapet of the Arno with George after he has thrown away the bloody photographs, the roar of the river suggests 'some unexpected melody to her ears'; when George kisses her among the violets the scene is described in the imagery of rivulets and streams and cataracts; when Mr Emerson announces, 'You love George', the words 'burst against Lucy like waves from the open sea'; and at the end of the novel when she is married and returns with George to the room with a view, love is attained through the harmonising influence of art and they once again hear the river 'bearing down the snows of winter into the Mediterranean'.

In *A Room with a View* Forster first uses Giotto's *The Ascension of St John* to reveal his themes through the characters' approach to the painting. But as the novel develops, these purely aesthetic responses become identified with moral issues. Forster constructs a witty analogy between Lucy and St John, for

whenever Lucy follows Mr Emerson's advice and moves toward illumination (portrayed in the painting by the golden rays that emanate from Christ), she is described in the imagery of ascension. When she accepts Mr Emerson and is sympathetic to George, 'her feelings were inflated spiritually'. Lucy's latent passion is defined by her talent for the art of music ('If Miss Honeychurch ever takes to live as she plays, it will be very exciting—both for us and for her'), and when she begins to play she is like the person who 'shoots into the empyrean without effort, whilst we look up, marvelling how he has escaped us, and thinking how we could worship him and love him, would he but translate his visions into human words, and his experiences into human actions' (34). In Italy Mr Beebe sees Lucy straining towards the realisation of this potential and tells Cecil, 'I can show you a *beautiful picture* in my Italian diary. Miss Honeychurch as a kite, Miss Bartlett holding the string. Picture number two: the string breaks.' Cecil reveals his egocentric pomposity when he pictures himself as the celestial equivalent of Christ in the fresco and 'suggested that he was a star and that Lucy was soaring up to reach him' (99–100). And when Lucy discovers that George had not laughed at her nor boasted of the kiss among the violets (a kiss that Charlotte interrupted and then revealed to Miss Lavish, who used it in her novel), she approaches salvation and her spirits 'leapt up as if she had sighted the ramparts of heaven' (163). The theme of *A Room with a View* is Lucy's reticent yet triumphant response to the call of life, and the victory of the intuitive and impulsive over the rational and repressive modes of experience. Italy and its art work some marvel in Lucy: they make her aware of her craving for sympathy and love, and manifest their power to evoke passion and bring it to fulfilment.

NOTES TO CHAPTER THREE

[1] E. M. Forster, 'Not Looking at Pictures' (1939), *Two Cheers for Democracy* (London, 1951), 140–1.

[2] Karl Baedeker, *Italy: a Handbook for Travellers. First Part: Northern Italy*, third edition (Leipzig, 1874), xiv.

[3] E. M. Forster, *Where Angels Fear to Tread* (London: Penguin, 1968), 84.

[4] *A Dictionary of Saintly Women*, ed. Agnes Dunbar, I (London, 1904), 317

[5] *Butler's Lives of the Saints*, eds. Herbert Thurston and Donald Attwater, I (London, 1956), 577–8.

[6] Raimond van Marle, *The Development of the Italian Schools of Painting*, XIII (The Hague, 1931), 14. In the second and greater fresco, which has less relevance to the novel, Santa Fina lies in front of an altar on a bier decorated with rich blue and gold brocade. As the bishop reads the funeral service the dead saint places her hand on Beldia's paralysed arm and heals it as well as the blindness of the boy who kisses her feet in gratitude. She is surrounded by twenty-six distinctive figures, including seven choir-boys with charming faces and a number of distinguished citizens of the town. Eight towers appear in the background, and an angel flies between the tallest ones on the left to signify the miracle of the bells that rang by themselves on the death of the saint.

[7] Almost all of Forster's fiction concerns the attempt to make the emotional leap from repression to fulfilment. In his Italian novels male love is disguised as a temptation, and the homosexual theme surfaces only in his posthumous works. See my essay on *Maurice*, 'Forster's Secret Sharer', *Southern Review* (Adelaide), v (March 1972), 58–62, and my review of *The Life to Come, Commonweal*, xcviii (21 September 1973), 506–8.

[8] E. M. Forster, *A Room with a View* (London: Penguin, 1972), 17.

[9] Thurston and Attwater, iv, 622–3.

[10] Oswald Sirén, *Giotto and Some of his Followers* (Cambridge, Mass., 1917), 70.

[11] Giorgio Vasari, *Lives of the Most Eminent Painters, Sculptors and Architects,* trans. Gaston de Vere, i (London, 1912–14), 73.

[12] Baedeker, 336.

[13] Roger Fry, 'Giotto', *Vision and Design* (London, 1920), 111, 115.

[14] *Ibid.,* 113-14.

[15] Sirén, 71.

[16] For a discussion of the bathing scene and Beebe's character see my essay ' "Vacant heart and hand and eye": The Homosexual Theme in *A Room with a View*', *English Literature in Transition*, xiii (1970), 181–92.

4 Maurice Greiffenhagen
and *The White Peacock*

Lawrence was a perceptive though eccentric critic of art and an accomplished painter,[1] and before the publication of *The White Peacock* in 1911 he trained himself as an artist by copying the pictures of the Pre-Raphaelites and their followers. In the novel Lawrence mentions the work of Rossetti, Millais, Burne-Jones and a number of minor artists, but the painting that had the most profound effect on him, and which he copied several times and presented to his family and friends,[2] was Maurice Greiffenhagen's *An Idyll* (1891)(plate VII).

Though Greiffenhagen (1862–1931) is now fairly obscure, he enjoyed a considerable reputation during his lifetime. His family originally came from Denmark; and he was born in London, taught at the Glasgow School of Art, illustrated Rider Haggard's best-selling novels and was elected to the Royal Academy in 1922. Greiffenhagen gives a rather bland description of his Theocritan *Idyll:* 'I wanted to paint a picture of a young man and maiden embracing in the fields, with a sentiment of youth and nature about it';[3] but during the composition of *The White Peacock* Lawrence writes an extremely enthusiastic letter about the aphrodisiac effects of seeing the painting.

> As for Greiffenhagen's 'Idyll', it moves me almost as if I were in love myself. Under its intoxication, I have flirted madly this Christmas; I have flirted myself half in love; I have flirted somebody else further It is largely the effect of your 'Idyll' that has made me kiss a certain girl till she hid her head in my shoulder Mon Dieu, I am really half in love. But not with the splendid uninterrupted passion of the 'Idyll' By the way, in love, or at least in love-making, do you think the woman is always passive, like the girl in the 'Idyll'? . . . I prefer a little devil—a Carmen.[4]

An Idyll arouses Lawrence's youthful emotions and makes him feel as if he were in love; and it also raises the question of whether a woman should be passive in love, like the 'maiden embracing in the fields', or 'a little devil', like Lettie Beardsall in *The White Peacock.* For the dangerous and threatening passion of Lettie and George Saxton could be ignited merely by the spark of the painting.

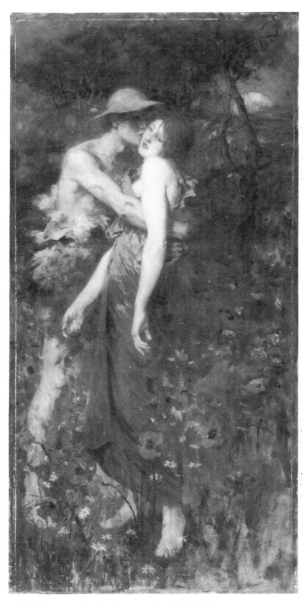

(VII) Maurice Greiffenhagen, *An Idyll*, 1891

In *An Idyll,* which plays an important symbolic role in the novel, a swarthy Pan figure, of great vigour and vitality, bare-chested and clothed in animal skins, seems rooted in a meadow where the grazing sheep and olive trees are lit up by a setting sun. He is lifting a pale, Pre-Raphaelite young woman off her feet, which are covered with bright poppies and daisies. He presses her half-naked bosom against his own body, entwines his fingers in the thick auburn hair cascading down her blue garment to her buttocks, and kisses her cheek as she turns away and swoons limply in his muscular arms, half afraid of passion. Cyril Beardsall's remark (a characteristic Lawrencean complaint) is an excellent gloss on the painting: 'A woman is so ready to disclaim the body of a man's love; she yields him her own soft beauty with so much gentle patience and regret; she clings to his neck . . . shrinking from his passionate limbs and his body';[5] and it echoes George's accusation: 'you have awakened my life . . . you start me off—then leave me at a loose end'.

The painting represents an ideal of 'splendid uninterrupted passion' that none of the characters in the novel is able to achieve. The virile farmer, George, admires the painting, which rouses him sexually: 'Wouldn't it be fine? . . . a girl like that—half afraid—and passion!'; but the response of the middle-class Lettie, who sees George as 'picturesque', is ironic and defensive: 'She may well be half afraid, when the barbarian comes out in his glory, skins and all Make love to the *next girl* you meet, and . . . she'll have need to be more than half afraid.' Yet when George hesitates and 'insists' (in the subjunctive), 'I don't know whether I should like any girl I know to—', Lettie mocks him and says he ought to have been a monk or a martyr instead of a satyr. George, 'breathlessly quivering under the new sensation of heavy, unappeased fire', glances at her breasts, shivers, and attempts to make small talk, for 'It was a torture to each of them to look thus nakedly at the other, a dazzled, shrinking pain that they forced themselves to undergo for a moment, that they might the moment after tremble with a fierce sensation that filled their veins with fluid, fiery electricity' (43–4). The painting reveals the emotions that they cannot and dare not express.

This scene of barely restrained passion is repeated thrice in *The White Peacock*: in the dance, the wood and the swim. Though the novel is seriously flawed by an awkward narrator who cannot possibly have seen all he reports, by an unfocused plot and two gratuitous accidents, and by a superfluity of wounded and bloody animals that are meant to suggest, as in Hardy, that 'life seems so terrible', Lawrence nevertheless shows considerable skill in his presentation of the four scenes that express the conflict of class and the frustration of love, and lead to a homosexual consummation in the 'Poem of Friendship'. The plot of *The White Peacock* is similar to *Wuthering Heights,* where Catherine marries the stiff Linton instead of the passionate Heathcliff, for Lettie is afraid of sex with George but not with Leslie Tempest; and when her love-making with Leslie is interrupted, 'Lettie followed, tidying her hair. She did not laugh and look

confused, as most girls do on similar occasions.' When George and Lettie fail to find emotional fulfilment or sexual realisation he marries the earthy Meg, who can satisfy his body but not his mind; and she weds Leslie, a 'mean fop', who provides mental but not physical satisfaction and who, in a fetishistic moment (the reverse of *An Idyll*) kneels down and rubs her cold feet while she touches his cheek and calls him 'dear boy'.

George's riotous dance with Lettie is the second scene of sublimated sexual passion. Mr Saxton shouts for them to stop.

> But George continued the dance; her hair was shaken loose, and fell in a great coil down her back; her feet began to drag; you could hear a light slur on the floor; she was panting—I could see her lips murmur to him, begging him to stop; he was laughing with open mouth, holding her tight; at last her feet trailed; he lifted her, clasping her tightly, and danced twice round the room with her thus. Then he fell with a crash on the sofa, pulling her beside him. His eyes glowed like coals; he was panting in sobs, and his hair was wet and glistening. She lay back on the sofa, with his arm still around her, not moving: she was quite overcome. Her hair was wild about her face. [115]

The powerful rhythms approximate Dionysian music as well as sexual movements and end in the climactic exhaustion of a sexual orgasm. This scene also repeats, in a subtle way that is clear when the painting is seen, the sexual posture of *An Idyll:* the man's glowing look as he lifts and tightly clasps the woman, and the woman's loose hair, parted lips, trailing feet and attitude of fearful yet passionate abandon.

Even after they are both engaged, George cannot give up Lettie, and in the wood that recallls the pastoral background of *An Idyll* he vainly pleads for her love and once again re-enacts the emotions of the painting.

> 'No, Lettie; don't go. What should I do with my life? Nobody would love you like I do—and what should I do with my love for you?—hate it and fear it, because it's too much for me?'
> She turned and kissed him gratefully. He then took her in a long, passionate embrace, mouth to mouth. In the end it had so wearied her, that she could only wait in his arms till he was too tired to hold her. He was trembling already. [248]

But their love cannot be resurrected, and their relationship does not progress beyond this embrace.

The swimming scene is the culmination of the novel (after it the characters listlessly follow their predestined fate) and is a synthesis not only of the idyllic passion of the dance and the wood, but also of the story of the first marriage of the gamekeeper Annable, which predicts what the marriage of George and Lettie would have been like. When Annable, a malicious Pan whose 'magnificent

physique, his great vigour and vitality, and his swarthy, gloomy face' recalls the shepherd in *An Idyll*, was courting his first wife, he used to swim in the river and 'dry myself on the bank full where she might see me I was Greek statues for her.' Annable, like George, was a poor young man, was called *son boeuf* (Lettie calls George *bos-bovis*), and suffers sexual humiliation. Annable openly expresses George's more covert hostility to women, and the titular white male peacock,[6] who dirties the head of an angel statue and symbolises the soul of woman, 'all vanity and screech and defilement', represents Lettie as well as Annable's Lady Chrystabel. In Lawrence's novels frustrated passion and frustrating marriage lead inevitably to a moment of male love.

The swimming scene takes place immediately after Lettie's final rejection of George during the third idyll in the wood, and at the end of Cyril's tepid and unsuccessful courtship of George's sister, Emily. The sexual debilitation of Cyril, who is sometimes called Sybil (he constantly urges George to sexual aggression with his sister, Lettie, but cannot act himself), suits him for the passive role of narrator–voyeur. He longs for someone to nestle against, and his strong attachment to George during the hay harvest culminates in the Whitmanesque 'Poem of Friendship' where the naked men roll in the grass and frolic in the pond, and the faithful dog chases away the intruding Emily.[7] Cyril's physical attraction to the rugged masculinity of George and Annable is an attempt to break away from his possessive mother, who 'hated my father before I was born', and regain his lost father. Annable's fatal accident and even Leslie's minor disaster seem to clear the field for Cyril and George, who later degenerates from a healthy animalism to an alcoholism similar to Mr Beardsall's. Cyril, who failed to recognise his father in their brief meeting before his death, is able to give George the final comfort he failed to provide for his parent.

Earlier in the novel George was sexually excited by looking at Cyril's reproductions of the homosexual Beardsley's *Atalanta* and *Salome:* 'the more I look at these naked lines, the more I want her. It's a sort of fine sharp feeling, like these curved lines.'[8] And at the pond, as Cyril *Beardsall* admires George's naked body, George 'laughed at me, telling me I was like one of Aubrey *Beardsley's* long, lean ugly fellows. I referred him to many examples of slenderness', in the same way that Annable compared himself to Greek statues. And as Cyril loses himself in contemplation of George's physical beauty he remembers the story of Annable. George

> saw I had forgotten to continue my rubbing, and laughing he took hold of me and began to rub me briskly, as if I were a child, or rather, a woman he loved and did not fear. I left myself quite limply in his hands, and, to get a better grip of me, he put his arm round me and pressed me against him, and the sweetness of the touch of our naked bodies one against the other was superb. It satisfied in some measure the vague, indecipherable yearning of my soul;

and it was the same with him. When he had rubbed me all warm, he let me go, and we looked at each other with eyes of still laughter, and our love was perfect for a moment, more perfect than any love I have known since, either for man or woman.[9] [257]

The 'rubbing' is explicitly homosexual as Cyril replaces his tall and threatening sister Lettie (just as George replaces Emily for Cyril), and becomes 'a woman he loved and did not fear' in this final representation of the limp, passive figure pressed against the powerful male in *An Idyll*. The feeble rationalisation ('to get a better grip') for the 'naked bodies one against the other' only heightens the homosexual effect, which to the reader is far from 'vague and indecipherable'. We are not told what George feels, but Cyril projects his own feelings on to his lover ('it was the same with him'). The frank, lyrical look 'with eyes of still laughter' is a satisfying contrast to George and Lettie's repressive torture 'to look thus nakedly at the other'. And Cyril's final statement is a paraphrase of David's lament for Jonathan in II Samuel 1: 26: 'very pleasant hast thou been unto me: thy love to me was wonderful, passing the love of woman'.

The male characters of *The White Peacock* are either Lintons or Heathcliffs; and they form a symbolic representation of the descent of man from the over-refined to the 'barbarian'—from Cryil and Leslie to George, Annable and the degraded and degenerate Mr Beardsall—in which the cultured men lack passion and the passionate men renounce culture. Though these incomplete men are unable to establish a successful heterosexual relationship, their dichotomy is symbolically unified in the homosexual consummation of George and Cyril. In the 'Poem of Friendship' the Whitmanesque and biblical motifs combine to form a satisfying male idyll that contrasts with unhappy marriages and frustrated love.

NOTES TO CHAPTER FOUR

[1] Lawrence's most important writings on art are: [Michelangelo's] David', 'Study of Thomas Hardy' and 'Introduction to These Paintings' (on Cézanne), *Phoenix* (London, 1936), 60–5, 455–76, 551–84; 'Making Pictures' and 'Pictures on the Walls', *Phoenix II* (London, 1968), 602–7, 608–15; and *Etruscan Places* (London, 1932). See also *The Paintings of D. H. Lawrence*, ed. Mervyn Levy (New York, 1964).

[2] Lawrence's copy of *An Idyll* is reproduced in Ada Lawrence and Stuart Gelder, *Young Lorenzo* (Florence, 1931), opposite p. 268. In *The White Peacock* Cyril gives George 'four large water-colours' as a wedding present.

[3] Quoted in J. Stanley Little, 'Maurice Greiffenhagen and His Work', *Studio*, IX (1897), 242.

[4] Letter to Blanche Jennings, 31 December 1908, in D. H. Lawrence, *Collected Letters*, ed. Harry Moore (London, 1962), 44.

[5] D. H. Lawrence, *The White Peacock* (London: Penguin, 1971), 317.

[6] Lawrence probably took his title from the lines in Tennyson's *The Princess* (1847), which also suggest the embrace of *The Idyll:*

> Now droops the milk-white peacock like a ghost,
> And like a ghost she glimmers on to me
> So fold thyself, my dearest, thou, and slip
> Into my bosom and be lost in me.

[7] There are a number of homosexual bathing scenes in *fin-de-siècle* literature. See, for example, Frederick Rolfe (Baron Corvo), 'The Ballade of Boys Bathing', *Art Review*, I (1890), 128:

> Breasting the wavelets, and diving there,
> White boys, ruddy, and tanned, and bare . . .
> Wondrous limbs in the luminous air,
> Fresh as a white flame, flushed, and fair.

[8] See George Ford, *Double Measure* (New York, 1965), 54: 'Beardsley shows Salome, the prophet-slayer, dressed in peacock skirts or surrounded by groups of peacocks. And this immensely long torso, the towering height of the princess, provides an explanation for Lawrence's having represented Lettie herself as almost six feet tall The young Lawrence, saturated in the art of the Pre-Raphaelites and of the 1890s, took the risk and relied upon his readers to surround his heroine with a cluster of associations: peacocks and tall princesses and what George Saxton calls the 'naked lines' of Beardsley's provocative drawings.

[9] There is a heterosexual and a lesbian swimming scene in *Sons and Lovers* and *The Rainbow*. In the former Paul is awed and frightened by Clara's swaying breasts as they dry themselves and he contemplates their love-making, and as he kisses her goose-flesh he ponders a woman's mystery. In the latter Ursula swims with Winifred Inger, and 'blinded with passion . . . the bodies of the two touched, heaved against each other for a moment, then were separate' (ch. 12).

5 Fra Angelico and *The Rainbow*

In his essay 'Making Pictures' Lawrence mentions his great pleasure and profit from copying English artists like Frank Brangwyn,[1] and then makes the connection between spiritual awareness and certain kinds of painting: 'I believe one can only develop one's visionary awareness by close contact with the vision itself; that is, by knowing pictures, real vision pictures, and by dwelling on them, and really dwelling in them. It is a great delight to dwell in a picture.'[2] Fra Angelico's *The Last Judgement* (plate VIII), which Lawrence saw in the Convento di San Marco in Florence, is precisely the kind of picture that helps to develop the sense of connection between the material and spiritual worlds. In their different ways Will, Anna and Ursula Brangwen 'dwell' in the painting and see it as a visual representation of their ideals, for *The Rainbow* is about the striving of men and women for the consummation of love, and Lawrence

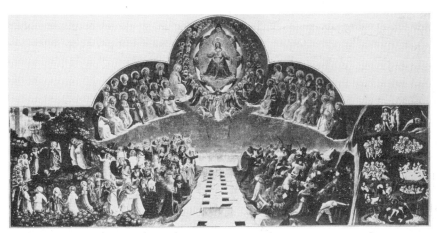

(VIII) Fra Angelico, *The last Judgement, c.* 1435

53

believes that 'Dürer, Fra Angelico, Botticelli, all sing of the moment of consummation, some of them still marvelling and lost in the wonder at the other being'.[3] Lawrence values art which, like his own work, attempts a spiritual interpretation of human experience, and he emphasises the visionary as well as the visual qualities of *The Last Judgement.*

The Bible is the literary, and the painting the pictorial, source for Lawrence's recurrent images of light, gateways, angels, circles, gardens and religious ecstasy; and most of the biblical references in the novel come from Genesis: the creation of Eve, the angels' visit to Abraham, the Sons of God and daughters of men, and Noah's covenant with the Lord, symbolised by the rainbow. If Genesis is Ursula's favourite book of the Bible, the Apocalypse is the most important to Lawrence, who records that 'Long before one could think or even understand Bible language, these ''portions'' of the Bible were *douched* over [my] mind and consciousness, till they became soaked in, they became an influence which affected all the processes of emotion and thought.'[4]

The iconography of *The Last Judgement* represents the opposition of salvation and damnation, heaven and hell; and Lawrence portrays these polarities in *The Rainbow* by contrasting illumination and darkness, inclusion and exclusion, consummation and annihilation. Lawrence uses religious imagery in the novel to describe the great moments of love and exaltation, and when he first introduces Angelico's painting in chapter six all these recurrent metaphors are gathered into a single image and achieve a simultaneity of verbal and visual meaning.[5] The entire novel leads to Ursula's hope for the future that is expressed in her heavenly vision of the New Jerusalem, what Lawrence calls 'the entry of the blessed into paradise', so that *The Last Judgement* is present in *The Rainbow* both as a symbolic centre of the narrative and in the biblical imagery that expresses the themes of the novel.

The brief opening section of *The Rainbow* reveals that the Brangwen women are traditionally distinguished from the men by their longing for something above and beyond themselves, for a widening circle of experience. While the men face inwards, the women want 'to enlarge their own scope and range and freedom', to achieve a higher being: 'How should they learn the entry into the finer, more vivid circle of life?'[6] The men recognise the difference in their modes of existence and say to the women, 'be the angel at the doorway guarding my outgoing and my incoming'. This superb overture creates a paradigm for the entire novel and relates the imagery to the structure of the book, for there are three entries into paradise, three transfigurations and three annihilations, one for each Brangwen generation. And the idealised comparison with angels, whose popular image had been created by Fra Angelico, reappears as a thematic leitmotif, not only in Lawrence's description of *The Last Judgement,* but also in Will's 'Creation of Eve', Tom's wedding speech, Will's appearance to Anna as the Angel of the Annunciation, and in the comparisons of Ursula to the angel in

the fire (Daniel 3: 28) and Anton's visit to the three angels who stood in Abraham's doorway (Genesis 18: 2).

Tom Brangwen's experience establishes the recurrent pattern of consummation and transfiguration, alternating with exclusion and annihilation, that is inherited by succeeding generations. When Tom falls in love with Lydia Lensky he experiences a 'transfiguration' as if he were 'on the brink of ecstasy, like a creature evolving to a new birth'. But Lydia's wedding ring, which symbolises her first marriage and her life in Poland, in which Tom had no part, 'excluded him: it was a closed circle. It bound her life, the wedding-ring She was like one walking in the Underworld, where the shades throng intelligibly but have no connection with one.' When Tom approaches Lydia's house to propose marriage, the light streaming from the window illuminates Lydia and her daughter Anna in the pictorial pose of Madonna and Child, and Tom is again excluded until the child is put to bed. After his marriage Lydia's pregnancy makes her unaware of Tom, 'annuls' his existence and leaves him isolated; and even the child Anna wants to exclude Tom from Lydia's bed. When Anna grows up and falls in love with Will, Tom watches the lovers dimly illuminated in the barn, where he had carried the young Anna when his first child was born, and he suffers the same exclusion that he felt when he observed the 'Madonna and Child' before his marriage. The correlative to this painful exclusion is the shelter, security and continuity that Tom finds when he wraps Anna in his mother's shawl, that Anna achieves in the span of the heavens between her parents, that Will discovers under the arch of the church porch, and that Ursula seeks in the love of Anton.

Tom and Lydia's second consummation occurs after two years of marriage and is described in religious imagery that merges with the inclusive and protective symbol of the rainbow. Their coming together again

> was the entry into another circle of existence, it was the baptism to another life, it was the complete confirmation
> [They] stood in the doorway facing eath other, whilst the light flooded out from behind on to each of their faces; it was the transfiguration, the glorification, the admission
> She was the gateway and the way out, she was beyond, and he was travelling in her through the beyond.

Through her parents' fulfilment in each other, Anna was secure and at peace.

> She played between the pillar of fire and the pillar of cloud in confidence, having the assurance on her right hand and the assurance on her left. She was no longer called upon to uphold with her childish might the broken end of the arch. Her father and her mother now met to the span of the heavens, and she, the child, was free to play in the space beneath, between. [96–8]

The imagery of gateways and arches, illumination and salvation, originates in the Bible and in *The Last Judgement.* The pillar of cloud and pillar of fire refer to Exodus 13: 21, where the Lord lights the way of the Israelites as they pass out of Egyptian bondage. And the entry through the gates to a greater life alludes to John's description of the heavenly Jerusalem in Revelation 21: 24–5: 'And the nations of them which are saved shall walk in the light of it: and the kings of the earth do bring their glory and honour into it. And the gates of it shall not be shut at all by day: for there shall be no night there.'

The two descriptions of Angelico's apocalyptic painting are preceded by the characters' parallel and contrasting responses to religious art. Will's religion is mystical and aesthetic rather than devotional and dogmatic, and he interprets Christianity in terms of art. Ruskin first stimulates Will's pleasure in medieval forms and his awareness of 'a ponderous significance of bowed stone, a dim-coloured light through which something took place obscurely, passing into darkness'. But Anna does not care very much about the church, which has an irresistible attraction for Will. When they examine a *Pietà* in 'Anna Victrix' (chapter six) Anna sees only the reality, 'bodies with slits in them, posing to be worshipped', whereas to Will 'it means the Sacraments, the Bread'. For Will the Lamb in the church window is 'the symbol of Christ, of His innocence and sacrifice', while Anna retorts, 'I like lambs too much to treat them as if they had to mean something' (163). Anna believed 'she was the ark, and the rest of the world was flood. The only *tangible,* secure thing was the woman'. Anna is defined by a literal approach to art as Will is by a symbolic, and both are limited by their inability, or refusal, to recognise their complementary connection. For without this connection they remain like the broken ends of an arch, incomplete until united. Like Anna, Ursula is also repelled by 'Jesus with holes in His hand and feet: it was distasteful to her'. But unlike her mother, who rejects the 'extra-human' and denies Will's mystical passion, the more sophisticated Ursula moves beyond realism and accepts 'the shadowy Jesus with the Stigmata: that was her own vision' (277).

The first description of *The Last Judgement,* in 'Anna Victrix', expresses Anna's joy and fulfilment in pregnancy, her literal transfiguration. Anna becomes isolated from Will in their recurrent cycle of love and conflict; and he destroys his beloved carving 'The Creation of Eve' when she jeers at him for distorting reality and making 'Adam as big as God, and Eve like a doll'. Will's carving symbolises his relations with Anna, for he begins it when they fall in love, continues it when they first marry, burns it when they quarrel, cannot return to it when Anna is estranged from him, and finally goes back to it twenty years later when their conflict has ended.

After the quarrel about the carving, Anna tearfully confesses to her parents that Will's coldness has prevented her from announcing her pregnancy, and when calm is ultimately 'restored to the *little circle,* the thought of Will

Brangwen's *entry* was not pleasantly entertained'. But when they become radiantly reconciled, Will appears illuminated 'through the open door [as] the level rays of sunset poured in, shining on the floor'; and as they walk home hand in hand, 'the blaze of light on her heart was too beautiful and dazzling'.

After this very careful preparation Lawrence presents the scene where the verbal and visual images coalesce as Anna finds among Will's reproductions a print of Fra Angelico's 'Entry of the Blessed into Paradise' (plate IX), the side of *The Last Judgement* that portrays man's salvation. The painting

> filled Anna with bliss. The beautiful, innocent way in which the Blessed held each other by the hand as they moved towards the radiance, the real, real, angelic melody, made her weep with happiness. The floweriness, the beams of light, the linking of hands, was almost too much for her, too innocent.
>
> Day after day she came shining through the door of Paradise, day after day she entered into the brightness. The child in her shone till she herself was a beam of sunshine How happy she was, how gorgeous it was to live: to have known . . . a terrible purifying fire, through which she had passed for

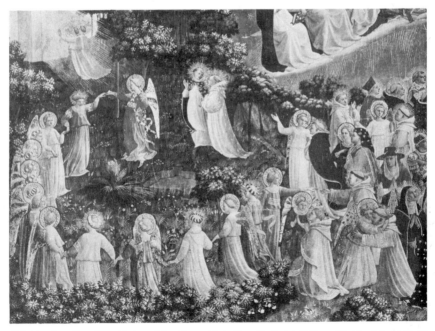

(IX) Fra Angelico, 'The Entry of the Blessed into Paradise', detail from *The Last Judgement*

once to come to this peace of golden radiance, when she was with child, and innocent, and in love with her husband and with all the many angels hand in hand. [182][7]

The painting represents Anna's yearning 'for a fullness of peace and blessedness', and the sense of creation that 'shines' within her allows her to experience the transcendent harmony of the angels.

Pope-Hennessy describes the characteristic qualities of the painting and writes that *The Last Judgement* (*c.* 1435) expresses Angelico's intellectual certainty, 'his sense of humility and awe in the divine presence', and is 'physically convincing yet devoid of sensuous appeal, direct, harmonious, elevated'.[8] In the arched central part of the painting, which is rainbow-shaped, Christ is seated in a mandorla, surrounded by eight cherubim and a double circle of seraphim. The Virgin sits on His right and John the Baptist on His left, and a semicircle of solemn saints extend out on both sides. Below Christ one angel carries the cross and two others sound the trumpet of doom as the double row of graves that stretch away into the distance are thrown open. On the left side kings, bishops, monks and nuns are being thrust by devils into the cavern of hell, and the torments of the damned in the seven circles of Inferno are portrayed on the extreme left.

On the right side of Christ, the blessed, who slowly turn from their wonder at the divine manifestation, are chastely embraced by angels in flowing robes who lead them into a paradisal garden of bright flowers, palm and orange trees, and a miniature lake—an ideal landscape of idyllic quietude. The angels are holding hands in a circle and performing a dance of graceful ecstasy that leads to the gates of paradise. The wall of heaven is pink and crenellated, and the blessed approach the golden roofs and towers of the New Jerusalem through a Romanesque arch that is flooded by celestial light. In his essay on the painter Ruskin emphasises the beauty of the delicate colours and writes

> it was for Angelico to make [the blessed] enter '*celestemente ballando, per la porta del Paradiso*'. But the notablest literal fulfilment of joy in him is that all nature becomes *transfigured* into the colours of blossoming To Angelico all nature becomes literally *couleur de rose*, so that architecture itself, trees, ground, all become rainbow-coloured.[9]

In *The Rainbow* the symbolic dances of Anna and Ursula appear shortly after each description of the painting, deny and negate the existence of Will and Anton, and provide an ironic contrast to the celestial dance of Angelico. The beatific hand-in-hand harmony of Anna and Will does not last very long, and they soon become hostile. So the pregnant Anna, who likes the story of King David who danced before the Lord and uncovered himself exultingly (II Samuel 6: 14–16), decides that she will dance Will's 'nullification' and dance to her unseen Lord. Like David's wife Michal, Will reacts angrily to this naked dance

before the fire, which exalts 'Anna Victrix' and annuls him by its self-absorbed exclusion: 'The vision of her tormented him all the days of his life, as she had been then, a strange exalted thing having no relation to himself' (186–7). Will takes refuge in the church and, in a phrase that blends biblical with painterly imagery, Anna sees from her Pisgah mount (where Moses first saw the Promised Land), a 'gleaming horizon, a long way off, a rainbow like an archway, a shadow-door with faintly coloured coping above it'. She is content within herself, and her separation from her husband is balanced by the new connection with her child, whom she names Ursula after 'the picture of the saint'.[10]

The emotional conflict of Anna and Will is expressed in their contrasting response to art and architecture, and culminates in the following chapter (seven) with their visit to Lincoln cathedral. The ecstatic Will sees the cathedral, which Ruskin calls 'the most precious piece of architecture in the British Islands',[11] as a sign in heaven 'spanned round with the rainbow', and he mounts its steep hill like a pilgrim at a shrine. But Anna characteristically concentrates on the detail of a sly, malicious little face carved in stone, and she insists that it is the carver's wife. Though Will objects that it is the face of a monk, Anna merely laughs as she did when she criticised his carving of Adam's wife, turning his absolute into a domestic reality, destroying his vital illusions and spoiling his passionate intercourse with the cathedral. But Will remains resolute: 'Still he loved the church. As a symbol, he loved it. He tended it for what it tried to represent, rather than for what it did represent' (209). Will's 'Creation of Eve', like the cathedral carving, expresses the struggle to realise a vision; and it is the biblical parallel of Will's creativity, just as David's dance symbolises Anna's ecstasy and the Sons of God Ursula's love.

The cathedral chapter appears between the two descriptions of *The Last Judgement* in chapters six and ten and is thematically related to both of them; for Will looks for the 'whole conception' and sees the painting in the same way that he saw the cathedral, while Ursula opposes her father's view and hunts out the detail of the painting just as Anna did with the small carvings in Lincoln.

> He loved the early Italian painters, but particularly Giotto and Fra Angelico and Filippo Lippi. The great compositions cast a spell over him . . . always, each time, he received the same gradual fulfilment of delight. It had to do with the establishment of a whole mystical, architectural conception which used the human figure as a unit. Sometimes he had to hurry home, and go to the Fra Angelico *Last Judgement*. The pathway of the open graves, the huddled earth on either side, the seemly heaven arranged above, the singing progress to paradise on the one hand, the stuttering descent to hell on the other, completed and satisfied him. He did not care whether or not he believed in devils or angels. The whole conception gave him the deepest satisfaction, and he wanted nothing more.
>
> Ursula, accustomed to these pictures from her childhood, hunted out their

detail. She adored Fra Angelico's flowers and light and angels, she liked the demons and enjoyed the hell. But the representation of the encircled God, surrounded by all the angels on high, suddenly bored her. The figure of the Most High bored her, and roused her resentment. Was this the culmination and the meaning of it all, this draped, null figure? The angels were so lovely, and the light so beautiful. And only for this, to surround such a banality for God! [281–2]

Will reveres the great composition, the complicated rendering, the architectural conception, and to him the human figure is an unimportant 'unit'. Will is not concerned about the reality of angels and devils, but Ursula questions and rejects the 'meaning of it all'. She divides the painting horizontally and admires only the more realistic lower half. Ursula *does* care about the angels and devils who welcome or torment the earthly people at the end of the world, and she delights in the vivid expression and great beauty of the angels. But Ursula rejects the stiff and hieratic composition of the upper half of the painting and is bored and even angered by the flat, Byzantine figure of Christ, 'draped and null', who is surrounded by saints in 'the seemly heaven' and who ignores the vast infernal darkness that sprawls beneath him. Berenson writes that Angelico 'was the typical painter of the transition from Medieval to Renaissance',[12] and his medievalism is manifested in the dichotomy of the divine and human elements in his painting. Ursula prefers the rainbow, whose span connects heaven and earth, to the Gothic form, 'which always asserted the *broken* desire of mankind in its pointed arches, escaping the rolling, absolute beauty of the round arch'.

Ursula's dance, which echoes Anna's, takes place in the chapter (eleven) that follows this second description of *The Last Judgement* and helps to establish the thematic parallels between the loves of Anna and Will, Ursula and Anton. In 'First Love' Ursula's life has become divided into the duality that derives from the painting, into 'a weekday world of people and trains and duties and reports' and 'a Sunday world of absolute truth and living mystery'. Her ambition throughout *The Rainbow* and into *Women in Love* is to make the visionary world triumph over the matter-of-fact world; and she imagines that the love of Anton, whom she compares to the impossible standard of the Sons of God, will lead her to this paradisal world, as Will once led Anna.

When Ursula tells Anton that it is right to make love in a cathedral she again aligns herself with Anna's view of Lincoln; and when she walks with Anton 'where her grandfather had walked with his daffodils to make his proposal, and where her mother had gone with her young husband', her love is placed in the perspective of earlier generations and she is strengthened by the traditions of the Brangwens. After Ursula gives away her necklace to the baby on the barge she dances with Anton in a symbolic union that recalls Anna and Will's gathering of the sheaves in chapter four, the second 'transfiguration' scene in the novel.

At first the dance is a form of connection and 'they become one movement,

one dual movement, dancing on the slippery grass'. But gradually Ursula withdraws into herself, as Anna had done, and away from Anton, who disapproved of her gift to the baby.[13] 'She liked the dance: it eased her, put her into a sort of trance. But it was only a kind of waiting, of using up the time that intervened between herself and her pure being.' The conflict inherent in the dance intensifies in their sexual relations, where 'her soul crystallised with triumph, and his soul was dissolved with agony and annihilation. She had triumphed: he was not any more' (321–5).

After exercising her corrosive power, and despising and destroying Anton when she seemed to be yielding to him in love—an annihilation *in* consummation—Ursula assumes the role of Christ in Angelico's painting: 'she would bring him back from the dead without leaving him one trace of fact to remember his annihilation by'. But Anton's destruction was too thorough and Ursula does not have this power: 'he could not rise again from the dead. His soul lay in the tomb.' It is significant that Tom and Will are annulled but able to recover the love of Lydia and Anna, but that Anton is permanently annihilated.

When her 'first love' disappoints her expectations and Anton leaves for the Boer War, Ursula becomes attracted to her lesbian teacher, Winifred Inger, and the 'Shame' chapter (twelve) contrasts the landscape of garden and mine to illustrate the recurrent theme of heaven and hell. When Ursula walked with Anton in the previous chapter she noticed how 'the glow of evening and the wheeling of the solitary pee-wit and the faint cry of birds came to meet the shuffling noise of the pits, the dark fuming stress of the town opposite'. And when Ursula, in an attempt to free herself from Winifred's perversion, takes her to meet her uncle Tom, the manager of a colliery, he detects in Winifred 'a kinship with his own dark corruption'. Tom describes the 'demon-like colliery' in terms of a burning fiery furnace—'The pits are very deep, and hot'—and, like the devils in Angelico's painting, Tom seems to enjoy the fact that 'living human beings must be taken and adapted to all kinds of horrors . . . subjected in slavery to that symmetric monster of the colliery'. Ursula sees Anton's intrinsic deadness represented in the landscape of the coal town, 'grey, dry ash, cold and dead and ugly'; and Tom's marriage to Winifred, where sexual is united to industrial corruption,[14] makes Ursula aware of the futility of her *liaison* with Anton.

Ursula's school (chapter thirteen) is another form of hell, and at Ilkeston, which in the opening paragraph of the novel symbolised something standing above and beyond in the distance, Ursula experiences 'the horrid feeling of being shut in a rigid, inflexible air, away from all feeling of the ordinary day It made her sick. She felt that she must go out of this school, this torture-place.' This school-hell is contrasted both to art and to nature: to the reproductions of Reynolds and Greuze in Miss Schofield's room and to the shining sky and 'luminous atmosphere of out-of-doors'.

Ursula's fourth attempt to escape into the widening circle of experience (chapter fourteen) and to 'be of the elect' is her enrolment in Nottingham University, which is presented in terms of the Medieval–Renaissance, Gothic–rainbow polarities implicit in Lawrence's description of Angelico. At first Ursula, like her father, Will, admires the (Victorian) Gothic form of the college, and 'her soul flew straight back to the mediaeval times, when the monks of God held the learning of men[15] and imparted it within the shadow of religion'. But she soon reverts to her old values and becomes disillusioned with the monastic associations and the sham Gothic, and angrily rejects the medievalism she connects with 'spurious Latinity, spurious dignity of France, spurious naiveté of Chaucer'. Like Christ surrounded by the cherubim and seraphim, the 'inner circle of light in which she lived and moved' is contrasted to the 'outer darkness'.

Ursula's bitter series of negative experiences renews her love for Anton when he returns from the war (chapter fifteen) to join her in what she hopes will be 'their final *entry* into the source of creation'. Ursula thinks 'they would soon come out of the darkness into the lights . . . newly washed into being, in a flood of new, golden creation'. She appears to Anton like a 'transfiguration in the refulgent light' and he awaits 'her judgement on him'. At the wedding of Will and Anna, Tom had announced in a festive speech that 'an Angel is the soul of man and woman in one: they rise united at the Judgement Day, as one Angel'. At the end of the novel, when Anton has married and sailed for India, Ursula writes to him and accepts his proposal. Though she had already recognised his deadness and broken with him, Ursula deceives herself and thinks, 'This was her true self, for ever. With this document she would appear before God at the Judgement Day.'

Ursula's judgement of Anton is ultimately, and justly, negative, and she must experience and 'come through' (in the Lawrencean sense) a sequence of failures that are described in terms of the iconography of *The Last Judgement*—medieval, Gothic, dark and hellish—before she can enter the circle of the blessed and become illuminated by the light and colour of the rainbow. These enriching failures—the school, the university, the lesbian love with Winifred, the bitterness of ecstasy with Anton (which foreshadows her mercurial and unstable love for Birkin), even the miscarriage (a strong contrast to Anna's swarm of children which Ursula associates with Rubens's *Fecundity*)—prepare Ursula for the final rainbow.

> The arc bended and strengthened itself till it arched indomitable, making great architecture of light and colour and the space of heaven, its pedestals luminous in the corruption of new houses on the low hill, its arch the top of heaven. And the rainbow stood on the earth . . . [and promised] that new, clean, naked bodies would issue to a new germination, to a new growth, rising to the light and the wind and the clean rain of heaven.

The architectural metaphor of the rainbow recalls the cathedral, and connects the first judgement of Noah in Genesis with the Last Judgement of Christ in Revelation. The rainbow is not a logical conclusion to the events of the novel, but a regenerative symbol which opposes Ursula's negative experiences and promises the salvation, 'transfiguration' and paradise that she ultimately achieves in *Women in Love*.

The Rainbow portrays a visionary quest by three generations of men and women; and as the Brangwens become more ambitious and seek a widening circle of experience they find it more difficult to achieve consummation and fulfilment. Lydia finds them in her husband, Anna in her children, and Ursula seeks them in a career, Tom in the land, Will in art, Anton in war. If the second and third generations suffer a decline from the heroic standard of Tom and Lydia, the giant race before the flood that drowns Tom (Anna sees Tom as 'a kind of Godhead' and angrily tells Will, 'I've known my own father, who could put a dozen of you in his pipe and push them down with his finger-end'), they are not so easily satisfied and they do succeed in enlarging their 'scope and range and freedom'.

Part of the greatness of *The Rainbow* lies in Lawrence's ability to connect and yet differentiate the Brangwens; and Anna, Will and Ursula are distinguished by the different ways they respond to the aspirations that are portrayed in the picture. Angelico's painting helps to structure and unify an enormously complex and innovative novel, and to focus the disparate images and values of three generations into a pictorial synthesis and harmony. *The Last Judgement* provides an artistic, visual and religious representation that encompasses the experience of mankind at the apocalyptic moment of religious history and is juxtaposed against the characters' vital quest for the connection between the material and spiritual worlds.

NOTES TO CHAPTER FIVE

[1] Sir Frank Brangwyn, R. A. (1867–1956), was employed during 1882–84 in the workshop of William Morris, whose ideas on art and design influenced Lawrence's portrayal of the craftsman Will Brangwen.

[2] D. H. Lawrence, 'Making Pictures', *Phoenix II* (London, 1968), 605.

[3] D. H. Lawrence, 'Study of Thomas Hardy', *Phoenix* (London, 1936), 460.

[4] D. H. Lawrence, *Apocalypse* (New York, 1966), 3.

[5] Emile Delavenay, *D.H. Lawrence: The Man and His Work* (London, 1972), 354, writes of Botticelli's *Mystical Nativity*: Lawrence's 'observations on this picture constitute a perfect expression of his conception of the overall structure of *The Rainbow*, of the relations of the parts to the whole, and of the artistic construction of the novel'. In the 'Study of Hardy' (475–6) Lawrence discusses Botticelli's representation of the 'perfect dual consummation', but he does not mention the *Mystical Nativity* in *The Rainbow* where, I believe, *The Last Judgement* has some of

the functions that Delavenay ascribes to Botticelli.

Keith Alldritt, *The Visual Imagination of D. H. Lawrence* (London, 1971), 84–6, makes some useful observations on the significance of *The Last Judgement* in *The Rainbow;* but his discussion is far from thorough, he does not analyse the painting, and he inexplicably reproduces the Berlin version of *The Last Judgement,* which Lawrence never saw.

[6] D. H. Lawrence, *The Rainbow* (London: Penguin, 1949), 10.

[7] Lawrence uses this imagery in the same way in *Women in Love*. Herbert Davis, 'Women in Love: A Corrected Typescript', *University of Toronto Quarterly*, XXVII (1957), 45, quotes a passage deleted from the novel: ' "Oh, but I love Fra Angelico's angels," cried Ursula, "they are so gay and tripping" '; and in the final version of *Women in Love* (London: Penguin, 1972), 287, Birkin thinks, 'There was another way, the way of freedom. There was the paradisal entry into pure, single being.' But in *The First Lady Chatterley* (London, 1972), 18, when Connie and Clifford hold hands early in the novel, before she meets the gamekeeper—'They were almost like two souls free from the body and all its weariness, two souls going hand in hand along the upper road that skirts the heaven of perfection'—this same imagery is used to express a different aspect of the painting: 'the sexless flights of Fra Angelico and Botticelli, the anguish of the idealists' who deny the body. ('Review of *The Story of Doctor Manente* by A. F. Grazzini', *Phoenix*, 275.)

[8] John Pope-Hennessy, *Fra Angelico* (London, 1952), 31. In this 'authoritative' work Hennessy offers the unfortunate opinion that *The Last Judgement* was painted by Zanobi Strozzi and that 'There is no reason to believe that any part of the . . . painting, as it at present stands, was executed by Angelico' (95). But after the important restoration in 1955 *The Last Judgement* was confirmed to be substantially by Angelico. See Elsa Morante, *Angelico* (Milan, 1970), 92.

[9] John Ruskin, 'Angelico', *The Schools of Art in Florence* (1874), *Works*, ed. E. T. Cook and Alexander Wedderburn, XXIII (London 1903–12), 260.

[10] Alldritt, 69, identifies this picture as Carpaccio's *The Dream of St Ursula*.

[11] Ruskin, *Works*, XXXVII, 433.

[12] Bernard Berenson, *Italian Painters of the Renaissance* (London, 1952), 49.

[13] This scene, which reveals the relationship of Ursula and Anton through a spontaneous gift to a poorer person, is similar in technique to the chapter 'A Chair' in *Women in Love*, where Birkin is drawn to Ursula when she gives away the chair they have just bought.

[14] Gerald's *liaison* with Minette in *Women in Love* is another union of sexual and industrial corruption.

[15] This phrase recalls 'the Sons of God saw the daughters of men' (Genesis 6: 2), quoted in *The Rainbow*, 279 and 295.

Mark Gertler and *Women in Love*

Two months after Lawrence had seen a photograph of Mark Gertler's most ambitious and famous painting, *Merry-Go-Round* (1916)(plate x), Lawrence informed Gertler that he had metamorphosed the painting of a whirligig into a gigantic frieze and used it in his latest novel, *Women in Love:*

> Sculpture, it seems to me, is truly a part of architecture. In my novel there is a man—not you, I reassure you—who does a great granite frieze for the top of a factory, and the frieze is a fair, of which your whirligig, for example, is part. (We knew a man, a German, who did these big reliefs for great, fine factories in Cologne.) Painting is so much subtler than sculpture, that I am sure it is a finer medium. But one wants the unsubtle, the obvious, like sculpture, as well as the subtle.[1]

Lawrence's transparent denial, 'not you, I reassure you', was sufficient to warn Gertler that, like so many of Lawrence's fictionalised friends, he was in for an unpleasant experience. For Gertler's character and career, which resemble Lawrence's in significant ways, his friendship with Lawrence and his unhappy love for Dora Carrington, form an important part of *Women in Love*; and his painting expresses the central theme of the novel: the decadence of modern society, dominated by the machine and carried to the extreme of war.

It is known that Lawrence used Carrington as a model for Minette and that Loerke is partly based on Gertler. But the way in which Lawrence transforms his attractive friend into the corrupt and sinister Loerke provides a valuable insight into his creative technique. *Merry-Go-Round* provoked a highly emotional response from Lawrence, who did not separate the impact of the work itself from his feelings about Gertler as a person and an artist. Since Lawrence uses the painting to define his own art, it is necessary to discuss Gertler's background and his relations with Lawrence in order to understand what role the artist and his works play in *Women in Love*.

Mark Gertler impressed everyone with his exuberant vitality, his exotic beauty and his artistic gifts. Aldous Huxley portrays him as Gombauld in *Chrome*

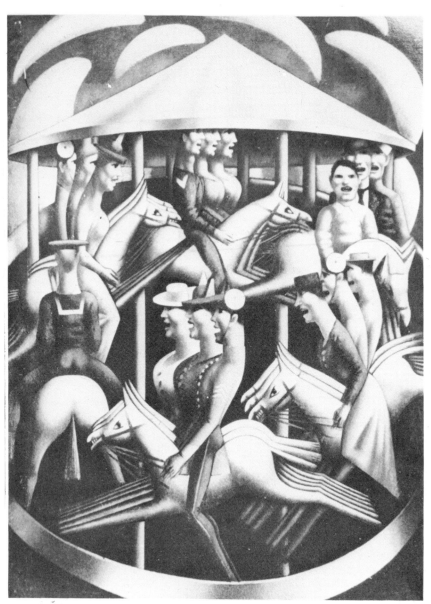

(X) Mark Gertler, *Merry-Go-Round*, 1916

Yellow, 'a black-haired young corsair of thirty, with flashing teeth and luminous dark eyes'.[2] Roger Fry writes, 'he is most passionately an artist—a most rare and refreshing thing'.[3] To St John Hutchinson, Gertler's friend and patron, 'There has seldom been a more exciting personality than when he was young . . . with amazing gifts of draughtsmanship, amazing vitality and sense of humour and of mimicry unique to himself—a shock of hair, the vivid eyes of genius and consumption'.[4] And Michael Holroyd summarises his attractive and charismatic character:

> Tempestuous and aggressive in his behaviour, he gave the impression of having schooled himself in the rudiments of polite society only through a most supreme effort of the will that might disintegrate at any second. He plunged into every activity which took his fancy with sudden and unrestrained violence, and was an exacting friend, a demanding and jealous lover.[5]

Even these brief descriptions suggest some important similarities between Gertler and Lawrence, who met in 1914 and remained friends and correspondents until Lawrence's death in 1930. Their volatile and exciting personalities, their lack of self-control, their tendency to be overbearing and possessive, to dominate and to wound their friends, are partly explained by their early poverty. For both men retained their regional accents and remained working-class outsiders in society, strongly attached to their families, especially their mothers, and always resentful of and uneasy with rich patrons. 'I think poverty is a terrible tragedy!' Gertler writes to Edward Marsh. 'How unfortunate I was to be born from the lower class—that is to say, without an income! A modern artist must have an income.'[6] And he says to his great love, Carrington, 'Yet you are the *Lady* and I am the East End boy',[7] which resembles Lawrence's feelings towards (and attraction to) Frieda. Both Gertler and Lawrence were close friends of S. S. Koteliansky and Dorothy Brett (who was at the Slade with Gertler), both were in Lady Ottoline Morrell's circle of friends at Garsington just before and during the Great War, and both took a pacifist stand against the war and were supporters of Bertrand Russell and Philip Morrell.

Yet Gertler and Lawrence, though extremely gifted, stood distinctively apart from the gilded youths at Cambridge and the Bloomsbury coterie. Gertler writes angrily in 1913:

> Always there exists that bridge between people and myself. I can't analyse the reason for this. They seem to be clever—very clever. They talk well, argue masterfully, and yet and yet there is something—something—that makes me dislike them. Some moments I hate them! I stand alone! But if God will help me to put into my work that passion, that inspiration, that profundity of soul that I *know* I possess, I will triumph over those learned Cambridge youths. One of them argued *down* at me about painting![8]

And this passionate hatred and self-justification are similar to Lawrence's denunciation, in the metaphor of disease and resurrection, after his disastrous weekend at Cambridge in 1915:

> It is true that Cambridge made me very black and down. I cannot bear its smell of rottenness, marsh-stagnancy. I get a melancholic malaria. How can so sick people rise up? They must die first.[9]

Both Gertler and Lawrence suffered from tuberculosis and were even treated by the same specialist, Andrew Morland. The sickly Gertler, who was hospitalised several times during the 1920s, explains to Carrington, 'I must live this nervous strained life always, always, and always. I must feel worried and ill—that is my fate. Therefore never feel worried when I look pale and haggard, it is part of me.'[10] In 1918 Lawrence, who refused to recognise his own disease, cautions Gertler, 'I should beware of Garsington. I believe there is something exhaustive in the air there, not so very restful';[11] and seven years later he says to Murry, 'I hear that poor Gertler is in a sanitorium'.[12]

When Lawrence first met Gertler the painter was hopelessly in love with the talented Carrington, whom he had met at the Slade and whom Ottoline compared to 'a wild moorland pony, with a shock of fair hair, uncertain and elusive eyes, and rather awkward in her movements, which gave her a certain charm'.[13] And Holroyd writes:

> With her short honey-coloured hair, now shaped pudding-basin fashion, her big blue forget-me-not eyes, delicate pale complexion, shy and diffident manner, she appeared to [Gertler] as fragile and sublime as a piece of priceless china. Her superior middle-class birth, emphasized by a rather mincing precise accent and punctuated between sentences by a little gasp, enhanced her distinctive feminine appeal He was captivated by her air of simplicity, her extraordinary childlike innocence, her passionate love of beauty, her generous trustfulness and odd, unexpected impulses.[14]

Carrington's oddest impulses were sexual. She vacillated between long periods of extreme repression when she hated the 'hanging flesh and female encumbrances' of her own lovely body, and brief submissions to confused and indiscriminate sex. During the former she prolonged Gertler's elaborate seductions for five years before giving in, briefly, to the 'unclean act'; and during the latter provided Lytton Strachey with his only (unsuccessful) heterosexual experience, married the virile Ralph Partridge, had an intense yet frustrating affair with his friend Gerald Brenan, and had several lesbian passions. Carrington finally swung back to repression, virtually gave up painting, and devoted her life to the cool and astringent Lytton Strachey, who made no sexual demands on her and was far more attracted to her handsome lovers than she was. She lived as Strachey's companion for fourteen years and shot herself when he died of cancer in 1932.

In 1916, however, the friendship of Gertler and Carrington 'developed into a fierce, intimate struggle of wills in which Carrington proved herself to be by far the more subtle and intransigent of the two'.[15] Encouraged and excited by her sexual promises that were continually broken and continually renewed ('If I find many more poems by Donne urging me to forsake my virginity I may fall by next spring, when the sun is hot once more'), Gertler became distracted, ill and unable to work—'I hate you because I love you and am therefore in the power of your cruel, advanced and unpassionate self!'[16]—and he fell more in love with her than ever before. (Their sexual conflict was much more intense than Middleton Murry and Katherine Mansfield's, and may have influenced Lawrence's portrayal of Gerald and Gudrun's 'struggle of wills'.) Lawrence, married and six years older than Gertler, offered him the kind of good advice that he was incapable of following himself:

> If you could only really give yourself up in love, she would be much happier. You always want to dominate her, which is no good. One must learn to relinquish oneself, not to bother about oneself, but to love the other person. You hold too closely to yourself, for her to be free to love you.[17]

But Lawrence disliked Carrington, and like others who did not understand her inner life, was confused and angered when she abandoned the attractive Gertler, Partridge and Brenan for the decrepit homosexual Strachey. Lawrence writes of Carrington:

> She was always hating men, hating all active maleness in a man.[18] She wanted passive maleness She could send out of her body a repelling energy to compel people to submit to her will It was only in intimacy that she was unscrupulous and dauntless as a devil incarnate. In public, in strange places, she was very uneasy, like one who has a bad conscience towards society, and is afraid of it. And for that reason she could never go without a man to stand between her and all the others.[19]·

Carrington naturally returned Lawrence's hostility, and in 1924 told Gerald Brenan, with a shrewd sarcasm she had learned from Strachey:

> Lawrence was very rude to me of course, and held forth to the assembly as if he was a lecturer to minor university students. Apparently he came back this winter [from America] expecting to be greeted as the new messiah. Unfortunately very few saw his divination.[20]

While Gertler was being tormented by Carrington's refusal (or inability) to love him he met Lawrence's friend, the novelist Gilbert Cannan, who had recently run off with Sir James Barrie's wife, Mary, while acting as his private secretary. When the strain of Carrington, poverty, creative work and high life at Garsington harmed Gertler's health, Cannan invited Gertler to paint at his mill in Hertfordshire. Gertler needed someone to talk to and Cannan needed material for

a new novel; and in 1916 Cannan published *Mendel*, which is based on Gertler's life and his relations with Carrington, and which also features Lawrence and Frieda as minor characters. Like most people, Lawrence disliked *Mendel* and was angered by it, and in 1916 he complained to Catherine Carswell, 'Gertler, Jew-like, has told every detail of his life to Gilbert.'[21]

Lawrence shares with many other eminent writers of his time (Pound, Eliot, Wyndham Lewis) a pronounced and nasty strain of anti-Semitism, which is activated as much by his provincial background and the attitudes of his fashionable friends as by his familiarity with the anti-Semitic writings of H. S. Chamberlain or Otto Weininger, as Delavenay suggests. Lawrence's attitudes are a curious compound of traditional prejudice against Jews and a concept of Jews as an ancient race with a depth of experience, but in a state of decay. Lawrence seems to reserve his outbursts of anti-Semitism for Jewish friends like Gertler and Koteliansky who, despite Lawrence's extremely offensive letters, were the only intimates with whom he never quarrelled. In 1917 Lawrence gives the generous and gentle Kot this unwelcome lecture:

> Why humanity has hated the Jews. I have come to the conclusion that the Jews have always taken religion—since the great days, that is—and used it for their own personal and private gratification, as if it were a thing administered to their own importance and well-being and conceit. This is the slave trick of the Jews—they use the great religious consciousness as a trick of personal conceit. This is abominable.[22]

And in a letter of the same year to another Jew, Waldo Frank, Lawrence repeats, 'The best of Jews is, that they *know* truth from untruth. The worst of them is, that they are rather slave like.'[23] The letter to Kot states that the Chosen People are elitist and smug, while the letter to Frank suggests that they are a cringing race. But this 'slave trick' and 'slave like' quality seem to be related in Lawrence's mind to Gertler's self-abasing revelations to Cannan and to Lawrence's scorn for Gertler, who could neither dominate the priggish Carrington nor abandon her for good.

In 1926 Lawrence makes still another anti-Semitic generalisation, inspired by the poetaster Louis Untermeyer, which is consistent with his earlier views:

> By virtue of not having a real core to him, he is eternal . . . that is the whole history of the Jew from Moses to Untermeyer: and all by virtue of having a little pebble at the middle of him, instead of an alive core.[24]

Though this may be true of Untermeyer, a poor stick to beat Moses and the 'great days' of the Jews, it certainly does not apply to Gertler, whose vital core, intensified by failing lungs, was as lively as Lawrence's. But the following letter of 1918 to Edith Eder, the Jewish wife of Lawrence's Jewish doctor, applies much more to Lawrence than to Gertler, for Lawrence identifies himself with the

vilified race of Jews: Gibbon

> says the Jews are the great *haters* of the human race—and the great
> anti-social principle.—Strikes me that is true—for the last 2500 years, at
> least.—I feel such a profound hatred myself, of the human race, I almost
> know what it is to be a Jew.[25]

Lawrence's letter to Gertler about *Merry-Go-Round* explains more fully what he
means by 'the best of the Jews': their capacity to know truth from untruth and
their value as haters of mankind. Even Untermeyer's hard little pebble has
meaning in the context of Lawrence's racial theory, for as a race on the point of
dissolution Jews are most capable of depicting this dissolution in art. Since an
'alive core' is not necessary to express chaos and decay, Lawrence sees
Merry-Go-Round as a product of the Jewish race.

In 1916, then, when Gertler and Lawrence had moved from poverty to
academic achievement and artistic success, and had become friends, when
Gertler was suffering with Carrington and Lawrence was having his own sexual
problems with Frieda and the Murrys in Cornwall, Gertler was painting
Merry-Go-Round and experimenting with sculpture and Lawrence was writing
Women in Love. In February 1915 Gertler tells Carrington, 'The other day I
picked up a piece of [Benin] African sculpture wood, like they have in the B.M.
[British Museum], for 10*s*! It gives me great delight and is like my work.'[26] In
November 1916 Lawrence reports to Gertler, 'Kot told me you had done your
first sculpture—'The Acrobats'. I wonder how you like it, what you think of it';[27]
and the following April, when he has seen the statue, he writes to Gertler, 'I
think the wrestlers interesting: but sculpture never quite satisfies me. It is not
sufficiently abstracted. One resents the bulk, it frustrates the clarity of
conception.'[28]

The bronze acrobats are two stylised and elongated nude male figures, the
standing one balancing the other, who grips his arms and hangs upside down
with his head between the knees of the upright man. The statue must have
reminded Lawrence of the wrestling scene in *Women in Love*, and may even
have influenced it.[29] Quentin Bell agrees that *The Acrobats* was influenced by
African sculpture; and Woodeson relates this work to Gertler's painting of the
same year: 'In its simplification and hardness of form and in its tight design of
pattern and limbs, it recalls the *Merry-Go-Round*.'[30] Gertler was so absorbed in
sculpture at this time that in November 1916, the month after he completed the
painting, he mentions to Carrington, 'I am now working on my carving of the
Merry-Go-Round.'[31]

The aesthetic of Gertler's painting, which is the model for Loerke's frieze, is
based more on the violence of the German expressionists than on his former
masters, Cézanne and Renoir. French painting 'is too refined for us—too sweet,'
Gertler states. 'We must have something more brutal today'[32] I like the

beauty that trembles on the abyss of ugliness.'[33] in *Merry-Go-Round* Gertler portrays sixteen soldiers, sailors and young women, in rigid military posture, spun by centrifugal force into wild gyrations. Huxley writes that 'Gertler's colour has always been strong, even violent; and there have been times when that violence seemed almost too much for him.'[34] And the intensity, brutality and mindless hilarity of the stylised, puppet-like figures, whose grimaces are repeated in their horses, are expressed in the hot, glaring colours. The roof of the whirligig, supported by eight vertical struts which contrast with the circular sweep of the platform, is brilliant orange and red, as if it had been melted in a crucible and poured out into a fiery umbrella. The roof harmonises with the subdued saffron of the women's clothing, but clashes with the deep crimson and blue of the military uniforms. The crescent clouds seem carved from the sky and drop thickly on to the roof, their pointed edges thrusting forward. The foreground is black, as if the pleasure machine were suspended over an abyss.

Quentin Bell gives the most complete description of the painting:

> It was perhaps his masterpiece; the colour is almost unbearably harsh and strident. Gertler seems to have been determined to show how much he could unleash The holiday-makers are deliberately reduced to the same wooden state of rigidity as their steeds, the clouds above are as aggressively Cézanne as they. Everything is held, as though within some whirling metallic labyrinth, by a system of ellipses and verticals. This compels the artist to insist upon a series of redundant visual rhymes which, with relentless iteration, render the strange, mazed, tipsy reel of the fairground. It is a picture which certainly deserves to be respected; but which is more easily admired than loved.[35]

Lytton Strachey's hyperbolic, theatrical and characteristically deprecating response to *Merry-Go-Round* provides an interesting contrast to Bell's objective analysis:

> Oh lord, oh lord have mercy upon us! It is a devastating affair isn't it? I felt that if I were to look at it for any length of time, I should be carried away suffering from shellshock. I admired it, of course, but as for *liking* it, one might as well think of liking a machine gun. But fortunately he does all that for himself—one needn't bother with one's appreciations.[36]

Strachey, who was also a pacifist, uses military metaphors to describe the painting, which was finished in late 1916, after two years of disastrous trench warfare and the failure of the Somme offensive during the summer and autumn. Like *Women in Love*, the painting is a bitter response to war, and it uses the same image of an unnatural spinning out of control as Yeats does in 'The Second Coming' (1921):

> Turning and turning in the widening gyre
> The falcon cannot hear the falconer;

Things fall apart; the centre cannot hold;
Mere anarchy is loosed upon the world.

The *Merry-Go-Round* was so cynical in its portrayal of unheroic soldiers that St John Hutchinson cautioned the civilian Gertler (who had a German name) about the provocation of showing it publicly:

> I want to ask you whether you think you are quite wise in exhibiting the 'Merry-Go-Round' at the London Group? It will of course raise a tremendous outcry—the old, the wise, the professional critic will go mad with anger and righteous indignation—and what strikes me is that these symptoms may drive them to write all sorts of rubbish about German art and German artists in their papers and may raise the question acutely and publicly as to your [pacifist] position. I think, if matters remained quiet, you are quite safe, but I am rather afraid of what might happen if the matter got into the papers and was taken up by the public at large.[37]

Lawrence's powerful response was the most extensive and important of all, and he too associated Gertler's work with the war, and reaffirmed his faith in their friendship:

> I was glad to hear such good news of the 'Roundabout'. I want very much to see it, and look forward to having a photograph copy I saw the *Daily Mirror* today—the Zeppelin wrecks, etc. How exhausted one is by all this fury of strident lies and foul death This is to tell you—and Kot—that the essential thing is not gone, that is in our relationship Our hope is in the central truth, and then in each other. And then we can create a new order of life, in the times after these.[38]

A month later, after Gertler had sent him a photograph of the painting, Lawrence (who wrote a play called *Merry-Go-Round* in 1912) writes his convoluted stream-of-consciousness letter which links the painting with *Women in Love* and deserves extensive quotation and analysis:

> Your terrible and dreadful picture has just come. This is the first picture you have ever painted: it is the best *modern* picture I have seen: I think it is great, and true. But it is horrible and terrifying. I'm not sure I wouldn't be too frightened to come and look at the original.
>
> If they tell you it is obscene, they will say truly. I believe there was something in Pompeian art, of this terrible and soul-tearing obscenity. But then, since obscenity is the truth of our passion today, it is the only stuff of art—or almost the only stuff. I won't say what I, as a man of words and ideas, read in the picture. But I *do* think that in this combination of blaze, and violent mechanised rotation and complete involution, and ghastly, utterly mindless human intensity of sensational extremity, you have made a real and ultimate revelation. I think this picture is your arrival—it marks a great arrival. Also I could sit down and howl beneath it like Kot's dog, in soul-lacerating despair.[39] I realise how superficial your human relationships

must be, and what a violent maelstrom of destruction and horror your inner soul must be. It is true, the outer life means nothing to you, really. You are all absorbed in the violent and lurid process of inner decomposition, your inner flame.—But dear God, it is a real flame enough, undeniable in heaven and earth.—It would take a Jew to paint this picture. It would need your national history to get you here, without disintegrating you first. You are of an older race than I, and in these ultimate processes, you are beyond me, older than I am. But I think I am sufficiently the same, to be able to understand.

Though Lawrence's initial praise appears to be unqualified ('the best *modern* picture', 'I think it is great'), we know from his essay on Cézanne that he dislikes most *modern* pictures. This ambivalent expression is characteristic of the entire letter. Lawrence calls the painting 'obscene' and compares it with Pompeian art because it expresses 'sensational extremity', the conjunction of human beings without spiritual interaction. There is a direct relation between Roman decadence, obscene art and the destruction of Pompeii by Vesuvius in ancient times; and Jewish decadence, 'obscene' painting and the destruction of Europe by the Great War in modern times. But Lawrence does not mean 'obscene' to be totally pejorative, for he says that obscenity is the 'truth of our passion today' and is therefore an essential material for modern art. So he praises Gertler's ability to reveal this truth ('that is the best of Jews—they *know* the truth'), which is 'a real and ultimate revelation'.

Lawrence's description of the painting is superb ('blaze and violent mechanised rotation'), but while he praises Gertler he also violently condemns him for his superficial human relationships (though Lawrence writes, 'the essential thing is our relationship', in the previous letter), and for the destruction and horror, not in Gertler's art, but in his soul.[40] Lawrence identifies the content of the painting with the state of Gertler's inner life, and his final point, Gertler's 'Jewishness', reveals the reason for Lawrence's ambivalence. For he needs to differentiate his own art from Gertler's, and he relies on the concept of Jewishness to explain this difference. He sees himself as sufficiently 'Jewish' to understand Gertler's vision, but backs away from involvement in these 'ultimate processes' himself.

Lawrence then continues:

This all reads awkward—but I feel there ought to be some other language than English [Hebrew?], to say it in. And I don't want to translate you into ideas, because I can see, you must, in your art, be mindless and in an ecstasy of destructive sensation. It is wrong to be conscious, for you: at any rate, to be too conscious. 'By the waters of Babylon I sat me down and wept, remembering Jerusalem.' At last your race is at an end—these pictures are its death-cry. And it will be left for the Jews to utter the final and great death-cry of this epoch: the Christians are not reduced sufficiently. I must

say, I have, for you, in your work, reverence, the reverence for the great articulate extremity of art.

Lawrence quotes Psalm 137, the great Jewish lament in exile that prophesies the imminent destruction of Babylon, to express the Jewish death-cry of a race at its end. Lawrence seems to suggest that only Jewish suffering and (what he calls in an earlier letter) Jewish hatred of the human race, a hatred fully shared by Lawrence himself, is capable of producing Gertler's apocalyptic picture—and his own apocalyptic novel. For just after he completed *Women in Love* he tells Catherine Carswell, 'This book frightens me: it is so end-of-the-world. But it is, it must be, the beginning of a new world too.'[41] Lawrence has reverence for Gertler's extremity of art that can lead to regeneration, to 'a new order of life, in the times after these'.

> Perhaps you are right about sculpture—I don't know—probably you are, since you feel so strongly. Only, somehow, it seems to me to be going *too far*—over the edge of endurance into a form of incoherent, less poignant shouting. I say this, trying to imagine what this picture will be like, in sculpture. But you know best. Only take care, or you will burn your flame so fast, it will suddenly go out. It is all spending and no getting of strength. And yet some of us must fling ourselves in the fire of ultimate expression, like an immolation. Yet one cannot assist at this *auto-da-fe* without suffering. But do try to save yourself as well. You must have periods of proper rest also. Come down here and stay with us, when you want a change. You seem to me to be flying like a moth into a fire. I beg you, don't let the current of work carry you on so strongly that it will destroy you oversoon.
>
> You are twenty-five, and have painted this picture—I tell you, it takes three thousand years to get where this picture is—and we Christians haven't got two thousand years behind us yet.
>
> I feel I write stupidly and stiltedly, but I am upset, and language is no medium between us.
>
> [P.S.] I am amazed how the picture exceeds anything I had expected. Tell me what people *say*—Epstein, for instance.
>
> Get somebody to suggest that the picture be bought *by the nation*—it ought to be—I'd buy it if I had any money. How much is it? I want to know—how much do you want for it?[42]

Lawrence regards himself as one who suffers by 'assisting at the *auto-da-fe*', but sees Gertler as one who throws himself *into* the flame. By 'Jewish' here he seems to mean an expression of primitive unconsciousness, a creation that goes over 'the edge of endurance' and ultimately destroys the artist. Though 'all spending and no getting of strength', an echo of Wordsworth, applies to Lawrence as well as to Gertler, Lawrence likens Gertler to a moth flying into a flame, a deathly contrast to the phoenix image he so frequently applies to himself.

Gertler's response to this bizarre, offensive and rather patronising letter is not

known, but he must have extracted the nuggets of praise from the silt of interpretation, for their friendship, unlike so many others, survived this letter, and Gertler's characterisation as Loerke, when *Women in Love* was finally published in 1920.

Like Gertler, Loerke is Jewish and spent an impoverished childhood in a garrison town in Polish Austria. Loerke is given some of Gertler's physical traits: the dark skin, 'the boyish figure and the round, full, sensitive-looking head, and the quick, full eyes' (456). But the corruption of this 'little *obscene* monster of the darkness' (as Birkin calls him) is emphasised by his homosexual relations with his soft young love-companion, Leitner, which bears no relation to Gertler's complete heterosexuality.

Loerke's artistic similarities to Gertler (whose painting was inspired by a Hampstead fair) are more significant:

> It was very interesting to Gudrun to think of his making the great granite frieze for a great granite factory in Cologne. She got from him some notion of the design. It was a representation of a fair, with peasants and artisans in an orgy of enjoyment, drunk and absurd in their modern dress, whirling ridiculously in roundabouts, gaping at shows, kissing and staggering and rolling in knots, swinging in swing-boats, and firing down shooting-galleries, a frenzy of chaotic motion. [476][43]

This passage synthesises the mood and action of the painting, suggests two synonyms for the *Merry-Go-Round* which were sometimes used as alternate titles (whirligig and roundabout), alludes to another painting by Gertler done in exactly the same style (*The Swing Boats*, 1915) and ends in a military metaphor ('firing down the shooting-galleries').[44]

Unlike Gertler, Loerke believes that 'Sculpture and architecture must go together. The day for irrelevant statues, as for wall pictures, is over Art should *interpret* industry as art once interpreted religion [There is] nothing but work! Nothing but this, serving a machine, or enjoying the motion of a machine' (476–7), what Lawrence calls 'the violent mechanised rotation' in Gertler's picture. The character of Loerke is not based on Gertler as he really was but on Lawrence's theoretical conception of him as the Jewish artist (which he states in the letter). Loerke is an artist who does not condemn the machine but, like the Italian futurists, identifies with it and glories in its 'interpretation'.

Loerke's glorification of the machine links him in two ways with another world of corruption in the novel—the coal mines of Gerald Crich. For Loerke's mechanised industrial art represents the mechanisation of the mines and the miners by Gerald, whose hand is symbolically caught and mangled in one of his own machines. And the ridiculous whirling motion of the roundabout recalls the frenzied gyrations of the rabbit Bismarck at Gerald's house, after it had clawed Gerald and Gudrun and sealed their fate in blood: 'Round and round the court it

went, as if *shot* from a gun, round and round like a furry meteorite, in a tense hard circle that seemed to bind their brains' (273). Gudrun is attracted to both Gerald's and Loerke's corruption, and reads the letters of Loerke's countryman, Bismarck, when she lives with Gerald in the Alps.

Like Gertler, Loerke has also done *bronze* statues, 'an early thing—*not* mechanical':

> The statuette was of a naked girl, small, finely made, sitting on a great naked horse. The girl was young and tender, a mere bud. She was sitting sideways on the horse, her face in her hands, as if in shame and grief, in a little abandon. Her hair, which was short and must be flaxen, fell forward, divided, half covering her hands.
>
> Her limbs were young and tender. Her legs, scarcely formed yet, the legs of a maiden just passing towards cruel womanhood, dangled childishly over the side of the powerful horse, pathetically, the small feet folded one over the other, as if to hide. But there was no hiding. There she was exposed naked on the naked flank of the horse. [482]

After showing Ursula and Gudrun a photograph of the statue, Loerke expounds his theory of art (*Kunstwerk*) that resembles Roger Fry's idea of 'significant form': 'That horse is a certain *form,* part of a whole form. It is part of a work of art, a piece of form'[45] (483). And as Alldritt has pointed out, Lawrence attacks Fry's theory in 'Introduction to These Paintings':[46]

> If you want to invoke an aesthetic ecstasy, stand in front of a Matisse and whisper fervently under your breath: 'Significant Form! Significant Form!'—and it will come. It sounds to me like a form of masturbation, an attempt to make the body react to some cerebral formula.[47]

But the angry Ursula, herself an artist (and presumably unsympathetic to Fry's first Post-Impressionist exhibition of 1910), intuitively sees through the falsity of Loerke's theories and passionately attacks him:

> 'The horse is a picture of your own stock, stupid brutality, and the girl was a girl you loved and tortured and then ignored' And how the situation revealed itself to her! She saw the girl art student, unformed and of pernicious recklessness, too young, her straight flaxen hair cut short, hanging just into her neck, curving inwards slightly, because it was rather thick; and Loerke, the well-known master-sculptor, and the girl, probably well brought up and of good family, thinking herself so great to be his mistress. [485-6]

The description of this young girl links Loerke with the novel's second world of corruption, the Bohemian set of the Café Pompadour, and it repeats the earlier portrayal of Minette, Halliday's pregnant mistress, whom Gerald sleeps

with in his host's flat.[48] Like Loerke's mistress, Minette

> was a girl with bobbed, blonde hair, cut short in the artist fashion, hanging
> straight and curving slightly inwards to her ears. She was small and
> delicately made, with fair colouring and large, innocent blue eyes. There
> was a delicacy, almost a floweriness in all her *form* She had beautiful
> eyes, *flower-like*, fully opened, *naked* in their looking at him. [68, 71]

The bobbed blonde hair, the large blue eyes and the tender bud of a body
connects Loerke's young and well brought up art student not only with Minette
Darrington but also with Gertler's love, Dora Carrington. In the novel both
Minette and the young model are used and then abandoned by their lovers,
whereas in life it was Carrington who, in Lawrence's view, was unscrupulous
and cruel to Gertler. Though the sexual roles are reversed in *Women in Love*,
Lawrence uses the destructive relationship of Gertler and Carrington to
emphasise the thematic connection between the perversion of art and the
perversion of love.

Gertler's statue, *The Acrobats*, is linked with *Merry-Go-Round* just as Loerke's
statue is related to the frieze; and the fact that *The Acrobats* was influenced by
African sculpture connects, in yet another way, Loerke's decadent Northern
sculpture with the decadent tropical sculpture that Gerald and Birkin find in
Halliday's flat. This primitive sculpture, which is twice described in the novel, is
specifically associated with the pregnant Minette, who is terrified of black
beetles, Lawrence's symbol of decadence and corruption. (Lawrence changed
the first description of West African sculpture to 'West Pacific' to avoid a libel
suit threatened by Philip Heseltine, the model for Halliday, but he retained 'West
African' in his second description.)

The first African statue, of a woman sitting naked in the posture of childbirth,
'clutching the ends of the band that hung from her neck, one in each hand, so that
she could bear down, and help labour', conveys 'the suggestion of the extreme of
physical sensation, beyond the limits of mental consciousness'. Gerald saw the
'face of the savage woman, dark and tense, abstracted in utter physical stress. It
was a terrible face, void, peaked, abstracted almost into meaninglessness by the
weight of sensation beneath. He saw Minette in it' (81–2, 87.)

The second African statue, about two feet high (the same height as *The
Acrobats*, 23 in.), is of a woman whose 'face was crushed tiny like a *beetle's*,
and had rows of heavy round collars, like a column of quoits, on her neck', and
is similar to the first one. This fetish has many of the qualities that Lawrence
attributed to *Merry-Go-Round* in his letter, and in the novel he substitutes African
for Jewish art as a symbol of 'the ecstasy of destructive sensation'. To Lawrence
both Jewish and African art, which would seem to have little in common, express
the history of an ancient race, older than Christianity, which has sensual rather
than spiritual values. Lawrence tells Gertler, 'it takes three thousand years to get

where this picture is—and we Christians haven't got two thousand years behind us yet'. And he writes in *Women in Love:* the statue 'had thousands of years of purely sensual, purely unspiritual knowledge behind her. It must have been thousands of years since her race had died, mystically.'

To Lawrence *Merry-Go-Round* portrays 'the utterly mindless human intensity of sensational extremity' and expresses 'what a violent maelstrom of destruction and horror [Gertler's] inner soul must be'. And in the novel Birkin–Lawrence thinks:

> Thousands of years ago, that which was imminent *in himself*, must have taken place in these Africans: the goodness, the holiness, the desire for creation and productive happiness must have lapsed, leaving the single impulse for knowledge in one sort, mindless progressive knowledge through the senses, knowledge arrested and ending in the senses, mystic knowledge in disintegration and dissolution, knowledge such as *beetles* have, which live purely within the world of corruption and cold dissolution. This was why her face looked like a *beetle's*: this was why the Egyptians worshipped the ball-rolling *scarab*: because of the principle of knowledge in dissolution and corruption. [285–6][49]

Just as Loerke and Gudrun 'kindled themselves at the subtle lust of the Egyptians', so Birkin drives with Ursula 'like an Egyptian Pharaoh'. And just as Lawrence is similar to Gertler in important ways, has a powerful intuitive response to *Merry-Go-Round* and associates himself with the 'anti-social principle' of the Jews ('I feel such a profound hatred myself'), so the African statues that suggest 'mindless progressive knowledge' beyond the senses and into 'disintegration and dissolution' express to Birkin 'that which was imminent *in himself*'. As Lawrence writes to Gertler, 'It would need your national history to get you here, without *disintegrating* you first . . . in these ultimate processes you are beyond me . . . over the edge of endurance into a form of incoherent' art. Like Conrad's Marlow, who stares into Kurtz's abyss but draws back just in time, Lawrence senses Gertler's disintegration without actually experiencing it.

Though Birkin realises there is another and better way to sensual knowledge, 'the paradisal entry into pure, single being, the individual soul taking precedence over love and desire for union', he is nevertheless strongly attracted to the 'sensual subtle realities far beyond the scope of phallic investigation' (286–7). Ursula perceives that Loerke's statue represents his corrupt relationship with the model. In the same way, though Birkin strives for 'star equilibrium' with Ursula, his sexual experience with her in 'Excurse' is represented in the African statue: a penetration 'deeper, further in mystery than the phallic source, [into] the floods of ineffable darkness and ineffable riches' (354).[50]

In *Women in Love* Lawrence uses Gertler's life and works as a correlative for his own ideas about sex, love, Jews, art and war. He employs African art to symbolise wilful sex and decadent love, and Jewish art to symbolise the

destructive principle that is manifest in machines and in war, so that the decadent Loerke both admires primitive art and glorifies machines in his German sculpture. Since Lawrence closely identified with Gertler, whose art was (he felt) horrible and terrifying, Lawrence had to transform his attractive friend into the sinister Loerke in order to objectify his destructive feelings and clearly dissociate his own 'Jewish' attitudes from his portrayal of Birkin and Ursula. Though Birkin and Ursula are not entirely free from the dissolution and decadence expressed in Gertler's painting, their love is defined by contrast to the three worlds of corruption in the novel—the mines and Bohemia which coalesce in Loerke's art—and which are all directly related to *Merry-Go-Round*, a unifying symbol in *Women in Love*.

NOTES TO CHAPTER SIX

[1] Quoted in Mark Gertler, *Selected Letters,* ed. Noel Carrington, Introduction by Quentin Bell (London, 1965), 133 (5 December 1916).

[2] Aldous Huxley, *Chrome Yellow* (London: Penguin, 1972), 15. Carrington appears in the novel as Mary Bracegirdle.

[3] *The Letters of Roger Fry,* ed. Denys Sutton (London, 1972), 417 (to Vanessa Bell, 23 October 1917).

[4] Quoted in John Rothenstein, 'Mark Gertler, 1891–1939', *Modern British Painters* (London, 1956), 213.

[5] Michael Holroyd, *Lytton Strachey: A Critical Biography,* II (London, 1968), 187–8.

[6] Gertler, *Selected Letters,* 56 (September 1913).

[7] *Ibid.,* 47 (December 1912).

[8] *Ibid.,* 57 (to Edward Marsh).

[9] D. H. Lawrence, *Letters to Bertrand Russell,* ed. Harry Moore (New York, 1948), 43 (19 March 1915).

[10] Gertler, *Selected Letters,* 146 (June 1917).

[11] D. H. Lawrence, *Collected Letters,* ed. Harry Moore (London, 1962), 543 (21 February 1918).

[12] *The Letters of D. H. Lawrence,* ed. Aldous Huxley (London, 1932), 639 (6 October 1925). See Gertler's letter to Koteliansky in *Selected Letters,* 210: 'I myself was going to write to Lawrence to take some steps about his health, as from what you write it sounds suspicious. I would strongly advise him to go to the doctor. He will then know exactly what is the matter' (7 August 1923).

[13] *Ottoline: The Early Memoirs of Lady Ottoline Morrell,* ed. Robert Gathorne Hardy (London, 1963), 277–8.

[14] Holroyd, II, 186.

[15] *Ibid.,* II, 188.

[16] Quoted in John Woodeson, *Mark Gertler* (London, 1972), 220, 222. See my review of Woodeson's book in *Virginia Woolf Quarterly,* I (Spring 1973), 80-84.

[17] Letter quoted in Rothenstein, 216 (20 January 1916).

[18] See Lawrence's description of Ursula's little sister: '*Dora* edged away like a tiny Dryad that will not be touched.' *Women in Love* (London: Penguin, 1972), 219.

[19] Quoted in Holroyd, II, 187.

[20] Dora Carrington, *Letters*, ed. David Garnett (London, 1970), 283 (4 March 1924).

[21] *The Letters of D. H. Lawrence*, ed. Huxley, 383 (2 December 1916).

[22] Lawrence, *Collected Letters*, 517 (3 July 1917).

[23] *Ibid.*, 520 (27 July 1917).

[24] *Ibid.*, 938 (to Mabel Dodge Luhan, 23 September 1926).

[25] *Ibid.*, 553 (?21 May 1918).

[26] Gertler, *Selected Letters*, 85.

[27] Lawrence, *Collected Letters*, 133.

[28] *Ibid.*, 508. A photograph of this statue appears opposite p. 145 in Gertler's *Selected Letters*.

[29] Emile Delavenay, *D. H. Lawrence: The Man and His Work* (London, 1972), 282, writes: 'It is possible that Gertler's 'Creation of Eve' (1914) . . . may bear some relation . . . to Will Brangwen's efforts to sculpt a birth of Eve' in chapter six of *The Rainbow*. A photograph of this painting appears opposite p. 80 in Gertler's *Selected Letters*. Gertler's painting may also have suggested an Adam and Eve passage that was deleted from the final version of *Women in Love*. Birkin tells Ursula, 'Spiritually, Adam preceded Eve. The spirit came first, then the flesh, and out of the reunion came understanding. That is the whole of the creation myth.' Quoted in Herbert Davis, '*Women in Love*: A Corrected Typescript', *University of Toronto Quarterly*, XXVII (1957), 46.

[30] John Woodeson, *Mark Gertler* (Exhibition Catalogue) (Colchester: The Minories, March 1971), 36.

[31] Gertler, *Selected Letters*, 133.

[32] *Ibid.*, 210–11.

[33] Quoted in Mary Sorrell, 'Mark Gertler, 1891–1939', *Apollo*, LVIII (November 1953), 135.

[34] Aldous Huxley, 'Introduction' to *Mark Gertler: Catalogue of Exhibition* (London: Lefevre Gallery, April 1937). A good colour photograph of the painting appears in the BBC pamphlet *The Artist and War in the Twentieth Century* (London, 1967), 23.

[35] Bell, in Gertler, *Selected Letters*, 11.

[36] Quoted in Holroyd, II, 203 (to Ottoline Morrell, 3 July 1916).

[37] Quoted in Gertler, *Selected Letters*, 128.

[38] *Ibid.*, 129 (27 September 1916).

[39] Kot's dog howling in soul-lacerating despair is an ironic echo of Keats' nightingale: thou 'Singest of summer in full-throated ease'. Gertler identified with Keats, a tubercular genius who was rejected by his great love, Fanny Brawne.

[40] Gertler committed suicide in 1939.

[41] Lawrence, *Collected Letters*, 482 (7 November 1916).

[42] *Ibid.*, 477–9 (9 October 1916).

[43] The original description of the frieze, deleted from the final version of the novel, is closely related to Gerald, for it portrays his totem, the Arctic wolf, and foreshadows his death by whirling snow: 'a village attacked by wolves, great naked men, ten feet high, fighting with a horde of wolves, and women running, falling, and a rush of wolves sweeping all like a storm driving in a shaggy whirl across the whole frieze.' Quoted in Herbert Davis, 51.

[44] A photograph of *The Swing Boats* appears in John Woodeson, *Mark Gertler* (London, 1972), plate 28.

[45] See Roger Fry's appreciative critiques, 'The Goupil Gallery', *New Statesman*,

xvi, (12 February 1921), 560, and 'Mr Gertler at the Leicester Galleries', *Nation and Atheneum,* xlii (24 March 1928), 935–6.

[46] Keith Alldritt, *The Visual Imagination of D. H. Lawrence* (London, 1971), 158.

[47] D. H. Lawrence, *Phoenix* (London, 1936), 567. Lawrence's references to Botticelli (106), Michelangelo (402), Watteau (138), Flaxman, Blake, Fuseli, Böcklin (510), Rossetti (16) and Rodin (402) suggest a standard by which to judge modern art. Lawrence associates Picasso (287) and the futurists (82), with Gudrun and with Halliday.

[48] Minette too is nominally related to the mines, for Gerald tells Birkin, 'Neither the *Minettes,* nor the *mines,* nor anything else' interest him; and like Gerald, Minette is not afraid of blood and stabs a man's hand in the Café Pompadour.

[49] See David Garnett, *Flowers of the Forest* (London, 1955), 53–4, quoting Lawrence's letter of 19 April 1915 on Garnett's homosexual friends: 'Never bring Birrell to see me any more. There is something nasty about him like black beetles. He is horrible and unclean. I feel I should go mad when I think of your set, Duncan Grant and Keynes and Birrell. It makes me dream of beetles.'

[50] For a thorough discussion of Birkin's anal intercourse with Ursula, and of the theme of sexual inversion in *The White Peacock, Aaron's Rod* and *The Plumed Serpent,* see my essay 'D. H. Lawrence and Homosexuality', *London Magazine,* xiii, (October–November 1973), 68–98.

Part II

Gustave Moreau
and *Against Nature*

Huysmans' essay on Gustave Moreau in *Certains* (1889) and his preface to the
1903 edition of *Against Nature* (1884) reveal that his interpretation of the
painter's work was very close to the conception of his novel, for both represent to
him an escape from the intolerable vulgarity and materialism of the
contemporary world (so exhaustively described by Zola) into 'the tumultuous
spaces of nightmares and dreams'. In *Certains* Huysmans' studied erethism
presents the classic posture of literary Decadence:

> One began walking and the scathed sight began to look around, and saw the
> horror of modern taste Those pavements teeming with a hideous
> crowd after money, women worn out by childbirth and stupefied by horrible
> trafficking, men reading vile newspapers or thinking of fraud and fornication
> as they pass the shops and are spied on by the licensed sharks of business and
> commerce, ready waiting to fleece their prey. All this gave one still a better
> understanding of the work of Gustave Moreau, timeless, escaping into the
> beyond, hovering in the realm of dreams, remote from the fetid ideas
> secreted by an entire people.[1]

And in the preface Huysmans remarks that Des Esseintes, his cultured, refined
and wealthy hero,

> has discovered in artificiality a specific for the disgust inspired by the
> worries of life and the American manners of his time. I imagined him
> winging his way to the land of dreams, seeking refuge in extravagant
> illusions, living alone and apart, far from the present-day world, in an
> atmosphere suggestive of more cordial epochs and less odious
> surroundings.[2]

Moreau's and Huysmans' common fascination with the 'more cordial epoch'
of Salome springs from their fear of women and their homosexual proclivities.
For Des Esseintes' escape from reality, from the whole mode of ordinary
existence, is really a rejection of women and an escape from sexuality, from
what Huysmans calls whoring women and fornicating men. The primary purpose

of Des Esseintes' hermetic phantasmagoria is to create through artifice and fantasy an aesthetic and sensual substitute for the hackneyed luxury of commonplace caresses. For his excessive indulgence in these dubious pleasures forced his over-fatigued senses into a state of lethargy and impotence, and created the long-desired complete 'sexual insensibility between brain and body'. Thus the complex sensual *correspondances* of the black dinner, the jewelled tortoise and the symphony of liqueurs are meant to provide a satisfaction that can no longer be achieved either by 'normal' or by abnormal sex. Even Des Esseintes' collection of late Latin literature is described in terms of physical corruption ('a decaying carcase, losing its limbs, oozing pus'[3]) that corresponds to his soul as well as to his body. His delight at the collapse of his friend's marriage, his deliberate depravation of a young boy, the purple bonbons that recall his sexual misadventures, and even his threatening vision of the Pox, all provide an artificial, oblique, vicarious and yet very definite sexual thrill.

Huysmans writes that Moreau's art contained 'insidious appeals to rape and sacrilege, to torture and murder',[4] but the Salome paintings that are purchased by Des Esseintes and play a prominent role in *Against Nature* also carried a strong appeal to the homosexual element in Huysmans. Baldick calls Huysmans 'a bizarre and tormented personality' and observes that 'in their sickly sensibility, their yearning for solitude, their abhorrence of human mediocrity, and their thirst for new and complex sensations, author and character were one'.[5] In the prologue to the novel Huysmans emphasises his hero's warped relationship with his parents: 'There was no gratitude or affection associated with the memories he retained of his parents: only fear. His father, who normally resided in Paris, was almost a complete stranger; and he remembered his mother chiefly as a still, supine figure in a darkened bedroom.'[6] And in the first chapter Des Esseintes' Baudelairean self-disgust is manifested in his 'craving to sully what memories he retained of his family ['a darkened bedroom'] with acts of sensual depravity'[7] (26).

Des Esseintes is attracted to the unsexed women of Edgar Poe and to Miss Urania, the androgynous American acrobat, and he is tremendously excited when he exchanges sexual roles with her and imagines himself as a passive female. Like Des Esseintes, Huysmans suffered periodical attacks of sexual impotence;[8] and like his hero, who boasted of 'unnatural love affairs and perverse pleasures' and who in his brief *liaison* with the mincing youth had never 'known such satisfaction mingled with distress', Huysmans had homosexual tastes. As he writes to the author of a book on homosexuality:

> Your letter and your book bring back to mind some horrifying evenings I once spent in the sodomite world, to which I was introduced by a talented young man whose perversities are common knowledge. I spent only a few days with these people before it was discovered that I was not a true homosexual—and then I was lucky to get away with my life.[9]

This letter contains some interesting revelations. It was discovered by *others*, not by Huysmans himself, that he was not an overt ('true') but a covert homosexual. And Huysmans was horrified not by the homosexual evenings, for he spent several days (not hours) in the sodomite world, but by the realisation that there was an element of inversion within himself. Though he maintains he is not a 'true homosexual', Huysmans's attitude towards women is summarised in the terse epigram 'It all comes down to syphilis in the end', and in the nightmare of sexual castration in which a savage flower blossoms between a woman's 'uplifted thighs, with its sword blades gaping open to expose the bloody depths' (101, 106).

Huysmans' subtle and witty juxtaposition of the concrete Dickens and the ethereal Moreau illuminates both the sexual and the aesthetic significance of the paintings in *Against Nature*. Huysmans contrasts the works of Dickens with the weirdly evocative paintings of Millais and Watts in the same way that he opposes Rubens' travesty of Salome as a Flemish butcher's wife to Moreau's exquisite princess. Nothing could be further from the 'mysterious ecstasy', the 'disquieting delirium' and the 'potent depravity' of the naked Salome than the 'vulgarity' and virtue of Dickens' respectably 'chaste lovers and his puritanical heroines in their all-concealing draperies . . . fluttering their eyelashes, blushing coyly, weeping for joy and holding hands' (109). Though the architecture of Moreau's painting is vaguely Byzantine, with Hindu and Moslem connotations, Des Esseintes is most attracted by its timeless unreality and the impossibility of placing it in any precise country or period. Huysmans contrasts Moreau's visionary 'return to past ages, to vanished civilisations, to dead centuries' to the realistic, Dickens-inspired 'picture of [industrial] London as an immense, sprawling, rain-drenched metropolis, stinking of soot and hot iron, and wrapped in a perpetual mantle of smoke and fog' (133–4). The amusing chapter on Des Esseintes' 'perilous journey' to London (a rare relief from the sacerdotal seriousness of the novel), which he abandons after an enormous 'English' dinner and before he reaches the Gare St Lazare, emphasises at Dickens' expense the superiority of the imagined to the actual world.

Huysmans states that Moreau's Salome 'crossed the frontiers of painting to borrow from the writer's art its most subtly evocative suggestions'. The story of Salome and Herod originates in the Gospels of Matthew and Mark, who relate that the tetrarch Herod divorced his first wife and contracted an incestuous marriage with Herodias, wife of his brother Philip and mother of Salome. When John the Baptist denounced this marriage he aroused the hatred of Herodias and was thrown into prison; and though Herodias was unable to kill John herself, she instructed Salome to ask for his head. Baudelaire, Mallarmé and Flaubert were all fascinated by the story of Salome; used her to symbolise a form of sexual abnormality, a paradoxical sensual sterility and evil beauty; and were the three dominant literary influences on both Moreau and Huysmans.

Baudelaire's theory of *correspondances*, his *paradis artificiel*, his *ennui* and his 'sick mind' pervade *Against Nature*; and Des Esseintes exhibits the works of the poet, who supplied the title of the novel, in a magnificent triptych. Baudelaire's 'Spleen et Idéal, xxvii' (1857) shows a characteristic fascination with luxurious sensuality and portrays Salome's cool, sterile and ambiguous virginity as an instrument of cruelty and lust:

> Avec ses vêtements ondoyants et nacrés,
> Même quand elle marche on croirait qu'elle danse
>
> Ses yeux polis sont faits de minéraux charmants,
> Et dans cette nature étrange et symbolique
> Où l'ange inviolé se mêle au sphinx antique,
>
> Où tout n'est qu'or, acier, lumière et diamants,
> Resplendit à jamais, comme un astre inutile,
> La froide majesté de la femme stérile.

Mario Praz states that Mallarmé's 'Hérodiade' (1864–67), which was influenced by Baudelaire, 'expresses not so much the external aura of preciosity which surrounds [Salome] as the anguish of a sterile, lonely soul, troubled with diseased imaginings'.[10] Moreau's *The Apparition* depicts the final moment of Mallarmé's poem; and in 1882 (the year after the premiere of Massenet's opera *Hérodiade*) Huysmans asked Mallarmé if he could borrow his poem (which was circulated in manuscript before publication) 'because my hero possesses the admirable Gustave Moreau water-colour . . . and I want to quote from your *Hérodiade* while attempting to describe Moreau's magical pictures'.[11]

Flaubert's 'grandiose pageantries of barbaric splendour' in *Salammbô* (1862) and *The Temptation of St Anthony* (1874) inspired Moreau's spectacular visions; and his tale 'Herodias', published the year after Moreau's sensational exhibition at the 1876 salon, emphasises (as Huysmans does) the sexual themes that are expressed in the conflict between Herod's lust and John's spirituality. Flaubert's John taunts the tetrarch, who had no children by Herodias, 'Your incest has already been punished, for God has afflicted you with the sterility of a mule';[12] and the novelist's highly wrought description of Salome's silk veils, fiery jewels, indolent ease and milky skin, and his lucent portrayal of her dance, prepares for the violent climax in which

> the girl depicted the frenzy of a love which demands satisfaction The jewels in her ears swung in the air, the silk on her back shimmered in the light, and from her arms, her feet, and her clothes there shot out invisible sparks which set men on fire.[13]

The figure of Salome, which Moreau portrayed in charcoal, pencil, ink, water-colour and oil, dominates his work and is pre-eminent among the glittering portraits of evil and death incarnate in female beauty, of Eve, Dalila, Helen and Cleopatra. Moreau describes Salome as a 'bored and fantastic woman, animal by

nature and so disgusted with the complete satisfaction of her desires [that she] gives herself the sad pleasure of seeing her enemy degraded'.[14] Moreau's emphasis on sadistic rather than sexual gratification is characteristic of his desire to escape from heterosexuality, and of what José Pierre calls 'the fundamental ambiguity of women in Moreau's work, composed of an irresolvable amalgamation of adoration and abhorrence, attraction and repulsion, love and hate, [which] underlies the incomparable fascination of their image'.[15] Moreau's ambivalence towards women is explained by his homosexuality, for he 'lived with a young man called Rupp, and when young had an affair with Fromentin, author of *Dominique*'.[16] And the fascination of Moreau's image derives partly from his homosexual interpretation of Salome: a threatening, symbolic castrator, demonically sensual but unreal and beyond sexual consummation.

Huysmans' descriptions of Moreau's 'two masterpieces', *Salome Dancing Before Herod* (plate XI) and *The Apparition*[17] (plate XII) (both 1876), which illustrate Moreau's theory of *La richesse nécessaire*, unify in their images the exotic decor, brilliant colours, aromatic incense and lavish lapidary detail (which Salome shares with the jewelled tortoise) of Des Esseintes' fantastic retreat; and they express the artificial, the sybaritic, the voluptuous and the voyeuristic qualities that his hero so admires. The first painting

> showed a throne like the high altar of a cathedral standing beneath a vaulted ceiling—a ceiling crossed by countless arches springing from thick-set, almost Romanesque columns, encased in polychromic brickwork encrusted with mosaics, set with lapis luzuli and sardonyx—in a palace which resembled a basilica built in both the Moslem and the Byzantine styles.[18]
>
> In the centre of the tabernacle set on the altar, which was approached by a flight of recessed steps in the shape of a semicircle, the tetrarch Herod was seated, with a tiara on his head, his legs close together and his hands on his knees.
>
> His face was yellow and parchment-like, furrowed with wrinkles, lined with years; his long beard floated like a white cloud over the jewelled stars that studded the gold-laced robe moulding his breast.
>
> Round about this immobile, statuesque figure, frozen like some Hindu god in a hieratic pose, incense was burning, sending up clouds of vapour through which the fiery gems set in the sides of the throne gleamed like the phosphorescent eyes of wild animals. The clouds rose higher and higher, swirling under the arches of the roof, where the blue smoke mingled with the gold dust of the great beams of sunlight slanting down from the domes.
>
> Amid the heady odour of these perfumes, in the overheated atmosphere of the basilica, Salome slowly glides forward on the points of her toes, her left arm stretched out in a commanding gesture, her right bent back and holding a great lotus blossom beside her face while a woman squatting on the floor strums the strings of a guitar.
>
> With a withdrawn, solemn, almost august expression on her face, she

(XI) Gustave Moreau, *Salome Dancing Before Herod*, 1876

(XII) Gustave Moreau, *The Apparition*, 1876

begins the lascivious dance which is to rouse the aged Herod's dormant senses; her breasts rise and fall, the nipples hardening at the touch of her whirling necklaces; the strings of diamonds glitter against her moist flesh; her bracelets, her belts, her rings all spit out fiery sparks; and across her triumphal robe, sewn with pearls, patterned with silver, spangled with gold, the jewelled cuirass, of which every chain is a precious stone, seems to be ablaze with little snakes of fire, swarming over the matt flesh, over the tea-rose skin, like gorgeous insects with dazzling shards, mottled with carmine, spotted with pale yellow, speckled with steel blue, striped with peacock green.[19]

Her eyes fixed in the concentrated gaze of a sleepwalker, she sees neither the tetrarch, who sits there quivering, nor her mother, the ferocious Herodias, who watches her every movement, nor the hermaphrodite or eunuch, who stands, sabre in hand, at the foot of the throne, a terrifying creature, veiled as far as the eyes and with its sexless dugs hanging like gourds under its orange-striped tunic. [63-4]

Despite the adjectival self-indulgence of Huysmans' Baroque style and his uncritical adoration of Moreau, it is impossible to improve upon the most brilliant *tour de force* in the novel. But it is important to discuss what Huysmans omitted, what he emphasised and how the paintings are related to the rest of the episodes in the book. Praz remarks that Moreau loaded his paintings 'with significant acessories in which the principal theme was echoed, until the subject yielded the last drop of its symbolic sap'.[20] But apart from the lotus blossom Huysmans does not mention the symbols of sensuality that emerge from Moreau's theatrical chiaroscuro: the twin columns of lapis lazuli crowned by a Baudelairean sphinx; the statue of Diana of Ephesus, goddess of fertility, that ironically appears behind Herod; Herodias' fan of peacock feathers; and the black panther which crouches on a carpet strewn with dead flowers.

Huysmans is primarily interested in the sexual dynamics and mutual excitation of the figures in the painting, and his main contribution to the Salome theme is to shift the focus from Salome to Herod; to transform Baudelaire, Mallarmé and Flaubert's theme of sterility into a more personal emphasis on impotence; and to stress the perverse aspects of Moreau. In Huysmans' description Herodias, withdrawn into the shadows next to the column and behind the guitarist who stimulates Salome's dance, acts as a procuress for her husband and her daughter. Salome's lascivious dance is meant to rouse Herod's dormant senses, but though Huysmans portrays him as 'quivering' he appears (like the hermaphrodite or eunuch) frozen and impassive in the painting, gives no sign of his 'lust and lechery' apart from commanding the dance, and seems quite beyond excitement.[21] The aged Herod appears to resemble the sickly Des Esseintes of 'former days, when his impotency had been established beyond doubt and he could think of woman without bitterness, regret or desire', and when he was

forced to surrender his mistress to a rival 'with less complicated whims and more reliable loins' (110, 115). Only Salome's nipples, hardening at the touch of her whirling necklace, are aroused by her own eroticism.

Huysmans' interpretation of the painting is packed with perversity and 'antique corruption'. Huysmans identifies most closely with the incestuous Herod, whose impotence is embodied in the eunuch with the sexless dugs, and manifested first in his voyeurism and then in his sadism. Salome's exhibitionism and self-arousal represent what Huysmans calls 'spiritual onanism in a chaste flesh';[22] and her lotus flower suggests necrophilia, for Huysmans relates how the divine flower, a symbolic penis, was inserted into the sexual parts of female corpses in ancient Egypt. Later in the novel the flowers that Des Esseintes carefully orders appear to be ravaged by syphilis as his mind switches 'from the vegetation to the Virus'.

If *Salome Dancing Before Herod* is voluptuous and voyeuristic, *The Apparition*, which created 'an even more disturbing impression' on Des Esseintes, is, like the stories of Edgar Poe, violent and visionary, supernatural and morbid:

> The murder had been done; now the executioner stood impassive, his hands resting on the pommel of his long, blood-stained sword.
>
> The Saint's decapitated head had left the charger where it lay on the flagstones and risen into the air, the eyes staring out from the livid face, the colourless lips parted, the crimson neck dripping tears of blood. A mosaic encircled the face, and also a halo of light whose rays darted out under the porticoes, emphasised the awful elevation of the head, and kindled a fire in the glassy eyeballs, which were fixed in what appeared to be agonised concentration on the dancer.
>
> With a gesture of horror, Salome tries to thrust away the terrifying vision which holds her nailed to the spot, balanced on the tips of her toes, her eyes dilated, her right hand clawing convulsively at her throat.
>
> She is almost naked; in the heat of the dance her veils have fallen away and her brocade robes slipped to the floor, so that now she is clad only in wrought metals and translucent gems
>
> The dreadful head glows eerily, bleeding all the while, so that clots of dark red form at the ends of hair and beard. Visible to Salome alone, it embraces in its sinister gaze neither Herodias, musing over the ultimate satisfaction of her hatred, nor the tetrarch, who, bending forward a little with his hands on his knees, is still panting with emotion, maddened by the sight and smell of the woman's naked body, steeped in musky scents, anointed with aromatic balms, impregnated with incense and myrrh. [67–8]

There is a distinct and significant contrast between the studied, almost calm moment portrayed by Moreau—Salome is gracefully poised on her toes with her jewelled brocade extending elegantly behind her—and the excitement of Huysmans' frenzied description of morbidity and sadism.[23] Herodias' hatred

achieves the climax of 'ultimate satisfaction', Herod pants with emotion, and Salome, her eyes dilated, claws convulsively at her throat with a hand that was 'commanding' in the previous picture.[24] All three figures are possessed by a sexual excitement that is both aroused and gratified by the decapitation of John, whose facial features and wounded expression bear a striking resemblance to Salome. Huysmans creates the sensation of what he calls 'spiritual perversity' through the *frisson* of sensual sacrilege in an ecclesiastical setting.

Huysmans suggests that the lotus blossom might symbolise 'a sacrifice of virginity, an exchange of blood, an impure embrace asked for and offered on the express condition of a murder', or might represent 'the allegory of fertility, the Hindu myth of life, an existence held between the fingers of woman and clumsily snatched away by the fumbling hands of man, who is maddened by desire, crazed by a fever of the flesh' (66). But Herod's decapitation of John—executed by the veiled eunuch with the phallic sword whose sexual threat has been nullified by castration—is clearly a violent but gratifying sexual deviation, a compensation for Herod's own castration fears and impotence, and a substitute for sex with Salome.

Des Esseintes' picturesque pathology and mannered morbidity reduce him to a Herod-like state of physical decrepitude ('the hollow cheeks and the big, watery eyes burning with a feverish brightness in this hairy death's-head') that is very similar to his condition before his retreat from the world. He is forced to call a doctor, who represses his *recherché* regimen and extinguishes his *raison d'être* by blandly suggesting that he 'try and enjoy the same pleasures as other people'. Forced to choose between death and deportation, Des Esseintes abandons his internal emigration and 'his beatific happiness', forgetting at the final moment his diseases, his nightmares and his 'appalling unhappiness', and he satisfies himself with an apocalyptic curse on mankind. At the end of the novel he is back where he first started, with *ennui* and the prospect of the pox.

Huysmans was probably thinking of his own work as well as Moreau's when he writes that the painter had 'no real ancestors and no possible descendants, [and] remained a unique figure in contemporary art' (69), for he believed that in *Against Nature* he was, like Stendhal, 'writing for a dozen persons, fashioning a sort of hermetic book that would be closed to fools'.[25] Yet Moreau influenced Redon, Matisse and Rouault (the first curator of the Musée Moreau) as well as the surrealist André Breton, who praised his 'unhealthy dreams'; and to Huysmans' surprise *Against Nature* 'fell like a meteorite into the literary fairground, provoking anger and stupefaction'.[26] The encyclopaedic pedantry of Huysmans' novel transformed Moreau's *richesse nécessaire* into an *embarras de richesse*, became the Bible of Decadent taste and had an astounding effect in the 1890s. As Dorian Gray religiously turned its pages 'it seemed to him that in exquisite raiment, and to the delicate sound of flutes, the sins of the world were passing in dumb show before him. Things that he had dimly dreamed of were

suddenly made real to him.'[27] Wilde wrote a play about Salome in 1893 which was illustrated by Beardsley and then transformed into an opera by Richard Strauss in 1905.[28] Huysmans' exotic compound of Ludwig II, Edmond de Goncourt, Barbey d'Aurevilly, Robert de Montesquiou, Baudelaire, Mallarmé and Flaubert, distilled in his imaginative alembic, became, as Praz writes,

> the pivot upon which the whole psychology of the Decadent movement turns; in it all the phenomena of this state of mind are illustrated down to the minutest details, in the instance of its chief character, Des Esseintes. 'Tout les romans que j'ai écrits depuis A Rebours sont contenus en germe dans ce livre', Huysmans remarked. Not only his own novels, but all the prose works of the Decadence, from Lorrain to Gourmont, Wilde and D'Annunzio, are contained in embryo in A Rebours.[29]

Despite the enormous influence of Huysmans' neurasthenia, of his 'most exalted flights of sensibility, most morbid caprices of psychology, and most extravagant aberrations of language' (185), there remains in Huysmans, as in Moreau, scarcely concealed by their imaginative innovations and technical brilliance, both an excess and an emptiness, a fatal and fundamental superficiality that makes their covert homosexual interpretations of the Salome theme, with all their weird fascination, little more than a glittering series of hothouse fantasies and escapist illusions that must ultimately be abandoned.

NOTES TO CHAPTER SEVEN

[1] J.-K. Huysmans, 'Gustave Moreau', *Certains* (Paris, 1904), 20. The tone of this diatribe is very like the opening paragraph of the fifth chapter, in which the paintings of Moreau are described.

[2] J.-K. Huysmans, 'Preface d'*A Rebours*', *En Marge*, ed. Lucian Descaves (Paris, 1927), 126. Huysmans' letter of 27 October 1882 to Mallarmé about *Against Nature*, quoted in Robert Baldick, *The Life of J.-K. Huysmans* (London, 1955), 85, is similar to the preface of 1903 and shows that the preface is an accurate reflection of Huysmans' thoughts about the novel at the time of its composition.

[3] Huysmans' fascination with disgusting details in this passage foreshadows his famous description of Grünewald's *Crucifixion* in the first chapter of *Là-Bas* (1891).

[4] Huysmans, 'Gustave Moreau', *Certains*, 19.

[5] Baldick, 81–2, 356.

[6] J.-K. Huysmans, *Against Nature*, trans. Robert Baldick (London: Penguin, 1959), 18.

[7] Like Baudelaire, Huysmans experienced in childhood his father's death and mother's speedy remarriage.

[8] John Brandreth, *Huysmans* (Cambridge, 1963), 59.

[9] Huysmans, quoted in Baldick, 82.

[10] Mario Praz, *The Romantic Agony* (London, 1933), 304.

[11] Huysmans, quoted in Baldick, 85. Mallarmé's poem is not quoted until the chapter on contemporary literature (p. 196), which appears later in the novel.

[12] Gustave Flaubert, 'Herodias', *Three Tales*, trans. Robert Baldick (London: Penguin, 1961), 108.

[13] *Ibid.*, 121.

[14] Quoted in Ragnar von Holten, 'Le développement du personnage de Salomé à travers les dessins de Gustave Moreau', *L'Oeil*, LXXIX-LXXX (juillet–août 1961), 45.

[15] Jean Paladilhe and José Pierre, *Gustave Moreau* (London, 1972), 113.

[16] Philippe Jullian, *Robert de Montesquiou* (London, 1965), 117.

[17] *Salome Dancing Before Herod*, formerly in the Huntington Hartford collection, was sold at the Parke–Bernet Galleries in March 1971 to the Armand Hammer Foundation in Los Angeles for $95,000.

[18] This exotic architecture reappears in the chapter on music, where Des Esseintes' favourite plainsong 'could tone in with the old basilicas and fill their Romanesque vaults' (202).

[19] For the lapidary tradition in the Bible see Isaiah 54: 11–12: 'I will lay thy stones with fair colours, and lay thy foundations with sapphires. And I will make thy windows of agates, and thy gates of carbuncles, and all thy borders of precious stones'; and Revelation 21: 19–21.

[20] Praz, 290.

[21] Mark 6: 22 tersely states that Salome 'danced, and pleased Herod', but the conception of Moreau's work naturally 'went far beyond the data supplied by the New Testament' (65).

[22] Huysmans, 'Gustave Moreau', *Certains*, 18–19.

[23] The other paintings in Des Esseintes' collection heighten this feeling of violent morbidity: 'the agonising varieties of human suffering' portrayed in the fanatical Jan Luyken's *Religious Persecutions;* the demonic skeletons of Bresdin's *Comedy of Death;* the 'sick and delirious' fantasies of Odilon Redon (Bresdin's pupil); Goya's 'terrifying and hallucinating' *Proverbs;* and the 'bizarre and frenzied energy' of El Greco's *Christ.*

[24] Art critics tend to follow Huysmans' interpretation of Salome 'petrified and hypnotised by terror' rather than the reality of Moreau's calmer representation. James Huneker, 'The Moreau Museum', *Promenades of an Impressionist* (London, 1910), 354, writes that Salome has 'become cataleptic at sight of the apparition'; and Holten, 51, states that 'Moreau gives the image of the repentance and terror of the princess'.

[25] Huysmans, quoted in Baldick, 78.

[26] *Ibid.*, 87.

[27] Oscar Wilde, *The Picture of Dorian Gray* (1890) (London: Penguin, 1949), 145.

[28] See also Jules Laforgue's 'Moralités légendaires' (1887), quoted in Philippe Jullian, *Dreamers of Decadence* (London, 1971), 249: 'There on a cushion, among the debris of the ebony lyre, shone John's head—like Orpheus once—coated with phosphorous, painted and curled, grinning at those twenty-four million stars'.

[29] Praz, 308–9. Huysmans also had an important influence on Walter Pater and George Moore.

8 Bellini, Giotto, Mantegna, Botticelli and *Swann's Way*

It was in Beauty that he was led by his temperament to seek Reality, and his life, which was entirely given to religion, was consequently oriented to aesthetic pursuits. But this Beauty to which he thus found himself dedicated was conceived by him not as an object of delight, made to give him pleasure, but as a reality infinitely more important than life itself, for which he would have given his own. That, you will discover, was the starting point of all Ruskin's aesthetic philosophy.

[Proust, 'John Ruskin']

Proust's analysis of Ruskin is also true of his own philosophy, and his essential point is that the manifestation of beauty in art is more 'real' than life itself. 'What we call reality,' writes Proust, 'is a certain relationship between sensations and memories which surround us at the same time',[1] and Proust enhances this reality and makes the immediate sensations of the present acquire immense significance by entwining them through aesthetic analogies with memories of the past.

The central passage in *Swann's Way* on the heightening of reality through the evocation of the imagination is recorded during Swann's reflections on the resemblance of Odette to Botticelli's Zipporah:

He had always found a particular fascination in tracing in the paintings of the Old Masters, not merely the general characteristics of the people whom he encountered in his daily life, but rather what seems least susceptible of generalisation, the individual features of men and women whom he knew, as, for instance, in a bust of the Doge Loredan by Antonio Rizzo, the prominent cheekbones, the slanting eyebrows, in short, a speaking likeness to his own coachman, Rémi; in the colouring of a Ghirlandaio, the nose of M. de Palancy; in a portrait by Tintoretto, the invasion of the plumpness of the cheek by an outcrop of whisker, the broken nose, the penetrating stare, the swollen eyelids of Dr de Boulbon [These artists] had regarded with pleasure and had admitted into the canon of their works such physiognomy as give those works the *strongest possible reality* and trueness to life He had retained enough of the artistic temperament to be able to find a genuine satisfaction in watching these individual features take on a *more*

general significance when he saw them, uprooted and disembodied, in the abstract idea of similarity between an historic portrait and a modern original.[2]

This comparison of people and paintings is the particular amusement of a man of cultivated taste who desires through the medium of art 'the communication of our present self with the past' (II, 1009) and the elevation of the commonplace to the more significant aesthetic plane.

An especially good example of this is Proust's comparison of Marcel's father with Abraham 'telling Sarah that she must tear herself away from Isaac' (51) in Benozzo Gozzoli's *Sacrifice of Isaac*. This analogy is made on 'the sweetest and saddest night of my life' (II, 1006) when the father indulges his son's weakness and allows his wife to spend the night in the child's room. This brief allusion, as much biblical as visual, immediately recalls the poignant chapters of Genesis, with their suggestive connotations, as well as the irony that Marcel was 'sacrificed' not by stern punishment but by casual permissiveness.

Swann's 'particular fascination' is related to the central theme of the novel, the recovery of the past through memory, and to the central technique: for 'just as the Japanese amuse themselves by filling a porcelain bowl with water and steeping in it little crumbs of paper which until then are without character or form', so through Swann's aesthetic analogies transient, intangible people 'take on colour and distinctive shape, become . . . permanent and recognisable . . . [and] taking their proper shapes and growing solid, spring into being' (66). As Marcel perceives much later, 'I realised also then all that the human imagination can put behind a little scrap of face . . . [one] imagines her to embody a strange creature, interesting to know, difficult to seize and hold.'

The range of Proust's aesthetic analogies is extremely varied and goes far beyond painting to include architecture, sculpture, mosaics,[3] furniture, porcelain, tapestries and stained glass. When the reality of Mme de Guermantes emerges from and then dissipates Marcel's imaginative conception of her as a woven Esther or a rainbow-coloured Gilbert the Bad in the church at Combray, 'My disappointment was immense. It arose from my not having borne in mind, when I thought of Mme de Guermantes, that I was picturing her to myself in the colours of a tapestry or a painted window, as living in another century, as being of another substance than the rest of the human race' (250). Proust satirically uses pictorial iconography when he speaks of 'the thousand arrows by which our own Legrandin had instantaneously been stabbed and sickened, like a Saint Sebastian of snobbery' (183); and he considers the philosophical implications of perspective in his famous discourse on the twin steeples of Martinville. The painter Elstir, a combination of Turner, Whistler and Monet, appears briefly in *Swann's Way* as M. Biche (he is an important character in the later volumes); and in a discussion with Swann on the nature of creative inspiration he states the Platonic idea (from the *Ion*) of the connection between madness and genius.

More significantly, the essence and spirit of a place are conveyed more through the imaginative inspiration of painters than through actuality. Marcel's idea of Venice is formed by Titian's drawing of a lagoon, and for him that city is the 'School of Giorgione, the home of Titian, the most complete museum of domestic architecture of the Middle Ages' (561). Florence too becomes 'a supernatural city [which] emerges from the impregnation by certain vernal scents of what I suppose to be, in its essentials, the genius of Giotto' (559). Similarly, Holland is, in essence, Vermeer, just as the 'Persian church' first lures Marcel to Balbec.

Some thirty painters are mentioned in *Swann's Way*, some of them in quite brilliant comparisons which actualise the intangible qualities of a character or a musical phrase. During a wedding in Combray church the regal Mme de Guermantes advanced along a red carpet and 'covered its woollen texture with a nap of rosy velvet, a bloom of light, giving it that sort of tenderness, of solemn sweetness in the pomp of a joyful celebration, which characterise . . . certain paintings by Carpaccio' (255), who portrayed those splendid receptions accorded to foreign ambassadors in the Palazzo Ducale. And at a concert the delightfully gradual appearance of the infinitely remote 'little phrase' of Vinteuil is compared to 'those interiors by Pieter de Hooch where the subject is set back a long way through the narrow framework of a half-opened door' (312).

But Proust's most significant use of the aesthetic analogy is his specific reference to four paintings that provide an almost Blakean visual complement to his descriptions. A careful examination of these works, which inspired Proust and were imaginatively transformed into words, will illuminate his creative process. The paintings are Gentile Bellini's *Sultan Mohammed II* (1480), Giotto's *Charity* (1305), Mantegna's *St James Led to Martyrdom* (1456) and Botticelli's *The Youth of Moses* (1482). Proust saw the paintings by Bellini, Giotto and Mantegna on his visit to Venice and Padua in 1900.[4]

Proust uses each of the four paintings in a different way, for a different purpose and with increasing complexity. In each case there is a conscious attempt to rival his former master, Ruskin, by extracting the very essence of the painting and finding the prose equivalent for this visual essence, for the 'patch of yellow' in the *View of Delft*. In Conrad's words, the 'task which I am trying to achieve is, by the power of the written word, to make you hear, to make you feel—it is, before all, to make you *see*. That—and no more, and it is everything.'[5] Proust's use of Bellini is purely ironic and mock-heroic. His use of Giotto's *Charity* moves from the purely pictorial to the allegorical qualities of the painting in order to consider the moral question of the ambiguity of vice and virtue. Proust selects a minor detail from the Mantegna painting, which stimulates Swann's dubious admiration for the footman, in order to emphasise several thematic ideas about the corrupt nature of society. Finally, the Botticelli painting, though used ironically, like the others, leads to significant revelations

about the function of memory, the transformation of unacceptable reality, and the relation between art and moral truth.

Bellini's portrait of Mohammed II (plate XIII) is used ironically when Marcel's friend Bloch, a precious Jewish youth who is never directly described, is compared by Swann to the Sultan. 'It's an astonishing likeness; he has the same arched eyebrows and hooked nose and prominent cheekbones. When his beard comes he'll be Mohamet himself' (136–7). Despite the physical similarity, this comparison is, of course, absurdly mock-heroic, for Bloch is an arch-aesthete whose gaucheness and affectation, rudeness and slander alienate him from Marcel's family. His outlandishness and weakness of character persist until the final volume, where he is described as 'a braggart and a miserable coward' (II, 905) who seeks to evade military service and who is unfavourably compared to that soldierly ideal, Robert de Saint-Loup.

Bloch's prototype, Mohammed the Conqueror (1432–81), captured Constantinople from the Christians in 1453 when he was little older than Bloch and founded the Ottoman empire that lasted until Proust's death. The 'perfidious' Sultan is portrayed as an atrocious barbarian by Gibbon (in chapter sixty-eight of the *Decline and Fall*), who concedes that 'a profane taste for the arts is betrayed in his liberal invitation and reward of the painters of Italy'. Vasari is more generous in his 'Life of Bellini': at the request of the Sultan, the Venetian senate resolved to send Gentile,

> and he was conveyed safely in their galleys to Constantinople, where, being presented to Mahomet, he was received with much kindness as a new thing. He presented a beautiful picture to the prince, who admired it much, and could not persuade himself to believe that a mortal man had in him so much of the divinity as to be able to express the things of nature in such a lively manner. Gentile painted the emperor Mahomet himself from life so well that it was considered a miracle.[6]

In Bellini's portrait the fifty-year-old Sultan is seen in a three-quarter view, framed by a rounded arch with decorated pillars. The five-pointed crowns of the three empires of Constantinople, Iconium and Trebizond appear on the left and right above the arch. A rich cloth, embossed with flowers and embellished with precious jewels, is placed across his robust chest and between the fretted columns. A heavy, elaborately folded, billowy white peaked turban rests low on the potentate's forehead, and touches his ears. The point of his long, thin, aquiline nose, which swells in the middle and droops toward his mouth, is accentuated first by his carefully trimmed, thick pointed beard that juts out from a deep indentation beneath his lower lip, and then by a double V formed by his crimson caftan and his luxuriously sleek fur mantle. His upper lip protrudes considerably over his lower, like the beak of a bird of prey. His neck and shoulders are powerful, his cheekbones prominent, but his heavy eyelids and

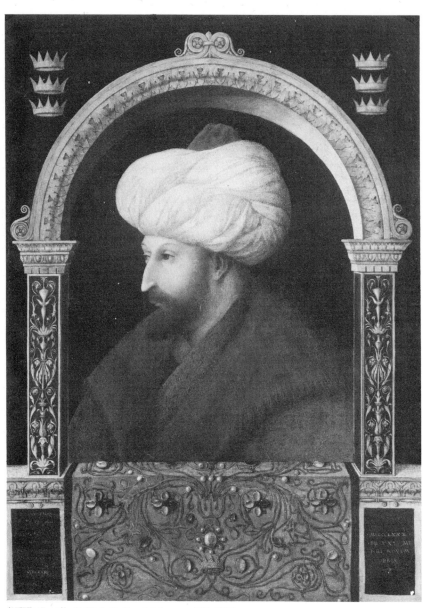

(XIII) Gentile Bellini, *Sultan Mohammed II*, 1480

dignified solidity suggest strength in repose. The overall impression of the portrait is of despotic self-assurance and a refined, restrained, yet sensuous ferocity, which is consistent with the jealous Swann's anecdote that the Sultan, 'on finding that he had fallen madly in love with one of his wives, stabbed her, in order, as his Venetian biographer artlessly relates, to recover his spiritual freedom' (510–11). The Jewish Bloch shares with him a merely Levantine correspondence.

Proust's employment of Giotto's *Charity* (plate xiv) is more subtle and complex. It is probable that he first became acquainted with *Charity* through his reading of Ruskin, who discusses the allegorical figures in *The Stones of Venice* and in *Fors Clavigera*, where he makes *Charity* the frontispiece to Letter Seven, and writes that 'she is giving her heart to God while she gives her gifts to men'.[7] In 'Pélerinages ruskiniens en France' Proust describes *Charity* 'trampling on bags of gold and offering us wheat and flowers'.[8]

In the Combray household of Aunt Léonie 'the kitchen-maid was an abstract personality, a permanent institution to which an invariable set of attributes assured a sort of fixity and continuity and identity throughout the long series of transitory human shapes in which that personality was incarnate' (111). This abstract pregnant maid, a poor sickly creature, 'grows solid and springs into being' through another of Swann's aesthetic analogies. For the folds of her ample smocks

> recalled the cloaks in which Giotto shrouds some of the allegorical figures in his paintings, of which M. Swann had given me photographs. He it was who pointed out the resemblance, and when he inquired after the kitchen-maid he would say: 'Well, how goes it with Giotto's Charity?' And indeed the poor girl, whose pregnancy had swelled and stoutened every part of her, even to her face, and the vertical, squared outlines of her cheeks, did distinctly suggest those virgins, so strong and mannish as to seem matrons rather, in whom the Virtues are personified in the Arena Chapel There must have been a strong element of reality in those Virtues and Vices of Padua, since they appeared to me to be as much alive as the pregnant servant-girl, while she herself appeared scarcely less allegorical than they. [112, 114]

The substantial, architectonic, *grisaille* figure of Giotto's *Caritas* is draped in a massive classical costume cinctured below her full breasts, the cascading folds of the drapery broken first at the belly (which suggested fullness to Proust, for Charity is traditionally depicted as nursing new-born babes)[9] and again atop the replete money bags and gold coins that she tramples underfoot. In her right hand she offers an abundant bowl of wheat, fruit and flowers, 'symbolic of the heavenly beauty which is hers to distribute here on earth'.[10] With her raised left hand she offers her heart (with its protruding artery) to God, who accepts it. A dim, luminous halo appears round her head, and her stylised wavy hair is crowned with a double wreath of roses. Her Roman nose and square, full jaw

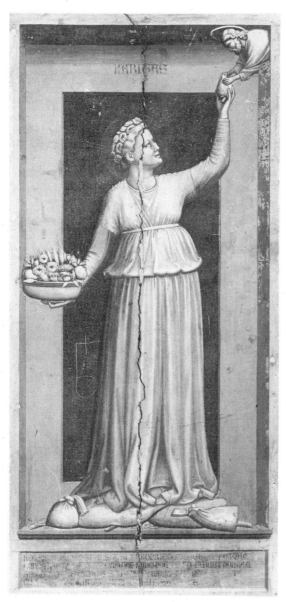

(XIV) Giotto, *Charity*, 1305

make her somewhat austere, but her expression is grave and dignified and she is full of humility. She is a representation of the idea of altruistic love and is directly contrasted to her opposite Vice, not the traditional Avarice, but Envy. Whereas Charity is open and bountiful, Envy is grasping and greedy, and clutches the gold that Charity disdains. Charity suggests a selfless, joyous repose; Envy is miserable and tormented by her horn which recoils to press into her neck, and the snake that issues forth from her mouth and twists to bite her between the eyes. She is consumed by flames that rise from below.

The comparison of the unmarried pregnant kitchen maid (Françoise calls her 'a dirty slut'), so obviously caught in 'Cupid's wanton snare', with Giotto's imposing virgin once agains seems ironic and mock-heroic. But this time the allegorical implications of the humble maid lead Marcel to some fascinating revelations about the nature of Charity. During the unbearable pain at the maid's confinement, when Françoise is sent out for a doctor, Marcel attends to the needs of his invalid aunt, who 'never sleeps'. He observes her as the snores cease and she awakens from a terrible dream—that her husband has come back to life and is forcing her to take daily exercise—to thank God he is safely dead and can no longer object to her valetudinarianism.

Later on, when the bedridden maid is 'still very weak and ill after her recent confinement', Marcel unexpectedly observes Françoise trying to kill a chicken, whose quite natural resistance provokes her outcries of 'Filthy creature!' This scene, which 'made the saintly kindness and unction of our servant rather less prominent' (172), is one of those painful Proustian revelations that exposes the unpleasant truths and the dark unsuspected side of a character. This disturbing impression is confirmed first when Françoise shows absolutely no sympathy for the maid's most appalling pains, and later when Marcel discovers that the maid's mournful air is caused by Françoise's pitiless stratagem of forcing her to prepare asparagus, which gave her 'such violent attacks of asthma that she was finally obliged to leave my aunt's service' (176). Marcel is then forced to revise his earlier judgement that the unfortunate maid allowed 'the superior qualities of Françoise to shine with added lustre' (115). Just as in the Arena Chapel the figure of Charity stands directly under *The Scourging of Christ*, so the maid's humble resignation is exacerbated by Françoise's envious cruelty.

The true embodiment of Charity in the novel is not the maid but Marcel's grandmother, who quite literally sacrifices her heart when she attempts to conceal her coronary attack in order to shield him from fear and grief. It is only afterwards that his grandmother 'realised that there was no need to hide from me what I had at once guessed, that she had had a slight stroke' (I, 939).

The theme of the ambiguity of Virtue and Vice (of all the multitudinous characters only Marcel's mother and grandmother escape the blemish of Vice) is adumbrated later in the novel when Swann arrives at the Salon of Mme de Saint-Euverte after a long absence and realises not only the ugliness but also the

viciousness of his former friends. The description of M. de Palancy (whose nose suggested the colouring of a Ghirlandaio) as a huge carp with great mandibles and a fragment of a glass aquarium in his eye socket foreshadows the great scene in *Within a Budding Grove* where the lobby of the Balbec Grand Hotel is described in the metaphor of human ichthyology. This man recalls to Swann, 'a fervent admirer of Giotto's Vices and Virtues at Padua, that Injustice by whose side a leafy bough evokes the idea of the forests that enshroud his secret lair'[11] (471–2). This thought is quite similar to Ruskin's statement that 'There is no moral vice, no moral virtue, which has not its *precise* prototype in the art of painting; so that you may at your will illustrate the moral habit by the art, or the art by the moral habit'.[12]

It is obvious from Proust's superb description of Mantegna (plate xv) that he learned a great deal from Ruskin's books on *quattrocento* painting. For just before Swann enters the Saint-Euverte concert room, where the piscatorial guests swim in their constricted sea of vice, he notices among the splendid, effortless footmen,

> a strapping great lad in livery [who] stood musing, motionless, statuesque, useless, like that purely decorative warrior whom one sees in the most tumultuous of Mantegna's paintings, lost in dreams, leaning upon his shield, while all around him are fighting and bloodshed and death; detached from the group of his companions who were thronging about Swann, he seemed determined to remain unconcerned in the scene, which he followed vaguely with his cruel, greenish eyes, as if it had been the Massacre of the Innocents or the Martyrdom of Saint James. He seemed precisely to have sprung from that vanished race . . . fruit of the impregnation of a classical statue by some one of the Master's Paduan models, or of Albert Dürer's Saxons. And the locks of his reddish hair, crinkled by nature, but glued to his head by brilliantine, were treated broadly as they are in that Greek sculpture which the Mantuan painter never ceased to study. [466–7]

Proust called Mantegna's *St James* 'one of the paintings I love best in the world'.[13] And Berenson's description is similar to Proust's, for he writes that Mantegna 'naively forgot that Romans were creatures of flesh and blood, and he painted them as if they never had been anything but marble, never other than statuesque in pose, processional in gait, and godlike in look and gesture'.[14]

Mantegna's brilliant perspective presents the scene of *St James Led to Martyrdom* from below, as if viewed while mounting a staircase. In the left foreground of the fresco the sombre apostle is framed by an elaborate and deeply vaulted barrel arch that soars to the top of the painting. He pauses on the way to martyrdom to heal a kneeling cripple, as two powerful and well armed escorts wait to bear him away. The muscular soldier with halberd and sword steps back as if in awe of the saint's healing power, and his right foot seems to project from the surface of the wall. In the right background curious townsfolk observe the spectacle from

(XV) Mantegna, *St James Led to Martyrdom*, 1456

crenellated towers and severe façades, while in the foreground a young soldier with a stave clears a path for the saint and pushes back a standard-bearer with a tall, furled banner. In the centre of the painting, at the foot of the mighty arch, a statuesque and wonderfully beautiful warrior, caught between the rude grappling of the soldiers and the startling miracle of the saint, rests on his embossed and coffin-shaped shield. Vigorous and healthy, his extremely muscular torso (a contrast to his slender arm and graceful fingers) seems embedded in his breastplate. He wears low boots, a double-skirted tunic and a mantle draped over the left side of his armour. He has a thick shock of hair, a proud, firm jaw, and glances to the right at the saint with a distant, ambiguous expression that suggests a vague regret. He represents stasis in kinesis, like a smooth rock in a tumultuous cataract.

As Swann approaches the aquatic salon he encounters other colossal, decorative, marmoreal servants on the monumental staircase, 'worthy to be named, like that god-crowned ascent in the Palace of the Doges, the "Staircase of the Giants'', and on which Swann now set foot, saddened by the thought that Odette had never climbed it' (467). This sentence brings into subtle conjunction a number of significant themes, for the architect of the 'Staircase of the Giants' is that same Antonio Rizzo whose bust of the Doge Leonardo Loredano has, for Swann, a speaking likeness to his coachman Rémi. Just as Odette does not permit Rémi to drive Swann to her house, so the Saint-Euvertes, observing the 'Hindu caste system', do not permit Odette to attend their salon; and it is because Odette is excluded from this society that Swann feels threatened by the ferocious aspect of the towering footmen, who seem to him like executioners in Renaissance paintings. The artificiality of this society is emphasised when we later learn that these impressive though indifferent lackeys do not really belong to the establishment but have been hired specially for the occasion. The coachman Rémi, like the decorative lads in livery, is ironically compared to exalted aesthetic figures in order to suggest the confusion and intermixture of high and low in this society. For in *The Past Recaptured*, when it is shattered and transformed by the Great War, 'the distinguishing characteristic of this social set was its prodigious aptitude at wiping out social classifications' (II, 1058). In that final volume we discover that the ruined Prince de Guermantes has married the vulgar Mme Verdurin for her money and has given her his title. And in the salon of this new Princesse de Guermantes we find not only the Saint-Euvertes but also Odette and Charles Morel (Baron Charlus's lover) who is the son of Marcel's uncle's valet. Just as the coachman is transformed by Swann's aesthetic analogy into a doge, and the splendid, nobly profiled lackeys are aesthetically (and perhaps) morally superior to the ugly guests, so in the final volume the servant has become, quite literally, the social peer of a prince.

When Swann is in love with Odette he compares her expression to 'those sheets of sketches by Watteau upon which one sees, here and there, in every

corner and in all directions, traced in three colours upon the buff paper, innumerable smiles' (345). But when he realises that she is, in fact, a 'kept' woman, a painful contrast to his conception of her as the gentle Zipporah, he describes her as 'an iridescent mixture of unknown and demoniacal qualities, embroidered, as in some fantasy of Gustave Moreau, with poison-dripping flowers, interwoven with precious jewels' (385). In his essay on Moreau Proust speaks of the paintings in which 'his dreams gathered together these red draperies, these green garments studded with flowers and precious stones, these grave heads that are the heads of courtesans'.[15] In these passages Proust is thinking of Moreau's fantastic and glittering portraits of destructive women—Eve, Dalila, Salome, Helen and Cleopatra—who have high, firm breasts, smooth, soft skin and globular navels, who are crowned with gold, draped with gossamer silk, and encrusted with dazzling jewels, and who are at once attractive and menacing.

The most famous, the most important, the most elaborately developed of Swann's aesthetic analogies is his comparison of Odette to Zipporah, Jethro's daughter, in Botticelli's *The Youth of Moses* (plate XVI). As Odette

> stood there beside him, brushing his cheek with the loosened tresses of her hair, bending one knee in what was almost a dancer's pose, so that she could lean without tiring herself over the picture, at which she was gazing, with bended head, out of those great eyes, which seemed so weary and so sullen when there was nothing to animate her, Swann was struck by her resemblance to the figure of Zipporah, Jethro's daughter, which he had seen in one of the Sixtine frescoes He stood gazing at her; traces of the old fresco were apparent in her face and limbs, and these he tried incessantly, afterwards, to recapture, both when he was with Odette, and when he was only thinking of her in her absence; and, albeit his admiration for the Florentine masterpiece was probably based upon his discovery that it had been reproduced in her, the similarity enhanced her beauty also, and rendered her more precious in his sight. [319, 321]

The story of Moses and Zipporah is related in Exodus 2: 16–22: 'Now the priest of Midian had seven daughters: and they came and drew water, and filled the troughs to water their father's flock. And the shepherds came and drove them away: but Moses stood up and helped them, and watered their flock And Moses was content to dwell with the man: and he gave Moses Zipporah his daughter. And she bare him a son, and he called his name Gershom.'

At the centre foreground of *The Youth of Moses*, under a cluster of protective trees, the willing Moses, in the role of Aquarius, has drawn a bucket of water from the high, round well and, leaning forward, is pouring it into a trough for expectant rams and ewes. To the left of the well, subtly linked to Moses by its stone rim, are two of Jethro's daughters. The unnamed daughter has her back to us, stands near Moses, leans on her shepherd's crook, and with the elegant

(XVI) Botticelli, *The Youth of Moses*, 1482

fingers of her extended left hand gestures toward the welcome defender. The youthful Zipporah, hesitant and shy, folds back with her left hand a soft, fawn-coloured shawl embroidered with purple and with a blue border that frames golden letters. She carries apples and acorns, and holds a forked reed that contains spun wool. She inclines her long neck, and her sweet, tender, wistful expression (she is ready to be kissed and won) is wonderfully appealing. Her forehead is high and round, her loosened tresses (which hold a myrtle leaf) are thick and flowing, her features delicate, eyes wide and questioning, nose slender and exquisite, lips full, soft and slightly open.

The actual, as opposed to the idealised, Odette is described in some detail, and Proust makes it clear that Swann actually finds her quite unattractive:

> She had struck Swann not, certainly, as being devoid of beauty, but as endowed with a style of beauty which left him indifferent, which aroused in him no desire, which gave him, indeed, a sort of physical repulsion; as one of those women of whom every man can name some, and each will name different examples, who are the converse of the type which our senses

demand. To give him any pleasure her profile was too sharp, her skin too delicate, her cheek-bones too prominent, her features too tightly drawn. Her eyes were fine, but so large that they seemed to be bending beneath their own weight, strained the rest of her face and always made her appear unwell or in ill humour. [279–80]

It is, then, through an imaginative transformation of reality that Swann elevates his love for the common Odette to an aesthetic plane, for Botticelli's Zipporah has a grace, delicacy and fineness that Odette obviously lacks, just as the biblical Zipporah, a virtuous daughter and devoted wife, is an ironic contrast to the depraved character of Swann's mistress.

The intricate relationship between taste and morality is explored at some length in connection with Botticelli's Zipporah. Before Swann meets Odette his sexual desire always runs counter to his aesthetic taste, for as his mistresses become more vulgar his perceptions become more refined. Now it would seem that his affair with Odette would improve his aesthetic taste, but at the start of the *liaison* his taste as well as his sensual desires are debased, for he follows Odette into the Verdurin circle and goes so far as to proclaim his hostess 'a great and noble soul'. But when Swann is struck by the resemblance to Jethro's daughter this habitual grotesque disparity vanishes, his former good taste is restored, and he renews his neglected interest in Vermeer. For the aesthetic analogy to Zipporah enables him 'to introduce the image of Odette into the world of dreams and fancies that, until then, she had been debarred from entering, and where she assumed a new and nobler form He could re-erect his estimate of her on the sure foundations of his aesthetic principles' (322). The imagination not only eternalises the fleeting moment and heightens reality but also allows Swann to come to terms with it.

But even these fanciful aesthetic foundations cannot support Swann's profound disillusionment. For when listening at the Saint-Euvertes' to a musical analogy, the 'little phrase' of Vinteuil, once the 'national anthem of their love',

> all his memories of the days when Odette had been in love with him, which he had succeeded, up till that evening, in keeping invisible in the depths of his being, deceived by this sudden reflection of a season of love, whose sun, they supposed, had dawned again, had awakened from their slumber, had taken wing and risen to sing maddeningly in his ears, without pity for his present desolation, the forgotten strains of happiness. [496]

Now Swann profoundly feels the Dantean perception:

> Nessun maggior dolore
> Che ricordarsi del tempo felice
> Nella miseria. [*Inferno*, v, 121–3]

It is only when he is finally disillusioned by the musical phrase that kindles his memory—and memory, in Proust, is more important than actual experience,

partly because it can objectify and distil experience—that 'Swann understood that the feeling which Odette had once had for him would never revive, that his hopes of happiness would not be realised now' (507). And Swann's final comment about this new understanding (which, ironically, does not prevent him from marrying Odette long after he has lost all feeling for her) is put in aesthetic terms: 'To think that I have wasted years of my life, that I have longed for death, that the greatest love that I have ever known has been for a woman who did not please me, who was not in my *style!*' (549). It is in Swann's final *aperçu* that Proust reveals how aesthetic perceptions illuminate moral truths.

Proust's aesthetic analogies are vital to the structure and meaning of *Swann's Way*. Through the medium of painting abstractions are embodied, memories are stirred and sharpened, and the commonplace is transformed by the imagination into a higher reality. Analogies with art deepen the portrayal of character and emphasise the psychological, moral and social themes of the novel. They also provide valuable insights about Proust's creative process, for his use of painting fuses a succession of recollections into a simultaneous memory, so that the novel becomes an act of evocation as well as of creation.

NOTES TO CHAPTER EIGHT

[1] Marcel Proust, *Remembrance of Things Past*, trans. C. K. Scott Moncrieff, II (New York, 1934), 1008.

[2] Marcel Proust, *Swann's Way*, trans. C. K. Scott Moncrieff (New York: Modern Library, 1956), 319–20. Italics mine. References to *Swann's Way* are to this edition. I have concentrated on Proust's use of four paintings in *Swann's Way*, since the two somewhat superficial books on this subject—Maurice Chernowitz, *Proust and Painting* (New York, 1945) and Juliette Monnin-Hornung, *Proust et la peinture* (Genève, 1951)—offer a general summary rather than a precise analysis.

[3] Proust gives a superbly satiric description of the snobbish Mme de Franquetot, who 'suffered acutely from the feeling that her own consciousness of her Guermantes connection could not be made externally manifest in visible characters, like those which, in the mosaics of Byzantine churches, placed one beneath another, inscribe in a vertical column by the side of some Sacred Personage the words which he is supposed to be uttering' (473).

[4] See George Painter, *Marcel Proust*, I (London, 1965), 271–2.

[5] Joseph Conrad, Preface to *The Nigger of the 'Narcissus'*. See also Huysmans' preface to *Marthe* (1876): 'I set down what I see, what I feel, what I have lived, writing it as well as I am able, *et voilà tout!*'

[6] Giorgio Vasari, *Lives of the Artists* (New York: Noonday, 1957), 136.

[7] John Ruskin, *Giotto and his Works in Padua*, *Works*, ed. E. T. Cook and Alexander Wedderburn, XXIV (London, 1906), 118.

[8] Quoted in Painter, I, 264.

[9] See Spenser's description of Clarissa in *The Faerie Queene*, I, x, 30:

> She was a woman in her freshest age,
> Of wondrous beauty, and of bounty rare,

With goodly grace and comely personage,
That was on earth not easie to compare;
Full of great love, but Cupids wanton snare
As hell she hated, chaste in worke and will;
Her necke and breasts were ever open bare,
That ay thereof her babes might sucke their fill:
The rest was all in yellow robes arrayed still.

[10] F. Mason Perkins, *Giotto* (London, 1902), 112.

[11] Bernard Berenson, *Italian Painters of the Renaissance* (London, 1952), 45–46, gives this description of Giotto's *Injustice*: 'a powerfully built man in the vigour of his years dressed in the costume of a judge, with his left hand clenching the hilt of his sword, and his clawed right hand grasping a double-hooked lance. His cruel eye is sternly on the watch, and his attitude is one of alert readiness to spring in all his giant force upon his prey. He sits enthroned on a rock, overtowering the tall waving trees, and below him his underlings are stripping and murdering a wayfarer.'

[12] John Ruskin, *Elements of Drawing, Works*, xv, 118.

[13] Letter to Robert de Montesquiou, quoted in Painter, i, 272.

[14] Berenson, 147.

[15] Marcel Proust, 'Gustave Moreau', *On Art and Literature*, trans. Sylvia Townsend Warner (New York: Delta, 1958), 347.

9 Vermeer
and *The Captive*

> All great writers are great colourists, just as they are musicians into the
> bargain; they always contrive to make their scenes glow and darken and
> change to the eye The best critics, Dryden, Lamb, Hazlitt, were
> actually aware of the mixture of elements, and wrote of literature with music
> and painting in their minds.
>
> [Virginia Woolf, *Walter Sickert*]

On 18 October 1902 Proust arrived at The Hague, saw Vermeer's *View of Delft*
(plate XVII) at the Mauritshuis Museum and 'recognised it for the most beautiful
painting in the world'.[1] Nearly twenty years later, on 24 May 1921 (the year
before his death), the exhibition of this painting in Paris inspired a rare diurnal
excursion. At 9 a.m., the hour when he usually retired to seleep, Proust girded
himself and set forth with an escort.

> On the stairs of his home, seized by a terrifying giddiness, he swayed and
> paused, then pressed on. At the Jeu de Paume Vaudoyer had to take his arm
> and steer his tottering steps to the *View of Delft* In the lower right
> quarter of the painting, immediately to the left of the first turret on the
> shadowed water-gate, he saw a fragment of rooftop caught by the sunlight of
> that eternal summer evening, with the pent-roof of its distant attic window,
> and beneath it the 'little patch of yellow wall'.[2]

Between these two climactic conjunctions of author and painting Proust
completed most of *Remembrance of Things Past*, in which the *View of Delft*
plays a considerable structural role, surfacing significantly like dolphins in a
sunlit sea, unifying scattered scenes, and providing a moral touchstone with
which to evaluate the characters as they develop through the years of the novel.
Vermeer's painting also becomes a corner-stone of Proustian aesthetics and helps
to figure forth the theme of the novel: the failure of love and the renunciation of
life for the dedication to art. A careful examination of the history and
iconography of the *View of Delft* is requisite to an understanding of why Proust
was so attracted to this unique painting and how he used it in his novel: of how
Vermeer helped to inspire Bergotte and Marcel in the way that he had first
inspired Proust.

Like Piero della Francesca and Georges de la Tour, Jan Vermeer (1632–75),
who enjoys an extraordinary reputation in our own time, remained obscure until
a revolution in taste led to his 'discovery' centuries after his death. Travelling
through Holland in 1842, Etienne Thoré, a young French art critic, 'saw the

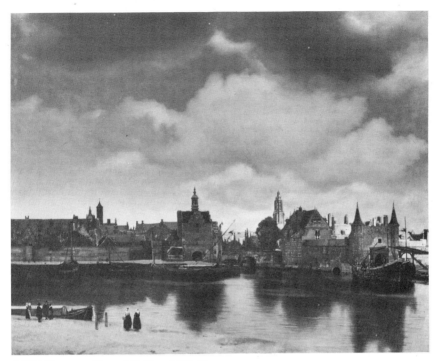

(XVII) Vermeer, *View of Delft*, c. 1658–60

View of Delft for the first time. It was a revelation to him. He was struck by its freshness, by a direct and sensitive rendering that to him was completely unconventional'.[3] Using the pseudonym of Willem Burger, Thoré belatedly revealed his discovery in a long article in the *Gazette des Beaux-Arts* for October 1866, in which he considers the *View of Delft* as Vermeer's principal work and reproduces a water-colour of the painting. The Goncourt brothers, characteristically *au courant*, anticipated Thoré's article and noted Vermeer's unusual chromatic technique when visiting Holland in September 1861: 'A confoundedly original artist, Vermeer. One might say that he represents the ideal sought by Chardin: the same milky paint, the same touch with little dabs of broken colour, the same buttery texture, the same wrinkled impasto on the accessories, the same 'stippling' of blues, of bold reds in the complexions, the same pearl-grey in the background.'[4]

Despite Thoré's essay and the Goncourts' *aperçu*, even so perceptive a critic (and novelist) as Eugene Fromentin omitted Vermeer from his *Maîtres*

d'autrefois (1876), a study of Dutch and Flemish painting from Van Eyck to Rembrandt. But Van Gogh had seen his compatriot's landscape and was especially enthusiastic about Vermeer's colours: if one sees Vermeer's 'city view at The Hague close up, it is *incredible*, and painted with entirely different colours from those one would suspect at a few steps' distance.[5] . . . There are certainly, on close examination, all the riches of a complete palette in his rare pictures; but the combination of citron yellow, pale blue and pearl-grey is characteristic of him.'[6]

In the year of Van Gogh's second letter Henry Havard published the first book on the painter, *Van der Meer de Delft* (1888), which firmly established Vermeer's modern reputation and brought his works to the particular attention of the French Impressionists. They 'looked up with reverence to Vermeer, and in particular to his two town views. Monet, Pisarro and Sisley, in their observation of the finest shades of colour and the lightest atmospheric vibrations, elevated the lesson of the *View of Delft* to its apotheosis.'[7]

The *View of Delft* (1658–60), which portrays the complex effect of sunlight and shadow on the town after a summer storm, was perhaps the first *plein-air* painting, and it anticipates the kind of outdoor landscape which was the natural result of Impressionist theory and which did not attract full attention until the 1890s. The sandy quay with its diminutive figures and moored barge are observed from a slight elevation just outside the town; and the broad canal, with its lucid and rippling water, the walls of Delft, with the towered Schiedam and Rotterdam Gates on the left and right, and the two balanced church towers piercing the cloudy sky in the far distance, are subject to the overwhelming power of light. Like Vermeer's *Lace-Maker*, which Proust admired in the Louvre, the ships' hulls and the façades of the two buildings on either side of the stone bridge are painted with *pointillés*, or tiny dabs of light, which seem to foreshadow both the technique of Seurat and the aims of Monet: 'c'est justement cet éclat, cette lumière féerique que je m'attache à rendre'.[8]

Kenneth Clark's analysis of Vermeer's 'photographic' perception suggests another affinity with the Impressionists, who were strongly influenced by the camera's 'way of seeing'.

> The rendering of atmosphere reached a point of perfection that for sheer accuracy has never been surpassed: Vermeer's *View of Delft*. This unique work is certainly the nearest which painting has ever come to a coloured photograph. Not only has Vermeer an uncannily true sense of tone, but he has used it with an almost inhuman detachment. He has not allowed any point in the scene to engage his interest, but has set down everything with a complete evenness of focus. Such, at least, is our first impression of the picture But the more we study the *View of Delft* the more artful it becomes, the more carefully calculated its design, the more consistent its components.[9]

Goldscheider writes that 'Vermeer's art is an art of vision, not of invention; an art of painting, not of composition.;[10] and Huyghe notes that Vermeer's techniques matched the Impressionists' photographic 'cult of observation and hostility to the imagination'.[11]

The famous patch of yellow *roof* (not wall) that the writer Bergotte sees in the moment of epiphany before his death appears just next to the pointed left turret of the Rotterdam Gate, amid the warm browns and blues of the stone buildings and tiled roofs, and it provides a golden contrast to the rich red roofs on the right side of the painting. A patch of yellow, less subtle perhaps but more prominent and impressively lemon, appears in *The Procuress* (Dresden), *The Maidservant Pouring Milk* (Amsterdam) and *A Painter in His Studio* (Vienna), but none of these indoor paintings stimulated Proust's sensibilities in quite the same way as the *View of Delft*.

De Vries observes that Vermeer 'possessed a fineness of vision that, through deep penetration and an almost oriental patience, led to a harmony that can never be surpassed'.[12] Though contemporary with Bernini and Rembrandt, Vermeer has no Baroque spontaneity or sensuality, no kinetic energy or dramatic action. The *View of Delft* is undramatic, passionless, remote and detached; a studied, static performance rendered through an impersonal mastery of technique. Vermeer's great qualities are harmony, serenity, sensitivity and clarity of vision; and the motionless tranquillity of the landscape is expressed in the smooth, enamel-like surface of the painting.

Huyghe has suggested that a Goethean 'elective' or spontaneous, emotional affinity existed between Proust and Vermeer, but it would perhaps be more useful to explain the intellectual and aesthetic grounds for Proust's attraction to the Dutch master.[13] Proust's admiration for the perfection of Vermeer was partially motivated by a desire to give full recognition to the few, and therefore more precious, works (there are only thirty-five extant Vermeers) of an unjustly obscure artist, and to oppose the prevailing taste (exemplified by Fromentin) for Rubens and Rembrandt. The need for renewal of standards in art was a vital issue at the turn of the century. Next, as we have seen, the techniques of colour and light in Vermeer's *plein-air* landscape, as well as his 'photographic' observation, exemplified the Impressionist theory of painting. In this way Vermeer, as well as Turner, Monet and Whistler, contributed to the composite character of Elstir, who like Bergotte and Vinteuil represents the ideal of the great artist to Marcel.

Then, Vermeer's minute detail, calm vision and absolute order impart a spiritual element to ordinary reality and express its symbolic and transcendent value. His 'perfect' painting reveals the artist's power to transform the real world by careful and exact observation. And Vermeer provides an essential correlative of order and permanence that is an absolute contrast to the mutability of Proust's world. Time is fixed in the eternal moment of Vermeer, whereas in Proust past memory is more real than the imprecise perceptions of the present. Vermeer

'captured' Delft in a way that Marcel could never capture Albertine, and this is what Marcel learns in *The Captive* when he begins to substitute the order of art for the jealousies and vagaries of love.

Finally, as we shall see in the analysis of *The Captive*, Vermeer's painting, and especially the symbolic patch of yellow, is Proust's way of placing himself in an artistic tradition and expressing his own aesthetic values. As he writes in *Cities of the Plain*:

> Certain artists of an earlier generation have in some *fragment* of their work realised something that resembles what the master has gradually become aware that he himself meant at one time to create. Then he sees the old master as a sort of precursor; he values in him, under a wholly different form, an effort that is momentarily, partially fraternal. There are bits of Turner in the work of Poussin, we find a phrase of Flaubert in Montesquieu.[14]

Just as Vinteuil's 'little phrase' (the musical equivalent of the 'little patch of yellow') was the 'national anthem' of the love of Swann and Odette, so Proust's allusions to Vermeer mark the stages of their unhappy *liaison*. Proust also emphasises the thematic parallels between Swann's love for Odette and Marcel's for Albertine by linking the two pairs of lovers through Vermeer. In *Swann's Way* Marcel was a passive observer of Swann's jealousy; in *The Captive* he is an active participant and sufferer. In both cases jealousy (of Forcheville and of Albertine's lesbian friends) leads to a painful resurrection of a love that must end in failure.[15] In *Swann's Way* Swann substitutes Odette for art; but in *The Captive* Marcel substitutes art for Albertine and discovers his true vocation as a writer.

When the connoisseur Swann first meets Odette she takes the initiative and invites him to tea, but he 'pleaded pressure of work, an essay—which, in reality, he had abandoned years ago—on Vermeer of Delft'. Odette then exposes her ignorance and the intellectual chasm that separates them by responding with ironic irritation: ' "this painter who stops you from seeing me"—she meant Vermeer—"I have never even heard of him, is he alive still? Can I see any of his things in Paris, so as to have some idea of what is going on behind that great brow which works so hard?" '[16]

Swann's interest in Vermeer revives with his interest in Odette, though the two seem incompatible rather than complementary, and on certain days 'she would call upon him in the afternoon, to interrupt his musings or the essay on Vermeer to which he had lately returned She asked whether [Vermeer] had been made to suffer by a woman, if it was a woman that had inspired him, and once Swann had told her that no one knew, she had lost all interest in that painter' (II, 30, 32). Odette is disappointed when Vermeer (who did not suffer like Keats) fails to yield a romantic agony and to produce the expected analogy between herself and Swann, but she does give a fair indication of the kind of

painful love she will inflict on 'poor Charles'. Ironically, when she no longer makes him suffer he loses interest in her, for pain alone kept his tedious attachment alive. Similarly, when the equally shallow Albertine asks Marcel, 'But did he ever murder anyone, Dostoievski?' he replies like Swann, 'I don't think so, dear Albertine, I know little about his life'.[17]

As the relationship between Swann and Odette decays towards the end of *Swann's Way* (and this decay is sacramentalised in marriage) Vermeer becomes an artificial basis of their 'common interests'. 'Have you left your essay on Vermeer here, so that you can do a little more to it tomorrow?' Odette asks Swann. ' "What a lazy-bones! I'm going to make you work, I can tell you," ' which proved that Odette kept herself in touch with his social engagements and his literary work, that they had indeed a life in common' (II, 112). And at the end of his affair with Odette, when Swann discovers she was not in his *style*, his essay on Vermeer replaces Odette in his life:

> Now that he was once again at work upon his essay on Vermeer, he wanted to return, for a few days at least, to The Hague, to Dresden, to Brunswick. He was certain that a 'Toilet of Diana' which had been acquired by the Mauritshuis at the Goldschmidt sale as a Nicholas Maes was in reality a Vermeer. And he would have liked to be able to examine the picture on the spot, so as to strengthen his conviction. [II, 188]

In a parody of Swann, Marcel compares himself and Albertine to 'students who already know all about the pictures which they are longing to go to Dresden or Vienna to see', and he often thinks of leaving Albertine and escaping to Venice.[18]

In the volumes between *Swann's Way* and *The Captive* Proust uses Vermeer to reveal character and to distinguish people of knowledge and taste from the philistines and boors. In *Within a Budding Grove*, when Marcel is surprised to find that Odette is familiar with Vermeer, she triumphantly 'answered me with: "I ought to explain that M. Swann was very much taken up with that painter at the time he was courting me. Isn't that so, Charles dear?" '[19] In *The Guermantes Way* Marcel accidentally exposes the ignorance of the Duc de Guermantes (and most of his class) when he praises the gallery at The Hague:

> 'Oh! The Hague! What a gallery!' cried M. de Guermantes. I said to him that he had doubtless admired Vermeer's *Street in Delft*. But the Duke was less erudite than arrogant. Accordingly he contented himself with replying in a tone of sufficiency, as was his habit whenever anyone spoke to him of a picture in a gallery, or in the Salon, which he did not remember having seen. 'If it's to be seen, I saw it.'[20]

In *Cities of the Plain* Charlus makes a Swann-like comparison between a painted fabric and a Vermeer, and then adds with an ironic jest, 'but we must not say it too loud or Swann will fall upon us to avenge his favourite painter, the Master of Delft'. Later in the novel Albertine's allusion to seagulls in Amsterdam provides

an occasion to deflate the pretentious Mme Cambremer (whose name stops just in time) by means of Vermeer: ' "Oh! So you have been in Holland, you know the Vermeers?'' Mme Cambremer asked imperiously, in a tone in which she would have said: "You know the Guermantes?'', for snobbishness in changing its subject does not change its accent.'[21] These interim allusions to Vermeer reveal that this painter is for the precious few: not for Odette or the Duc de Guermantes or Charlus or Mme Cambremer, but for Swann and Bergotte and Marcel. Proust employs Vermeer as a moral as well as an aesthetic touchstone.

In *The Captive* the paradigm of painful love represented by Swann and Odette is repeated not only in the relations of Marcel and Albertine (which also echo the earlier love of Marcel and Gilberte Swann) but also in those of Charlus and Morel. When Marcel thinks of parting from Albertine he recalls his separation from Gilberte and asks Albertine to return a book of Bergotte's that is at her aunt's. But in a generous gesture that recalls Gilberte's precious gift to him of Bergotte's essay on Racine, in a white packet tied with mauve ribbons, Marcel inscribes his Bergotte manuscript to Albertine and gives it to her.

More significantly, Charlus, who tells Morel that Odette 'forced me to help her betray Swann, with five, with six other men', is himself betrayed by his lover, Morel.[22] Though Morel is a homosexual, he is engaged to Jupien's niece and carries on a passionate correspondence with the Racinean actress Léa, who is 'notorious for her exclusive interest in women' and whose friendship with Albertine arouses the jealousy of Marcel. After Morel, inspired by the vengeful Mme Verdurin, publicly condemns the dumbfounded Charlus, Marcel returns to Albertine to face a similar 'explosion of *her* wrath'. And Marcel's false confidence about Albertine's loyalty and his surprising discovery that she has suddenly left him, are portrayed in the illuminating perspective of Morel's betrayal of Charlus. (In the same way the Princesse de Guermantes' callous indifference to the death of her friend Swann on the night she wore the striking red shoes to a party anticipates Mme Verdurin's frank indifference to the death of Princess Sherbatoff on the day of her *soirée*. The death of Swann, like the death of Marcel's grandmother in *The Guermantes Way*, foreshadows Bergotte's death in *The Captive*.)

It is significant that all these disastrous love relationships develop within the context of art and are nourished and even defined by art: Swann and Odette by Vermeer, Marcel, Gilberte and Albertine by Racine and Bergotte, Charlus and Morel by the music of Vinteuil. For art represents a permanent reality, a soothing, contemplative calm that is the opposite of the passion and flux of human relationships in Proust's novel. Marcel remarks of Albertine: 'On each occasion a girl so little resembles what she was the time before (shattering in fragments as soon as we catch sight of her the memory that we had retained of her and the desire that we were proposing to gratify) that the stability of nature which we ascribe to her is purely fictitious and a convenience of speech'

(I, 78). The *View of Delft*, for example, composes the shattered fragments of memory and the successive images of experience into a unified and meaningful reality which remains impervious to the distressing uncertainties and fresh betrayals, even after death, of the incurable malady of love.

This opposition of life and art is a major theme in Proust and is related to the essential difference between the novel and painting. For the novel is basically a linear art that presents a temporal sequence of images, while painting produces an immediate simultaneity of experience. As Proust states in his important conclusion to chapter II:

> and so I am brought up against the difficulty of presenting a permanent image as well of a character as of societies and passions. For it changes no less than they, and if we seek to portray what is relatively unchanging in it, we present in succession different aspects (implying that it cannot remain still but keeps moving) to the disconcerted artist. [II, 166]

One of the ways that Marcel, 'the disconcerted artist', attempts to understand and to 'capture' Albertine is to admire her 'in an artistic fashion', after the manner of Swann. When Marcel is happy with Albertine he casts his thoughts of her 'into the composer's phrase or the painter's image', allows her to escape into the fluid space of his mind, and discovers that 'she had at that moment the appearance of a work by Elstir or Bergotte; I felt a momentary enthusiasm for her, seeing her in the perspective of imagination and art' (I, 66-7).

This transformation of love object into art object bridges the opposition of life and art and marks an important stage in Marcel's artistic development. The next stage occurs when, with a rare tranquillity of mind, Marcel detaches his thoughts from Albertine, turns them to art, and wonders, 'could life console me for the loss of art, was there in art a more profound reality, in which our true personality finds an expression that is not afforded it by the activities of life?' (I, 209). When Marcel at last realises that art possesses greater value than 'the nullity I had found in all my pleasures and in love itself' and is (unwillingly) freed from Albertine, he decides to devote his life to art.

The death of Bergotte, which at first appears to be a digression, is in fact the most important episode in *The Captive* and is related—though obliquely—to the principal events of that novel. Bergotte's fatal stroke appropriately occurs in the context of Marcel's struggle for a literary vocation, for that 'genuinely unpretentious and obliging' man, Marcel's 'godlike elder', had been the first to initiate him into the study of art and philosophy and had praised Marcel's intelligence. Bergotte's works inspired Marcel and gave him 'a joy of which I felt myself to have experienced in some innermost chamber of my soul, deep, undivided, vast, from which all obstructions and partitions seem to have been swept away'.[23]

Like Proust himself, 'for years past Bergotte had ceased to go out of doors',

and Painter states that 'in all the details of Bergotte's illness Proust is thinking of his own'.[24] Bergotte suffers from insomnia and nightmares, takes toxic narcotics that make the remedy worse that the disease and has an attack of uremia. But he reads a perceptive critique of an exhibition that includes the *View of Delft*—'a picture which he adored and imagined that he knew by heart'—and which compares the patch of yellow to some priceless specimen of Chinese art,[25] and, though ill, he goes to see it. Bergotte, who 'loved nothing really except certain images and . . . the composing and painting of them in words'[26] but had not written anything for twenty years,

> remarked for the first time some small figures in blue, that the ground was pink, and finally the precious substance of the tiny patch of yellow wall. His giddiness increased; he fixed his eyes, like a child upon a yellow butterfly which it is trying to catch, upon the precious little patch of wall. 'That is how I ought to have written,' he said. 'My last books are too dry, I ought to have gone over them with several coats of paint, made my language exquisite in itself, like this little patch of yellow wall.' [I, 249][27]

Inspired by Vermeer in this vital yet fatal moment of *éclaircissement*, Bergotte realises an important aesthetic truth—how to *paint* his images—as well as the gravity of his own condition. 'In a celestial balance there appeared to him, upon one of its scales, his own life, while the other contained the little patch of wall so beautifully painted in yellow. He felt that he had rashly surrendered the former for the latter', but this sacrifice had enabled him to achieve great art. At this moment Bergotte suffers another attack, rolls to the floor and is suddenly dead. Proust then considers the question of art and immortality, and states that the true artist

> begins over again a score of times a piece of work the admiration aroused by which will matter little to his body devoured by worms, like the patch of yellow wall painted with so much knowledge and skill by the artist who must for ever remain unknown and is barely identified under the name of Vermeer. [I, 250]

Because he possessed a creative genius analogous to Vermeer's, Bergotte too was not wholly and permanently dead, and Proust transfigures his funeral into the iconography of a Renaissance painting. 'They buried him, but all through the night of mourning, in the lighted windows, his books arranged three by three kept watch like angels with outspread wings and seemed, for him who was no more, the symbol of his resurrection' (I, 251).[28]

Bergotte dies as he perceives the transcendent synthesis of two arts. After an intense scrutiny of Vermeer's significance, 'he sees the old master as a sort of precursor' and makes the ultimate discovery that he ought to have created his 'language exquisite in itself, like this little patch of yellow wall'. Vinteuil had also discovered this Baudelairean *correspondance*, this inherent relationship of

all art, when he chose

> the *colour* of some sound, harmonising it with the rest. For with other and more profound gifts Vinteuil combined that which few composers, and indeed few painters have possessed, of using colours not merely so lasting but so personal that, just as time has been powerless to fade them, so the disciples who imitate him who discovered them, and even the masters who surpass him do not pale his originality. [II, 64–5]

This revelation of the unity of art and the relation of its highest manifestations—Vermeer's patch of yellow, Vinteuil's little phrase, or a striking image by Racine or Bergotte—signifies a great extension of the potentialities of art, each one supplementing and strengthening the characteristics of the other. For Proust the greatest artists, the ones who achieve immortality through their work, are able to achieve the kind of artistic transcendence that was described by Schiller in his *Aesthetic Education of Man* (1795):

> The plastic arts, at their most perfect, must become music and move us by the immediacy of their sensuous presence. Poetry, when most fully developed, must grip us as powerfully as music does, but at the same time, like the plastic arts, surround us with serene clarity.[29]

Bergotte's comprehension of a great work of art through some minute yet essential detail illustrates Bergson's theory that the primary function of the artist is 'to see and to make us see what we do not ordinarily perceive'.[30] As Marcel tells Albertine when explaining Dostoyevsky by an analogy with Vermeer, all great works of art are both unique in themselves and related to other great works. 'You must have realised that [Vermeer's pictures] are fragments of an identical world, that it is always, however great the genius with which they have been re-created, the same table, the same carpet, the same woman, the same novel and unique beauty, an enigma, at that epoch in which nothing resembles or explains it, if we seek not to find similarities in subjects but to isolate the peculiar impression that is produced by the colour' (II, 237). The *impression* of Vermeer's *colour*, as the Goncourts and Van Gogh perceived, is the key to the secret of his genius.

Just as the sublimity of sound in Vinteuil's little phrase seemed to express certain profound states of soul, so Vermeer's patch of yellow suggests 'these resemblances, concealed, *involuntary*, which broke out in different colours, between two separate masterpieces'. Both these aesthetic manifestations, the sound and the colour, are intimately connected with those pleasurable impressions of eternal moments 'which at remote intervals I recaptured in my life as starting-points, foundation-stones for the construction of a true life: the impression that I had felt at the sight of the steeples of Martinville, or a line of trees near Balbec,' or a *madeleine*, a stiff hotel napkin, the clanking of a

locomotive wheel, the uneven stones of Venice (II, 74). Like a great work of art, these memories transform the momentary and fragmented impressions into a clear and meaningful order, and so form the basis of the true artist's life.

This ordering of experience is, for Proust, the essential greatness of Vermeer and the reason why he valued him so highly, for like Bergotte, Proust saw in the master a quality he was striving to achieve in his own work. The *View of Delft*, a concrete and tangible work of art, is for Bergotte as for Marcel a profound equivalent of these eternal moments, a kind of permanent, 'voluntary' memory, more real and more substantial than life—an image subject to the scrutiny of an analysing intelligence, and capable of producing that precious and exhilarating insight when the past is recaptured in the present.

NOTES TO CHAPTER NINE

[1] George Painter, *Marcel Proust: a Biography,* I (London, 1959), 307.

[2] *Ibid.,* II (London, 1965), 320.

[3] Frithjof van Thienen, *Jan Vermeer* (London, 1949), 1.

[4] Edmond and Jules de Goncourt, *Journal,* ed. Robert Ricatte, IV (Paris, 1956), 236.

[5] *The Complete Letters of Vincent Van Gogh,* II (London, 1958), 433–4.

[6] *Ibid.,* III, 504.

[7] A. B. de Vries, *Jan Vermeer van Delft* (London, 1948), 58. Vermeer's only other landscape is the less ambitious *Street in Delft.*

[8] Letter from Monet to Durand-Ruel, 11 March 1884, in *Les Archives de l'impressionisme,* ed. Lionello Venturi, I (Paris, 1939), 273.

[9] Kenneth Clark, *Landscape into Art* (London, 1949), 32–3

[10] Ludwig Goldscheider, *The Paintings of Vermeer* (London 1958), 38.

[11] René Huyghe, 'Affinités electives: Vermeer et Proust', *Amour de l'Art,* XVII (janvier 1936), 11.

[12] De Vries, 39.

[13] Maurice Chernowitz, *Proust and Painting* (New York, 1945), 71–4, gives some reasons for Proust's attraction to Vermeer, but I find these rather general and inadequate. Roger Allard, 'Les arts plastiques dans l'oeuvre de Marcel Proust', *Nouvelle Revue Française,* XX (1923), 222–30; Juliette Monnin-Hornung, *Proust et la peinture* (Genève, 1951); Barbara Bucknall, *The Religion of Art in Proust* (Urbana, Ill., 1969); I. H. E. Dunlop, 'Proust and Painting', *Marcel Proust,* ed Peter Quennell (London, 1971), 105–25; and John Cocking, 'Proust and Painting', *French Nineteenth Century Painting and Literature,* ed. Ulrich Finke (Manchester, 1972), 305–24, do not seriously discuss Vermeer's significance.

[14] *Cities of the Plain,* I, 301. All the volumes are translated by C. K. Scott Moncrieff and published in London in 1971 by Chatto & Windus.

[15] Marcel observes the light filtering through the shutters of Albertine's room 'striped from top to bottom with parallel bars of gold' in the same way that the jealous Swann sees the light from the shuttered room where he imagines (wrongly, this once) that Odette is sleeping with Forcheville. Compare *Swann's Way,* II, 76, and *The Captive,* II, 171.

[16] *Swann's Way,* I, 272–3.

[17] *The Captive,* II, 238–9.

[18] *Ibid.*, I, 76.

[19] *Within a Budding Grove*, I, 150–1.

[20] *The Guermantes Way*, II, 295. Proust means the *View of Delft*; the *Street in Delft* is in the Rijksmuseum in Amsterdam.

[21] *Cities of the Plain*, I, 149, 299.

[22] See *The Captive*, II, 81: 'Morel was the son of that old valet who had enabled me to know the lady in pink, and had permitted me, years after, to identify her with Mme Swann.'

[23] *Swann's Way*, I, 126.

[24] Painter, II, 320.

[25] The critic who made this comparison (and who accompanied Proust to the Jeu de Paume) was Jean Vaudoyer in 'Le mystérieux Ver Meer', *L'Opinion*, 30 avril, 7 and 14 mai 1921.

[26] *Within a Budding Grove*, I, 188.

[27] A rather different patch of yellow appears just after the death of Bergotte when Marcel's butler spies Charlus's yellow trousers as the Baron lingers in the middle stall of a *pissoir* (I, 254).

[28] See *The Captive*, II, 66; 'Vinteuil had been dead for many years; but in the sound of these instruments which he had animated, it had been given him to prolong, for an unlimited time, a part at least of his life.'

[29] Friedrich Schiller, 'Twenty-second Letter', *On the Aesthetic Education of Man*, ed. E. M. Wilkinson and L. A. Willoughby (Oxford, 1967), 155.

[30] F. C. Green, *The Mind of Proust* (Cambridge, 1949), 273.

Painting is essentially a system of moral values made visible.

[Stendhal, *History of Painting in Italy*]

Lampedusa, like Proust, has an intensely pictorial imagination and employs an extensive museum of art to visualise the major themes of *The Leopard* (1958). The fresco of Perseus and Andromeda in the Rosary room; the sensual fountain of Amphitrite in the garden at Donnafugata in which 'the sense of tradition and the perennial expressed in stone and water' are fixed in a Proustian moment of 'time congealed'; the ancestral portrait of *Arturo Corbera at the Siege of Antioch* and the half-obliterated painting of the consenting shepherdess in the secret chambers of the ducal palace, all illustrate and prophesy the love of Angelica and Tancredi.[1] Angelica is compared to a Madonna by Andrea del Sarto, the rapacious Sedàra is likened to a 'Japanese print of a huge violet iris with a hairy fly hanging from a petal', and when Prince Fabrizio 'swallows the toad' and conveys Tancredi's marriage proposal to Sedàra he remembers 'one of those French historical pictures in which Austrian marshals and generals, covered with plumes and decorations, are filing in surrender past an ironical Napoleon'.[2] Just as Lampedusa's use of symbolic *objets d'art* is profoundly Proustian, so the Ponteleones' grand ball at the end of *The Leopard* is closely modelled on the last scene of Proust's novel, 'The Princess de Guermantes Receives', which illuminates the themes of change and decay, and the triumph of bourgeois over aristocratic values.

During this ball the Leopard discovers a painting by Greuze called *Death of a Just Man* (plate XVIII) in the library that is decorated in the style of the 1790s, the decade of the French revolution. (Characteristically, 'the Ponteleones hadn't done it up for seventy years'.)

> The man was expiring on his bed, amid welters of clean linen, surrounded by afflicted grandsons and granddaughters raising arms toward the ceiling. The girls were pretty, provoking, and the disorder of their clothes suggested sex more than sorrow; they, it was obvious at once, were the real subject of the picture. [261]

The Prince is strongly attracted to this melancholy scene and identifies with the

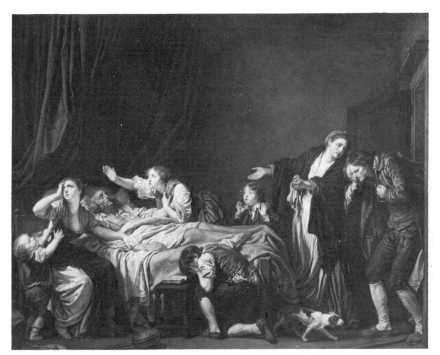

(XVIII) Greuze, *Le fils puni*, 1778

dead father because he knows that he and his class are doomed and dying. On his own deathbed he calculates that he has *really* lived only two or three years of his long life—the rest was pain and boredom, a kind of death in life. The bourgeois death in the Greuze painting mirrors Fabrizio's own *déclassé* death later in the novel, and predicts both the decline of his wealth and social prestige (his eldest son has already escaped to London and become a clerk) and the descent of the entire family into the middle class. The painting symbolises the Prince's profound conviction that nothing really matters and his fatal inability to act, except when he opposes his own interests or even his own survival.

Angelica's triumph at the ball (her meteoric ascent is the social equivalent of Odette de Crecy's career) completes her conquest of Concetta which began when Tancredi told the false and brutal anecdote of the convent rape, the most poignant moment of the book, when the two girls pass each other like stars, one rising, the other sharply descending. Angelica's social success ensures the defeat of the Salinas by the Sedàras, who are an old family—or soon will be. The discovery of the painting in the context of the ball, the last spasm of the moribund aristocracy

and final flaring up of a dying fire, relates Sicilian to European society and shows that Palermo receives its Bourbon taste and rulers, as well as its revolutionary ideas, from France.

The painting also plays a thematic and structural role in *The Leopard*. It illustrates the two important themes of decadent taste and sexual licence, and relates them both to the theme of death. The Greuze is a pictorial parody of an earlier scene, the return of the prodigal son, Tancredi; and it carefully connects 'A Ball' to the last two chapters of the novel, 'Death of a Prince' and 'Relics', which take place many years later. In order to understand the significance of Greuze's painting in *The Leopard* (it is the only one of the numerous *objets d'art* that is given a specific artist and title) we must first analyse the visual and thematic content of the painting, and then show how Lampedusa's response to the interpretations of Greuze by Diderot and the brothers Goncourt explains why this particular painting is the symbolic core of the novel.

Jean-Baptiste Greuze (1725–1805) painted three well known deathbed scenes: *La dame bienfaisante* in Lyons, *Le paralytique* in Leningrad and *Le fils puni* in the Louvre; and though none of these paintings exactly matches Lampedusa's description, he was probably thinking of *Le fils puni*, which portrays all the salient characteristics: an afflicted family, welters of clean linen and disordered clothes that suggest sex more than sorrow. Brookner writes that Greuze 'seems rather to have been inspired by a wistful vision of the ideal family in which children are begotten easily, remain devoted to their parents, and are always there at the death'.[3] It is the failure of the prodigal son (who returns, *hélas,* too late) to live up to this sentimental ideal of filial piety that is the ostensible subject of *Le fils puni* (1778). For Greuze depicted the manners and morals of the bourgeois class in saccharine genre pictures; he aimed at high tragedy and achieved well executed bathos.

The bad son enters stage right—bent in grief and beating his breast in remorse—frozen (like the rigid dog) at the dramatic yet anticlimactic moment, as the heavy draped canopy over the mortuary bed seems about to fall at the end of the last act. But guided by the extended arm of the mother (handkerchief in hand) and the standing daughter (holding the father's arm), our attention is directed first to the clean linen surrounding the nobly composed features of the dead father at the centre of the painting, and then to the distraught daughter (eyes rolled to heaven), whose grief has allowed her left breast to fall nearly out of her dress. (Is it this alarming exposure that arouses the fixed and wide-eyed stares of her siblings across the bed and that causes the kneeling lad to cover his eyes before the open Bible?) The head of the *déshabillée* daughter was inspired by the ecstatic saints of Guido Reni, for Greuze 'seems to have been the first artist in the eighteenth century to respond to the appeal of this master'.[4] Like Reni, Greuze was extremely successful in his own time and was called 'a second Raphael'.

The critic who was largely responsible for establishing Greuze's Raphaelesque

reputation was Denis Diderot; and the basis, and limitations, of Diderot's art criticism were analysed by Schiller in a letter to Goethe of 1797. 'In his aesthetic works, I think, he still looks too much to foreign and moral aims, he does not seek these sufficiently in the subject itself and in its representation. To him the beautiful work of art must always serve some other purpose.'[5] Diderot's panegyric of *Le paralytique* in the *Salon* of 1763 reveals that he found in Greuze the perfect expression of moral and didactic art.

> This fellow Greuze is really my man First, I like the genre—it is moral painting. What! Haven't painters used their brushes in the service of vice and debauchery long enough, too long indeed? Shouldn't we be glad to see him at last collaborating with dramatic poetry in order to move, to educate, to inspire us and induce us to virtue? Courage, my friend Greuze, make painting moral and make it always like that![6]

Greuze's 'collaboration with dramatic poetry' meant that works like *Le paralytique* were the equivalent in rhetorical painting of Diderot's own sentimental play *Le père de famille* (1758), and exemplified his theory of *tragédie moyenne*, 'which would have as its subject our domestic misfortunes'.[7] Diderot's high praise of Greuze suggests the artist's affinity to his contemporary English 'men of feeling', Henry Mackenzie and Samuel Richardson: 'Here is your painter and mine, the first among us to have the idea of making art moral and of constructing a sequence of events which could easily have been made into a novel.'[8]

Though Diderot characterised *Le fils puni* as 'a lesson for fathers and children',[9] he was also aware of Greuze's veiled (and unveiled) pornography, his sexual innuendo and his orgasmic women, for he writes with disapproval of a pastel of Mme Greuze (a notorious spendthrift and adulteress who helped to ruin her husband): 'That half-open mouth, those swimming eyes, that relaxed position, that swollen throat, that voluptuous mixture of pain and pleasure, obliges all decent women in the place to lower their eyes and blush with shame.'[10]

It is this Tartuffian hypocrisy of Greuze—the painter of *The Broken Eggs* and *Girl Weeping for the Death of Her Canary*, pictorial allegories of lost virginity[11]—that attracted the particular condemnation of the Goncourts in *French Painting of the Eighteenth Century* (1871), though they also attacked the influence of Diderot on Greuze and the artist's 'deplorable tradition of literary painting and moralising art'.[12] To the perceptive Goncourts, Greuze's celebration of the felicities of domestic mediocrity merely masked an insidious and dangerous corruption.

> There is something airy and coquettish in his touch which deprives motherhood of its sanctity and dignity. When he would depict conjugal happiness in two figures leaning over a cradle, his parents seem to smile with

the smile of sensuous pleasure, the gesture of the mother is the caress of the demi-mondaine The character of the man influenced the ideas of the painter, investing all these moral narratives with the *suspicion of libertinage,* at times allowing us to discern in his character of moralist no more than a Baudouin with an official veneer of virtue

The particular subtlety of this art is in its transformation of the simplicity and heedlessness of a young girl into something *sensually inviting* And white, the colour dedicated to youth, to the candour of women and the radiant modesty of their dress, becomes, in these pictures, an irritating stimulus, *a delicate excitation to licence, an allurement.*[13]

It is clear that Lampedusa reacts against Diderot's praise, and that he employs the Goncourts' interpretation of Greuze's titillation. For the Prince thinks the studied 'disorder of their clothes suggested sex more than sorrow' and that the girls were obviously 'the real subject of the picture'.

There are two other passages in the Goncourts' influential essay that suggest important themes in *The Leopard* and illuminate the character of the dreamy Prince, who 'belongs to an unfortunate generation, swung between the old world and the new' and ill at ease in both (209). For they write of Greuze:

He was the painter of illusion. His inspiration was the supreme example of the soaring trend towards rejuvenating affections, towards thoughts, pictures, plays, which might recover the lights of the morning for the spirit of a sinking society. He spoke directly to the sensibilities of the period, he was attached to its sentimentalities. He represented, personified Charity, in his 'Dame de la Charité' [*La dame bienfaisante*]. He caressed and satisfied the instincts of the time.[14]

The Leopard concerns the hopeless attempt to maintain illusions—of class, prestige, honour and faith—in the face of revolutionary transformations, for even the pragmatic Tancredi believes, 'If we want things to stay as they are, things will have to change' (40). Like Greuze, the Leopard, a famous astronomer, wants to 'recover the lights of morning for the spirit of a sinking society'. He searches for his eternal appointment with Venus in her 'own region of perennial certitude', and finds her not only in the celestial lights but also in the guise of the Woman in Brown who brings him death.[15]

The aristocratic Prince ironically identifies with the bourgeois banalities of Greuze, emphasised by the homely bedwarmer and kitchen utensils studiously placed on the floor of the bare room, and he never imagines a more appropriately noble and heroic death (as in David) or a luxurious and exotic end (as in Delacroix). His attraction to the mediocre Greuze is the aesthetic parallel of his alliance through marriage to the rapacious Sedàras, a humiliating union that recirculates into the Prince's family some of the money stolen from him by Sedàra. Though resolutely democratic, Greuze had an aristocratic clientele (his greatest patron was the Empress Catherine of Russia) and he was ruined by the

French Revolution. The Goncourts write of Greuze, in a striking parallel with the Leopard, 'Slipping into poverty, he finally vanished in oblivion. He grew old, a survival of himself, dragging along with him the heavy burden of a dead reputation.'[16]

The flattering distortion of reality and the sexual licence of *Le fils puni* is appropriate to the moribund Sicilian aristocracy, and reflects the shabby grandeur, the revolting decor and the decadent taste of that reactionary and rococo class. Within this society the 'aesthetic' judgements of the ignorant Angelica enable her 'to acquire the reputation of a polite but inflexible art expert, which was to accompany her quite unwarrantably throughout her life' (253). Even the Prince admires the taste, sentiments and 'affected simplicity' of the age of Greuze, for his drawing room, where the Rosary takes place, is decorated in the rococo style; and the palace at Donnafugata retains 'an air of excited sensuality all the sharper for being carefully restrained' which it inherited from 'the dying eighteenth century'. He even calls his scruples concerning Angelica 'Rousseauesque'. Fabrizio is disgusted by the nineteenth-century novels of Dickens, George Eliot, George Sand, Flaubert and Dumas, which Bourbon censorship excludes from Sicily, and he attacks the latest writings of Proudhon and Marx. He dislikes Verdi's tempestuous *'Noi siamo zingarelli'*, which is played for him as he enters feudal Donnafugata, and dies as a barrel organ grinds out a mechanical aria by Donizetti.

By contrast, the modern Garibaldino, Tancredi, enthusiastically discusses Bellini and Verdi (whose name was used to form the patriotic acrostic *Vittorio Emmanuele Re Di Italia*) with the liberal Chevalley when he escorts the politician through the village; and Tancredi is referred to by Fabrizio 'as a kind of Mirabeau', the great French orator who attempted to reconcile the monarchy and the revolution. The noble Sicilians who own Greuzes in 1862 will soon disappear like their French predecessors, who were destroyed by the cyclical revolutions of the nineteenth century.

The sexual licence of Greuze's art, thinly veiled with respectability, provides an ironic reflection of the sexual themes in *The Leopard*. The phenomenal appearance of Angelica (a rose fertilised by her grandfather's nickname, Peppe 'Mmerda) rouses the carnal jealousy of the Prince, and Tancredi's passionate yet ultimately restrained courtship of the voluptuous maiden makes the Leopard envy 'the chances open to a Fabrizio Salina and Tancredi Falconieri of three centuries before, who would have rid themselves of urges to bed down with the Angelicas of their day without ever going before a priest, or giving a thought to the dowries of such local girls' (116). Fabrizio's *liaison* with his mistress Mariannina is the last spark of his atavistic lust which evolved from his masochistic ancestor the Saint-Duke, who 'had scourged himself alone, in the sight of God and his estates' to redeem the land with drops of his own holy blood. While Tancredi and Angelica pursue the Keatsian 'promise of pleasure

that would never turn to pain', the Prince must content himself with the erotic reflection, 'her sheets must smell like Paradise' (see the Song of Solomon 4: 11).

Fabrizio loves the adventurous Tancredi more than his own pallid children, and though he disapproves of Tancredi's revolutionary ardour the Leopard gives him a roll of gold pieces when he joins Garibaldi's rebels. The moving scene of Tancredi's return from the wars with his friend Cavriaghi is influenced generally by Odysseus' return to Ithaca in the *Odyssey* (xvii) and specifically by the similar return of Nicholai Rostov and his friend Denisov from the campaigns against Napoleon in *War and Peace* (iv, i). Lampedusa achieves a powerful effect by individualising his beautifully rendered scene within the archetypal tradition of the eternal return portrayed by Homer and by Tolstoy. In both *War and Peace* and *The Leopard* the young warriors are greeted with excitement by the faithful retainer at the entrance to the great house (the fictional equivalents of Odysseus' nurse, Eurycleia), rush to the surprised and highly emotional reception of the large family circle, forget to introduce their weary companions, and search distractedly for their most beloved—Nicholai's mother and Tancredi's fiancée—who arrive after the climactic entrance. Tancredi's triumphant return is a parody of the retributive return in *Le fils puni* and is the literary embodiment of Greuze's sentimental *La pieté filiale,* discussed by Diderot in the Salon of 1763.[17]

Yet Tancredi's betrothal is also a betrayal: 'It's the end of the Falconieris, and of the Salinas too.' The first sentence of *The Leopard, 'Nunc et in hora mortis nostrae'*, is the dominant theme of the novel: aristocratic pride in a moment of decline, and the erosion and extinction of a noble fortune, fame and family. This sense of death hangs darkly over the ruined palaces, whose inhabitants foregather to congratulate themselves on still existing. Prince Fabrizio, with his keen sensibility to presages and symbols, strives to attain 'this life of the spirit in its most sublimated moments, those moments that are most like death' (54). Like most Sicilians he has a powerful longing for oblivion, and he reflects: 'While there's death there's hope.'

The Leopard's death is the climax of the novel, for he is the last of the Salinas, and it is foreshadowed first by a series of symbolic victims and then by *Le fils puni.* The Prince sympathises and even identifies with these victims: he prays at the evening Rosary for the eviscerated royalist soldier whom he finds decomposing in his garden; he again commends the soldier's soul to God when he receives the six slaughtered infant lambs from his feudal tenants; he feels compassion for the glaucous-eyed rabbit lacerated by horrible gunshot wounds at Donnafugata; and yearns for his faithful star Venus, a symbol of the perennial certitude of death, as he passes the butchered bulls, their thick blood slowly dropping to the ground.

On the way to the ball the Prince encounters an ominous priest hurrying through the crooked streets with the last sacrament—'in one of those barred

houses someone was in a *death agony*'—and he descends from his carriage and kneels in respect on the pavement. He senses the atmosphere of death that pervades the decaying city of Palermo, and at the ball he attempts to escape from his black gloom and the living ghosts of his past mistresses in the silent library. As soon as he sees Greuze's painting, the Leopard, who earlier in the novel prided himself on his white waistcoat, admired the nuns' purest white linen and 'saw himself as a white-haired old man walking beside herds of grandchildren' (85), in the iconographic tradition of Greuze,

> asked himself if his own death would be like that; probably it would, apart from the sheets being less impeccable (he knew that the sheets of those in their *death agony* are always dirty with spittle, discharges, marks of medicine), and it was to be hoped that Concetta, Carolina, and his other womenfolk would be more decently clad. But the same, more or less. As always, the thought of his own death calmed him as much as that of others disturbed him. [261]

Fabrizio dies a figurative and symbolic death on the very night he sees the Greuze, and this death is emphasised by the structure of *The Leopard,* for nothing in his life seems very significant after the ball, and the next chapter of the novel, 'Death of a Prince', takes place twenty-six years later. For a dozen years or so he had been courting death and 'feeling as if the vital fluid, the faculty of existing, life itself in fact and perhaps even the will to go on living, were ebbing out of him slowly' (277). His *aperçu* that the sheets are too clean anticipates his own death in a seedy Palermo hotel where he re-enacts, in a less sanitary and aesthetic way, the *Death of a Just Man,* and hears his own death rattle like the earth of a parched Sicily vainly awaiting rain.

The dying Leopard is first treated by a poor doctor, 'impotent witness of a thousand wretched *death agonies',* whose description corresponds to the old father in Greuze's painting: 'Above a torn frock coat stretched his long, haggard face stubbled with white hair, the disillusioned face of a famished intellectual' (282). The Prince's grandson Fabrizietto sits next to him and holds his hands, and like the little boy in the painting 'was staring at him with the natural curiosity of one present at his first *death agony'.* As in the Greuze, the Prince is surrounded by six figures (his grandson, nephew, three children and the doctor) and the woman in the brown travelling dress who arrives at the moment of death is the fictional equivalent of the *fils puni,* who has travelled to the deathbed direct from the road and dropped his crutch at his grief-stricken entrance. Prince Fabrizio's death is a bitter parody of Greuze's sentimental idealisation, for he expires far from his palace, amid the prison stench of crushed cockroaches and stale urine.

The last chapter of *The Leopard,* 'Relics', which describes the final humiliation of the Salina family, is also related to the exposed daughter in *Le fils*

puni, for, like the Greuze, the painting of the fake Madonna in the family chapel is in bad taste and not at all what it is taken to be.

> It was a painting in the style of Cremona[18] and represented a slim and *very attractive young woman, with eyes turned to heaven* and an abundance of brown hair scattered in *gracious disorder* on half-bare shoulders; in her right hand she was gripping a crumpled letter, with an expression of anxious expectancy not unconnected with a certain sparkle in her glistening eyes [There were] none of those symbols which usually accompany the image of Our Lady; the painter must have relied on the virginal expression as a sufficient mark of recognition. [300–1; italics mine]

When the Monsignor sees this painting he chastises the family chaplain for pretending it is a holy image and saying Mass in front of a picture of a girl waiting for a rendezvous with her lover.

A few days later, when the Vatican expert exposes the falsity of the numerous relics and necessitates a reconsecration of the family chapel, the proud Salina spinsters witness the destruction of their pre-eminence with the Church. Concetta then throws out the rotting hide of her enbalmed dog Bendicò, her last link with the pre-revolutionary past, and withdraws into her own closed world that 'had already ceded all the impulses it could give her and now consisted only of pure forms. The portrait of her father, just a few square inches of canvas . . . the portraits of dead people she no longer loved, the photographs of friends who had hurt her in their lifetime . . . the water-colours [that] showed houses and palaces most of which had been sold' (305, 319). Concetta had destroyed her future with Tancredi by her own imprudence and the rash Salina pride, and her bitter memories, like her father's, 'left a sediment of grief which, accumulating day by day, would in the end be the real cause of [her] death' (73).

Lampedusa uses *Le fils puni* to define the character of the Prince by placing Fabrizio in a reactionary and decadent tradition and at the same time endowing him with the capacity to recognise its falsity and sentimentality. By exploiting the biographical parallels between Greuze and the Leopard, and by emphasising Fabrizio's old-fashioned rococo taste and his attraction to Greuze's painting, Lampedusa also maintains the necessary critical and ironic distance between himself and his eighteenth-century hero, although their class and their essential values are identical. Lampedusa's reference to 'a bomb manufactured in Pittsburgh, Pennsylvania' that destroyed the ballroom in 1943 seems like an awkward authorial intrusion; but it distinctly suggests the beginning of the end of Mussolini's twenty-five-year rule in Italy, which could have occurred only after political power shifted to the incapable hands of the democratic masses as a result of the Italian revolution. As the Prince tells Chevalley, 'We were the Leopards, the Lions; those who'll take our place will be little jackals, hyenas' (214).

In *The Leopard* Lampedusa surrounds the Prince with a depth and richness by

evoking echoes of the Bible, Dante, Ariosto, Tasso, Stendhal, Flaubert, Baudelaire, Tolstoy and Proust.[19] Similarly, he uses the literary interpretations of Diderot and the Goncourts to place Greuze in an aesthetic and cultural tradition; and he incorporates Greuze's licentious hypocrisy, Diderot's moral self-deception and the Goncourts' shrewd insight into the ambivalent character of Fabrizio. Lampedusa makes *Le fils puni* reflect a personal and historical crisis: the death of the Leopard, his memories, his traditions and his class. Though Lampedusa could not admire Greuze's 'pure forms' in the way that Proust admired Vermeer or Huysmans Moreau, his use of Greuze's painting and the values it represents is a striking example of the great strength of *The Leopard*: Lampedusa's unusual ability to absorb and transform other works of art into his own traditional yet original masterpiece.

NOTES TO CHAPTER TEN

[1] See my essay 'Symbol and Structure in *The Leopard*', *Italian Quarterly*, IX (Summer–Fall 1965), 50–70.

[2] Giuseppe Tomasi di Lampedusa, *The Leopard*, trans. Archibald Colquhoun (New York: Pantheon, 1960), 145.

[3] Anita Brookner, *Greuze* (London, 1972), 58.

[4] *Ibid.*, 42.

[5] *Correspondence Between Schiller and Goethe*, trans. Dora Schmitz, I (London, 1879), 365 (7 August 1797).

[6] Denis Diderot, *Salons*, ed. Jean Seznec and Jean Adhèmar, I (Oxford, 1957), 233. Diderot's admiration for Greuze was shared by contemporary critics: 'Among the *Drawings*, the *Death of a Father of a Family* particularly interested Raphaël, who found in this moral subject ''the pathetic and sublime author of 'The paralytic helped by his children.' '' For Saint-Aubin, it evoked Poussin.' (Seznec and Adhèmar, IV, 44)

[7] Diderot, quoted in Brookner, 30–1.

[8] Diderot, *Salons*, II, 144.

[9] *Ibid.*, II, 158.

[10] *Ibid.*, II, 151. A wittier critic remarked of Greuze's *La voluptueuse* in the Salon of 1769: 'The author has been unwise in making free with an expression which should be reserved for happier moments.' (Quoted in Brookner, 67.)

[11] The Salina family portraits of various aunts 'pointing sorrowfully at the bust of some extinct dear one' (201) suggest Greuze's *The Inconsolable Widow* (Wallace Collection, London), where the grieving woman is half-naked and exquisitely ready for another husband.

[12] Edmond and Jules de Goncourt, 'Greuze', *French Eighteenth Century Painters*, trans. Robin Ironside (London, 1948), 222.

[13] *Ibid.*, 247–8; italics mine. Pierre Antoine Baudouin (1723–69), a French painter in the style of Boucher, was one of the most daring minor masters of the eighteenth century. His *Confessional* went too far, even for contemporary taste, and caused a considerable scandal. Some of the greatest French paintings of this period, like Fragonard's *The Swing* (Wallace Collection), have an element of the obscene.

[14] *Ibid.*, 245.

[15] The significance of Venus in *The Leopard* is heightened by Lampedusa's oblique allusion to the opening passage of *Paradiso,* VIII, where Beatrice becomes increasingly radiant as she rises with Dante from Mercury to Venus. In the light of Venus Dante sees the spirits of the blessed illuminated, some more quickly, others more slowly, according to the measure of their divine regard. For a specific allusion to '*Veni, sponsa de Libano*' in *Purgatorio,* XXX, see *The Leopard,* 164.

[16] Goncourts, *French Eighteenth Century Painters,* 250.

[17] Greuze was unduly fond of these complementary pictures. His two drawings *La mort de bon père de famille regretté par ses enfants* and *La mort d'un père denaturé abandonné par ses enfants* were both exhibited in the Salon of 1769.

[18] According to the *Enciclopedia italiana,* Tranquilo Cremona (1837–78) had a 'sensibilità preziosa e delicata . . . [che] riassume bene lo spirito di una società e di un'epoca'.

[19] See my essay 'The Influence of *La Chartreuse de Parme* on *Il Gattopardo*', *Italica,* XLIV (September 1967), 314–25.

Part III

11 Holbein
and *The Idiot*

> Never before had a painter so charnally envisaged divinity nor so brutally
> dipped his brush into the wounds and running sores and bleeding nail holes
> of the Saviour. Grünewald had passed all measure. He was the most
> uncompromising of realists, but his morgue Redeemer, his sewer Deity, let
> the observer know that realism could be truly transcendent.
>
> [J.-K. Huysmans, *Là-Bas*]

During the composition of *The Idiot* (1868) Dostoyevsky and his wife saw Hans
Holbein's *Christ in the Tomb* (plate XIX) in the Basel Kunstmuseum, and Anna
records in her *Diary* for 24 August 1867 that

> the Dead Saviour [was] a marvellous work that positively horrified me, and
> so deeply impressed Fyodor that he pronounced Holbein as a painter and
> creator of the first rank. As a rule, one sees Jesus Christ painted after His
> death with His face all tortured and suffering, but His body with no marks on
> it at all of pain and suffering . . . though of course they must have been
> there. But here the whole form is emaciated, the ribs and bones plain to see,
> hands and feet riddled with wounds, all blue and swollen, like a corpse on
> the point of decomposition. The face too is fearfully agonised, the eyes half
> open still, but with no expression in them, and giving no idea of *seeing*.
> Nose, mouth and chin are all blue; the whole thing bears such a strong
> resemblance to a real dead body that I should not like to be left with it in a
> room alone. I cannot judge it aesthetically at all, for to me it is just a piece of
> real life, and only makes me feel horror and repugnance. Fyodor, none the
> less, was completely carried away by it.[1]
>
> On his agitated face I noticed the frightened look which I had seen many
> times during the first moments of his epileptic fits. I took his arm, went with
> him to another room and made him sit down on a bench, expecting him to
> have a fit any moment. Fortunately, it did not come: Fedya calmed down
> gradually but insisted on going to see the picture again, this time he stood on
> a chair.[2]

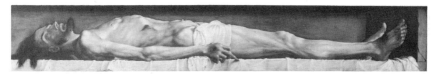

(XIX) Holbein the Younger, *Christ in the Tomb*, 1521

136

The *Diary* is similar to the description of the painting in *The Idiot*, for Dostoyevsky also emphasises Holbein's unusual portrayal of agonised suffering and decomposition, and the resemblance of Christ's body to an actual corpse. And in the novel Dostoyevsky recreates Anna's emotions of horror and repugnance and his own obsessive, physical response—which was compared to an epileptic fit—in the violent reactions of Prince Myshkin, Rogozhin and Hippolyte to *Christ in the Tomb*.

Dostoyevsky was fascinated by Holbein's painting, which seemed to question the possibility of Christ's Resurrection, because he felt that he himself had experienced a return from the dead when he was reprieved at the final moment from the 'certainty' of execution by firing squad. In Myshkin's narration of this autobiographical event in *The Idiot*, the condemned prisoner, who thinks of himself as a dead man, describes his reprieve as a resurrection: 'What if I were to return to life again? What an eternity of days, and all mine!'[3]

Wasiolek states that Dostoyevsky wrote *The Idiot*

> between fits of gambling and fits of epilepsy, when there was no money and very little hope Devoured by a passion for gambling and then by guilt, humiliated by poverty, driven by deadlines, choking on foreign air, alarmed and disgusted by political currents, forced to move restlessly from apartment to apartment with a pregnant wife, and forced to bear the shock of the death of his three-month-old daughter—these comprise Dostoyevsky's physical and spiritual environment during the eighteen months *The Idiot* was in the making.[4]

The chaos of Dostoyevsky's life is clearly reflected in the chaos of the *Notebooks* and the novel, for *The Idiot* suffers from a lack of form and focus, and an excess of repetitive scenes and irrelevant digressions. The *plot* concerns the tortuous oscillations of Myshkin's love for Nastasia and Aglaya; but Dostoyevsky uses Holbein's *Christ in the Tomb* to structure the novel by reinforcing the analogy between Christ and Myshkin, the paradox of Christ's humanity and man's divinity, and to express the major *thematic* polarities of materialism and spirituality, atheism and belief, damnation and redemption. As one critic writes (without elaborating his statement), Holbein's picture 'is the symbolic heart of the work'.[5]

The atmosphere of *The Idiot* is haunted and obsessive, and the ambivalent feelings of horror and attraction which the Holbein aroused in Dostoyevsky are expressed in the novel through the conflict of Myshkin and Rogozhin. These two characters, who represent two sides of Dostoyevsky's personality, are destructively drawn to each other. Rogozhin is frequently described as 'mad', and his mental derangement is analogous to that intensely sub- and superhuman aspect of Myshkin's mental deficiency.[6] Rogozhin's materialism is represented by the 100,000 borrowed roubles with which he successfully bids for Nastasia;

his atheism is symbolised by the tin cross that he exchanges for his gold one; and his belief in power is expressed by the knife that he uses to threaten the Prince and to kill Nastasia when he can no longer endure her infidelity and his own humiliation.

Rogozhin tries to buy Nastasia with money; Myshkin, Dostoyevsky's attempt 'to portray the perfect man',[7] tries to redeem her with love. His idiocy is the cross he bears to atone for man's sins; he is a zealous Christian, he reads men's souls, he has a truthfulness of spirit, he seeks justice and judges men humanely. Nastasia, the female complement of the violent and self-destructive Rogozhin, has a powerful beauty that she uses to 'overthrow the world'; but the Prince believes in the spiritual power of meekness. The promiscuous Nastasia is like Emma Bovary, deceived by the hope of romantic love; the chaste Prince is like Don Quixote, the 'poor knight' lost in the illusions of romantic chivalry and platonic love but 'capable of living up to an ideal all his life'. Nastasia humiliates her lovers and insists they burn themselves to prove their devotion. Myshkin is given a ludicrous hedgehog and gets slapped in the face. Myshkin is Christ, whose 'heart was pierced' and who 'seemed to arise from the dead'; and Nastasia is Mary Magdalene, for she 'is persuaded that she is the most hopeless, fallen creature in the world', and the Prince tells her, 'you have suffered, you have passed through hell and emerged pure, and that is very much'. He wants to marry Nastasia and will take her as she is, with nothing; but she refuses and is 'rescued' by Rogozhin.

Dostoyevsky frequently characterises the figures in the novel through objects of art.[8] The passionate Nastasia has a statue of Venus in her house; she exhibits her decorative actress friend 'like a valuable picture'; and the shattering of the expensive Chinese vase by the Prince symbolises the destruction of his relationship with Aglaya. The secret sorrow in the face of Alexandra, Aglaya's eldest sister, reminds the Prince of Holbein's Madonna in Dresden;[9] the life-sized portrait of Rogozhin's father inspires the same observation from both Myshkin and Nastasia; and the Prince's fair hair, sunken cheeks and 'thin, pointed and very light coloured beard' resemble the stylised Christ of the Russian icons.

The Prince's idea of Nastasia derives from her image, and he first encounters her beauty through her photographic 'portrait', which defines Nastasia and her relation to the other characters. Gania and his sister Varia mistakenly believe that Nastasia's gift of the portrait means that she will accept Gania's proposal; Adelaida observes, 'Such beauty is real power. With such beauty as that one might overthrow the world'; Myshkin rather awkwardly compares Aglaya's beauty with Nastasia's; and when he first sees the portrait he realises that his love is hopeless, and ironically tells Gania, 'I cannot marry at all. I am an invalid.' But the Prince recognises from the portrait that Nastasia must have suffered terribly, and the strange contrast of her pride and hatred, simplicity and

loveliness, makes a profound impression on him: 'The sight of the portrait face alone had filled his heart full of the agony of real sympathy; and this feeling of sympathy, nay, of actual *suffering*, for her, had never left his heart since that hour, and was still in full force.' (331)

Myshkin's compassion for Nastasia ('I felt that I could not *bear* to look at it . . . I'm *afraid* of her face') is similar to his sympathy for Christ's suffering when he sees the copy of Holbein's *Christ in the Tomb* in Rogozhin's house, which seems 'like a burial ground'. The life-sized painting has a 'strange and rather striking shape, it was six or seven feet in length, and not more than a foot in height'. Dostoyevsky says 'it represented the Saviour just taken from the cross' but this is misleading, for the painting is not a Deposition but an Entombment.[10] When Rogozhin points out the picture, the Prince immediately identifies it as a Holbein and remarks, 'I saw the picture abroad and could not forget it.' Rogozhin seems to drop the subject but suddenly asks the Prince, 'do you believe in God?'

> 'That picture! That picture!' cried Myshkin, struck by a sudden idea.
> 'Why, a man's faith might be ruined by looking at that picture!'
> 'So it is!' said Rogozhin, unexpectedly. [206–7]

Holbein's *Christ in the Tomb* (1521), which was influenced by Mantegna's *Dead Christ* in Milan and Grünewald's Isenheim altarpiece in Colmar, emphasises human mortality and the terrors of death. The dead Christ is rigidly stretched out on a winding sheet within a greenish marble tomb, His gangrenous fingers extending over the edge of the austere bier. His dark matted hair falls on the white cloth, His eyes are rolled upward, His mouth is twisted open, and His face is illuminated from below by a light that casts shadows over the anguished features. Chamberlain writes that

> the rigidity of the limbs, the haggard cheeks with strongly projecting bones, the staring, half-sunken eyes, the lifeless skin, the colourless face with bloodless [swollen] lips, the emaciated body with its ribs standing out, have all been set down with relentless accuracy. The indication of decay in the hands and feet, and in the flesh turning green round the wounds in the side, helps to intensify the terror and horror of death which the picture intended to depict.[11]

The origin of *Christ in the Tomb* helps to explain its extraordinary effect. This painting was originally an anatomical 'study of a dead man, and one whose end has, perhaps, been brought about by violence . . . [but] having painted this vividly realistic study, which no patron was likely to purchase, [Holbein] made it of marketable value by adding the words and the title, and so turning it into "Christ in the Tomb" '.[12] 'Jesus Nazarenus Rex Judaeorum' is carved on top of the tomb, and angels with instruments of torture are depicted between the stark words. The scientific exactitude of Holbein's agonising physical details

cauterises all spiritual feeling and could ruin a man's faith by denying the divinity of Christ. There is neither dignity nor pity in death, and we can scarcely see the Christ for the corruption.

The characters of Myshkin and Rogozhin are reflected in their very different interpretations of the Holbein painting. It is a *memento mori,* an image of a tortured and dead Christ, after the Crucifixion and before the Resurrection; and it naturally inspires the Prince's pity and compassion for Christ's terrible suffering and sacrifice for mankind, because he is Christ-like himself. Myshkin's goodness and innocence, which seem so guileless and simple, but which unintentionally cause so much chaos and torment, derive from his capacity for loving the base and degraded, and his own corresponding tendency to be persecuted and despised. This is part of his faith in the resurrected and redeeming Christ.

By contrast, Rogozhin likes to look at Holbein's painting because it confirms his fear that Christ is not divine, but mortal, and seems to deny the doctrine of His Resurrection and the consequent redemption of mankind. The Holbein provides a focus for an idea that obsesses Myshkin—the fact of mortality and the possibility of immortality—and he reveals that he is not absolutely convinced by the doctrine of the Resurrection when he exclaims, 'a man's faith might be ruined by looking at that picture!' Similarly, the question that Rogozhin asks the Prince, 'do you believe in God?', suggests that his atheism contains an element of faith: 'Les extrémités se touchent'. *Christ in the Tomb,* therefore, provokes a crisis of faith that influences the characters and explains their actions.

After Rogozhin suggests the symbolic exchange of crosses that makes them brothers, the Prince leaves him; but he is haunted by a vision of Rogozhin's demonic, 'dreadful eyes' (an important leitmotif in the novel) that reminds Myshkin of his epileptic symptoms.

> These moments, short as they are, when I feel such extreme consciousness of myself, and consequently more of life than at other times, are due only to the disease—to the sudden rupture of normal conditions . . . [but] when I recall and analyse the moment, it seems to have been one of harmony and beauty in the highest degree—an instant of deepest sensation, overflowing with unbounded joy and rapture, ecstatic devotion, and completest life. [214]

Myshkin's epilepsy is a metaphor for his spiritual insight. For these moments of ecstatic devotion paradoxically transcend the limitations of disease in the same way that his belief in the Resurrection transcends Christ's bodily corruption, so that the Prince's faith is strengthened, just as Rogozhin's is weakened, by *Christ in the Tomb.*

Hippolyte also sees the painting in Rogozhin's house, and his more thorough description of the Holbein later in the novel clarifies Myshkin's reaction and

relates the painting to the themes of *The Idiot*, for the tubercular Hippolyte and the epileptic Prince both identify with Christ's passion.

There was nothing artistic about it, but the picture made me feel strangely uncomfortable. It represented Christ just taken down from the cross. It seems to me that painters as a rule represent the Saviour, both on the cross and taken down from it, with great beauty still upon His face. This marvellous beauty they strive to preserve even in His moments of deepest agony and passion. But there was no such beauty in Rogozhin's picture. This was the presentment of a poor mangled body which had evidently suffered unbearable anguish even before its crucifixion, full of wounds and bruises, marks of the violence of soldiers and people, and of the bitterness of the moment when He had fallen with the cross—all this combined with the anguish of the actual crucifixion.

The face was depicted as though still suffering; as though the body, only just dead, was still almost quivering with agony. The picture was one of pure nature, for the face was not beautified by the artist, but was left as it would naturally be, whosoever the sufferer, after such anguish.

I know that the earliest Christian faith taught that the Saviour suffered *actually* and not figuratively, and that nature was allowed her own way even while His body was on the cross.

It is strange to look on this dreadful picture of the mangled corpse of the Saviour, and to put this question to oneself: 'Supposing that the disciples, the future apostles, the women who had followed Him and stood by the cross, all of whom believed in and worshipped Him—supposing that they saw this tortured body, this face so mangled and bleeding and bruised (and they *must* have so seen it)—how could they have gazed upon the dreadful sight and yet have believed that He would rise again?'

The thought steps in, whether one likes it or no, that death is so terrible and so powerful, that even He who conquered it in His miracles during life was unable to triumph over it at the last. He who called to Lazarus, 'Lazarus, come forth!' and the dead man lived—He was now Himself a prey to nature and death. Nature appears to one, looking at this picture, as some huge, implacable, dumb monster; or still better—a stranger simile—some enormous mechanical engine of modern days which has seized and crushed and swallowed up a great and invaluable Being, a Being worth nature and all her laws, worth the whole earth, which was perhaps created merely for the sake of the advent of that Being.

This blind, dumb, implacable, eternal, unreasoning force is well shown in the picture, and the absolute subordination of all men and things to it is so well expressed that the idea unconsciously arises in the mind of anyone who looks at it. All those faithful people who were gazing at the cross and its mutilated occupant must have suffered agony of mind that evening; for they must have felt that all their hopes and almost all their faith had been shattered at a blow. They must have separated in terror and dread that night, though each perhaps carried away with him one great thought which was never

eradicated from his mind for ever afterwards. If this great Teacher of theirs could have seen Himself after the Crucifixion, how could He have consented to mount the Cross and to die as He did? This thought also comes into the mind of the man who gazes at this picture. I thought of all this by snatches—probably between my attacks of delirium—for an hour and a half or so before Colia's departure.

Can there be an appearance of that which has no form? And yet it seemed to me, at certain moments, that I beheld in some strange and impossible form, that dark, dumb, irresistibly powerful, eternal force. [391–2]

The first two paragraphs give a detailed description of the painting which closely corresponds to Dostoyevsky's original response to it in Basel. Hippolyte's remarks that 'There is nothing artistic about it' and that 'The picture was one of pure nature' emphasise the painting's realism; but his assertion that the body was 'only just dead, [and] was still almost quivering with agony', which intensifies and protracts Christ's suffering, is denied by the substantial putrefaction and the startling stiffness of the corpse.

The last two paragraphs attempt an interpretation and raise the central question of faith: how could Christ's followers 'have gazed upon the dreadful sight and yet have believed that He would rise again?' Hippolyte suggests that an 'enormous mechanical engine', a 'powerful, eternal force', has destroyed Christ and with Him all possibility of redemption for a world that caused His dreadful death. If the painting portrays this destructive force, 'an appearance of that which has no form', then it denies the divinity of Christ, who, if this painting be true, could not 'have consented to mount the Cross and to die as He did'.

According to Robert Jackson, Dostoyevsky believed that 'Hans Holbein's painting is clearly bad art because it disturbs man's moral and religious tranquillity; it is the embodiment of an aesthetics of despair'.[13] But this assertion, apart from contradicting Anna's statement that Dostoyevsky 'pronounced Holbein as a painter and creator of the first rank', is too simplistic and superficial. Myshkin does *not* believe that Holbein represents 'an aesthetics of despair'; and the function of 'good art' is surely not to soothe and confirm man's religious tranquillity (a sentimental illustration of the Gospels would do that) but to heighten his moral and spiritual awareness.

Dostoyevsky relates *Christ in the Tomb* to the spiritual crisis experienced by a man just before his execution. This subject fascinates the Prince, who compulsively narrates two stories of executions and is deeply moved when he hears of two others from Lebedeff and Hippolyte. Myshkin suffers, and imaginatively identifies with those that suffer; and he believes that immediately before their execution men achieve a spiritual awareness, analogous to an epileptic fit, because they re-enact the agony of Christ. While waiting to see General Epanchin just after he arrives in St Petersburg, Myshkin tells the astonished servant about an execution by guillotine that he witnessed in Lyons.

Imagine what must have been going on in that man's mind at such a moment; what dreadful convulsions his whole spirit must have endured; it is an outrage on the soul

Now with the rack and tortures and so on—you suffer terrible pain, of course; but then your torture is bodily pain only (although no doubt you have plenty of that) until you die. But *here* I should imagine the most terrible part of the whole punishment is, not the bodily pain at all—but the certain knowledge that in an hour,—then in ten minutes, then in half a minute, then now—this very *instant*—your soul must quit your body and that you will no longer be a man—and that is certain, *certain!* . . .

Doubtless there may be men who have been sentenced, who have suffered this mental anguish for a while and then have been reprieved; perhaps such men have been able to relate their feelings afterwards. Our Lord Christ spoke of this anguish and dread. [18–20]

The execution, described in the metaphor of an epileptic convulsion, is an outrage on the soul precisely because it denies the divine element in man at the same time that it arrogates divine powers to the executioner. Christ's foreknowledge of His own death (like Dostoyevsky's before the firing squad) made Him suffer the anguish and dread as well as the torture and pain; and in Gethsemene He said, 'My soul is exceeding sorrowful, even unto death: tarry ye here, and watch with me. And he went a little farther, and fell on his face, and prayed, saying, O my father, if it be possible, let this cup pass from me: nevertheless not as I will, but as thou wilt' (Matthew 26: 38–9). His final utterance, 'My God, my God, why hast thou forsaken me?', expresses the paradox of the human and divine elements of Christ, and the domination of the carnal aspect that is emphasised in the Holbein painting.

During his first meeting with Aglaya and her sisters the Prince obsessively returns to the story of the guillotine, which elicits the same response from him as the Holbein painting: 'I didn't like it at all . . . but I confess I stared as though my eyes were fixed to the sight. I could not tear them away.' Aglaya's sister Adelaida is an artist who asks Myshkin to suggest a subject, and though he claims to know nothing about art he recommends a realistic aesthetic (like Holbein's) and tells her 'one only has to look, and paint what one sees'. Aglaya enthusiastically describes an essential characteristic of the Prince when she states, 'I should think you could teach *us* to see . . . to instruct us in your views.' The Prince finally tells Adelaida 'to draw the face of a criminal, one minute before the fall of the guillotine', states that 'When I was in Basle I saw a picture very much in that style', and then suggests a detailed picture of the moment of execution—and of insight. 'Draw the scaffold so that only the top step of the ladder comes in clearly. The criminal must be just stepping on to it, his face white as notepaper. The priest is holding the cross to his blue lips, and the criminal kisses it, and knows and sees and understands everything. The cross and

the head—there's your picture' (59–62). The Prince's picture contrasts the earthly and the divine and emphasises the criminal's awareness of the possibility of redemption, for he has received absolution and kissed the cross. But in a letter to Aglaya later in the novel,[14] Nastasia says that *she* would paint Christ with a little child who 'leans its elbow upon Christ's knee, and with its cheek resting on its hand, gazes up at Him, pondering as children sometimes do ponder' (439). Nastasia intends this sentimental scene to contrast Aglaya's innocence with her own worldliness; but it also reveals the profound difference between the Prince's conception of Christianity and Nastasia's superficial and saccharine view of religion.

The third execution story concerns the guillotining of the Comtesse du Barry, the mistress of Louis XV, and is related by the brutish Lebedeff, who expresses an unusual sympathy and hopes that because she suffered as Christ did, 'perhaps the Saviour will pardon her other faults, for one cannot imagine a greater agony' (185). Hippolyte tells the Prince the fourth story of an execution: the death of Stepan Gleboff, who was impaled on a stake in the time of Peter the Great. Myshkin, of course, remembers this martyrdom, which is similar to a crucifixion: ' "I know, I know! He lay there fifteen hours in the hard frost, and died with the most extraordinary fortitude—I know—what of him?" ' And Hippolyte, who is dying of tuberculosis and later attempts a theatrical suicide, replies somewhat cryptically, 'Only that God gives that sort of dying to some, and not to others' (503–4). Death by execution is for Dostoyevsky àn *imitatio Christi.*

Like the four executions that clarify the complex pattern of *The Idiot,* the Prince's three epileptic fits, which produce an 'intense quickening of the sense of personality', develop the theme of the spiritual crises inspired by *Christ in the Tomb.* The Holbein painting prompts the Prince to tell Rogozhin of a murder by a religious peasant who 'took a knife, and when his friend turned his back, he came up softly behind, raised his eyes to heaven, crossed himself, and saying earnestly—"God forgive me, for Christ's sake!" he cut his friend's throat like a sheep, and took the watch'. The murderer, who seems to combine Myshkin's faith with Rogozhin's materialism ('extremes meet'), ironically sacrifices his friend like the Lamb of God while begging forgiveness 'for Christ's sake'. But Rogozhin ignores the spiritual conflict and the element of the absurd, sees it merely as religious hypocrisy, and finds it enormously funny that such a thoroughgoing believer should 'murder his friend to the tune of a prayer'. Though Rogozhin virtually admitted his atheism, when the Prince recalls the strange scene in the gloomy house he thinks that Rogozhin 'was fighting for the restoration of his dying faith. He must have something to hold on to and believe, and someone to believe in. What a strange picture that Holbein is!' (218.) As Myshkin reflects on the painting and passes through the dark corridors of his hotel the jealous and atheistic Rogozhin, his eyes flashing 'like a raving

madman', attempts to murder the god-like Prince, who falls into an epileptic fit and crashes down a flight of stairs as his assailant rushes past him.

The second fit occurs after another spiritual crisis in one of the climactic scenes of the novel. When the Prince is told that Pavlicheff, his former guardian and protector, had been converted to Roman Catholicism by a Jesuit, he violently condemns that religion. 'Atheism only preaches a negation, but Romanism goes further; it preaches a disfigured, distorted Christ—it preaches Anti-Christ They have exchanged everything—everything for money, for base earthly *power*! And is this not the teaching of Anti-Christ?' Though the Prince admits that 'it is easier for a Russian to become an atheist than for any other nationality in the world', he insists, 'We must let *our* Christ shine forth upon the Western nations, our Christ whom we have preserved intact, and whom they have never known' (524–7). It is clear that the 'disfigured, distorted Christ' of Romanism is related to the carnal Christ of Holbein, and that Catholics and atheists (like Rogozhin) who cannot see the true Christ of Holy Russia, preserved intact and shining forth, have exchanged everything (including their cross) for materialism, for 'base earthly *power*'. After delivering this violent peroration the Prince shatters the Chinese vase, utters a wild cry as he falls writhing to the ground, and is declared unfit to be Aglaya's husband by her mother, who fails to see the spirituality of Myshkin 'shining forth'.

Though the Prince loves both Nastasia and Aglaya, he must try to redeem the former rather than marry the latter. When the two women finally meet at the end of the novel, and the angry Aglaya rushes out of the room, 'The Prince made a rush after her, but he was caught and held back. The distorted, livid face of Nastasia gazed at him reproachfully, and her blue lips whispered: "What? Would you go to her—to her?" ' (555). But even the Christ-like love of the Prince is unable to save Nastasia, and his third fit occurs when he discovers that Rogozhin has murdered her with the same knife that precipitated his first fit.

It seems inevitable after all the narratives of actual and judicial murder—including the case of a multiple murderer whose defence counsel 'observed that in the poverty-stricken condition of the criminal it must have come *naturally* into his head to kill these six people'—that *The Idiot* culminates with a gruesome murder in the very place where *Christ in the Tomb* is exhibited. There is a strange and terrible beauty in what Proust calls the House of Murder, a 'beauty blended with a woman's face that is the unique thing which Dostoyevsky has given to the world'.[15]

Like Holbein's Christ, Nastasia's body is stretched out, beneath a white sheet, and 'from under a heap of lace at the end of the bed peeped a small foot, which looked as though it had been chiselled out of marble; it was terribly still'. And Rogozhin has to cover the gashed and wounded body with the best American oilcloth and four jars of disinfectant because of the suppurating putrefaction. The Prince is overwhelmed by the sight of Nastasia's corpse, and after his final fit,

which coincides with Rogozhin's 'brain fever', Myshkin relapses into incurable idiocy.

The Christ-like Prince Myshkin, who hopes to find heaven on earth, is an idiot only if judged by the values of the contemporary world, and he reveals how far modern man has deviated from the original principles of Christianity, from the pristine faith of the Russian believers whom the Prince contrasted with the Western Anti-Christ of materialism and power. As the Prince, who quotes—and lives—the Gospels, tells Lebedeff, 'Give up serving, or trying to serve, two masters,' God and mammon. The tragedy of *The Idiot* is that if man lives without God, as Rogozhin does, he is destroyed by greed, passion and pride; and if he lives like God, as Myshkin does, he is rejected, despised and an idiot. The Prince's epileptic idiocy makes him suffer and identify with Christ, and heightens his spiritual awareness, so that he is able to transcend the materialistic reality of Holbein's mortuary Redeemer. But the inability of the other characters in *The Idiot* to see beyond Christ's suffering and Myshkin's disease represents the triumph of atheism over Christianity and the loss of man's salvation that follows his loss of faith.

NOTES TO CHAPTER ELEVEN

[1] Anna Dostoevskaia, *The Diary of Dostoyevsky's Wife*, trans. M. Pemberton (New York, 1928), 419. The ellipsis and italics are in the original.

[2] Anna Dostoevskaia, quoted in David Magarshack, *Dostoyevsky* (London, 1962), 384.

[3] Fyodor Dostoyevsky, *The Idiot*, trans. Eva Martin (London: Everyman, 1967), 57.

[4] Fyodor Dostoyevsky, *The Notebooks for 'The Idiot'*, ed. Edward Wasiolek (Chicago, 1967), 1, 3–4.

[5] Richard Peace, *Dostoyevsky: An Examination of the Major Novels* (Cambridge, England, 1971), 97.

[6] See Marcel Proust, *The Captive*, trans. C. K. Scott Moncrieff, II (London: Chatto & Windus, 1971), 240: 'In Dostoyevsky I find the deepest penetration, but only into certain isolated regions of the human soul.'

[7] Dostoyevsky, quoted in Robert Lord, *Dostoyevsky: Essays and Perspectives* (London, 1970), 85.

[8] For discussions of Dostoyevsky's knowledge and use of painting in his other novels, see Robert Jackson, 'Dostoyevsky and the Fine Arts', *Dostoyevsky's Quest for Form* (New Haven, 1966); and Peace, pp. 96–97: Dostoyevsky sees Claude Lorrain's *Acis and Galatea* 'as some sort of pledge that man can live in a state of harmony and happiness. The picture is interpreted in this light in both *Stavrogin's Confession* and *A Raw Youth*, and it obviously inspires the depiction of "heaven on earth" in yet a third work: *The Dream of a Comic Man'*.

[9] See *Notebooks*, ed. Wasiolek: 'This is *The Madonna of Burgomeister Meyer*, which was then in the Royal Gallery of Dresden and was Holbein's copy of his own original (1525–26) in Darmstadt. The figure of the Madonna is an example of ideal Nordic beauty, with flowing golden hair, an oval face, and a high forehead, with the

eyes cast down.' Though Dostoyevsky clearly meant the comparison to be complimentary, Jackson, p. 260, n. 15, quotes Dostoyevsky as saying, 'The Italians presented the true mother of God—the Sistine Madonna: but the Madonna of the best German artist, Holbein? Do you call that a Madonna? A baker's wife. A petit bourgeois! Nothing more!'

[10] Edward Wasiolek, *Dostoyevsky: The Major Fiction* (Cambridge, Mass., 1964), 94, mistakenly writes of 'the sight of Holbein's picture of Christ's descent from the cross, which hangs in Rogozhin's apartment'. According to Paul Ganz, *The Paintings of Hans Holbein* (London, 1950), 218, the painting 'belongs under a lost "Deposition" by Holbein, preserved in an engraving'.

[11] Arthur Chamberlain, *Hans Holbein the Younger* (London, 1913), 101.

[12] *Ibid.*, 101–2.

[13] Jackson, 67.

[14] The hateful love letters that Nastasia writes to Aglaya unite the two women in the same way as the crosses bind Rogozhin and Myshkin.

[15] Proust, *The Captive*, II, 237.

12 Van Eyck
and *The Fall*

On the second page of *The Fall* Jean-Baptiste Clamence points out an empty
rectangle 'where a picture has been taken down' from the back wall above the
barbaric barman in the Mexico City. He hints about a famous art theft at the end
of the second chapter, and the mystery is explained in the final chapter when he
opens a cupboard in his room and reveals the panel of *The Just Judges* that was
stolen from St Bavon Cathedral in Ghent.

 The Just Judges forms part of Jan Van Eyck's complex altarpiece *The
Adoration of the Lamb* (1432) (plate xx), a huge and resplendent celebration of
the redemption of guilty man by the innocent blood of Christ. In contrast to the
elaborate painting, the brief novel appears to be simple in structure, and is cast in

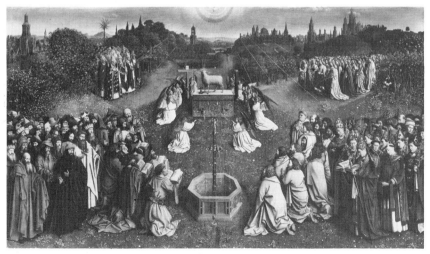

(XX) Van Eyck, *The Adoration of the Lamb*, 1432

the form of Clamence's narrative of his own past and of recent historical events that seem to justify his condemnation of modern life. But just as all the parts of the altarpiece focus on the central Lamb and express the moral and religious vision symbolised by Christ, so all the anecdotes and themes of Clamence's ironic monologue expose his corrupt character and explain his negative views. The subject of *The Fall* is the problem of guilt in a world where it is no longer possible to be innocent and where there is no redemption for the guilty.

The importance of the painting in elucidating the meaning of the novel is twofold. It provides a visual representation of the theological framework of the novel: the Christian answer to the problem of guilt as revealed in the Gospels and the Book of Revelation. The biblical metaphor of the novel, as well as the aesthetic and historical allusions, are directly related to *The Adoration,* so that (for example) John the Baptist wears camel's hair in Matthew 3: 4 and in the altarpiece, just as Jean-Baptiste does in the novel. At the same time the painting provides a moral and religious reference for Clamence's confession of damnation. Since the novel's mode is completely ironic and thoroughly negative (except by implication), an awareness of Van Eyck's vision of faith and belief in the possibility of innocence provides one firm contrast to Clamence's clever but evil reasoning, and helps to define Camus' beliefs.

All analyses of *The Fall* discuss the problem of Camus' irony, and whether Clamence speaks for Camus or is a negative *persona* who provides an ironic contrast to Camus' beliefs. Despite the difficulties of interpreting this thematically elusive novel, critics like Thody and Cruickshank entirely ignore the significance of the painting, while others confine themselves to banal comments. Germaine Brée writes of Clamence, 'As a whole, the painting "The Adoration of the Lamb" would mean little to him, for he adores only himself';[1] and Hartsock ignores Camus' ironic reference to the copy that replaced the original panel and states, 'He revels in the possession of *The Just Judges,* because he alone knows the *true* judges, while others worship false ones; because he may be put into prison for theft and thereby have more to suffer,'[2] though he is not put into prison. Two psychoanalytic critics use the painting to fortify their own unconvincing theories. Barchilon says, 'The judges on horseback are going to see the Innocent Lamb, one more attempt at reunion with a "just father" who would establish his innocence',[3] though the putative father does not exist in the novel. And Sperber, who publishes a photograph of the painting without the Holy Ghost, concludes rather lamely, 'This, then, is a painting with elements which would have great appeal to Clamence in terms of the Icarian elements in his personality.'[4] The more important question is why the painting 'appealed' to Camus.

The Adoration of the Lamb is a paradise picture, the painter's dream of heaven. The subject is 'the ultimate beatitude of all believing souls . . . united in the worship of the Lord'.[5] 'In the midst of the replenished earth, gay with

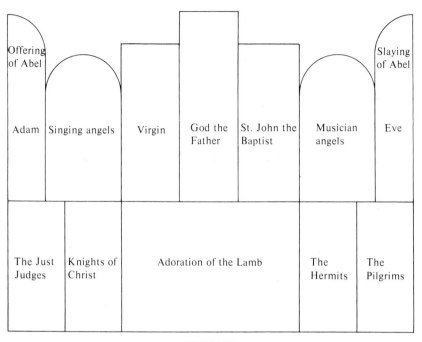

INTERIOR

(Fig. 1 *also facing page*)

foliage, fruits and flowers, man is entering upon infinite bliss. The era of eternal happiness is being ushered in by a solemn act of gratitude and praise which the elect render to Jesus Christ the Redeemer.'[6] The fall of man is depicted in the panels of Adam and Eve in the upper register of the interior of the polyptych. And John the Baptist, the name saint of the narrator of the novel, appears twice in the altarpiece: first in austere *grisaille* in one of the exterior panels, where he holds a lamb (there is also a lamb in the 'Offering of Abel' in the top of the 'Adam' panel), and then in an unprecedented position to the left of God the Father, where he raises his head from the book of the prophet Isaiah, open at the first verses of chapter forty: 'Comfort ye, comfort ye my people, saith your God The voice of him that crieth in the wilderness, Prepare ye the way of the Lord, make straight in the desert a highway for our God.' On the vaulted arches of the gilded niche behind St John's head are the rather overwhelming words from the sermon of Petrus Chrysologus, Bishop of Ravenna, on the beheading of the saint—'This is St John the Baptist, greater than man, equal to the angels, the sum of the law, the sanction of the Gospels, the voice of the

EXTERIOR

Apostles, the silence of the Prophets, the lamp of the world, the witness of the Lord"[7]—which suggest the misplaced egomania of Jean-Baptiste Clamence.

The central panel of the lower register, which gives its name to the entire polyptych, is inspired by the Book of Revelation, witnessed and inscribed on Patmos by St John the Evangelist (who is also portrayed in the altarpiece):

> And in the midst of the elders stood a lamb . . . [that] wast slain, and hast redeemed us to God by thy blood
>
> A great multitude, which no man could number, of all nations, and kindreds, and people, and tongues, stood before the throne, and before the Lamb, clothed with white robes, and palms in their hands And all the angels stood round about the throne These are they which came out of great tribulation, and have washed their robes, and made them white in the blood of the Lamb. Therefore are they before the throne of God, and serve him day and night For the Lamb which is in the midst of the throne shall feed them, and shall lead them unto living fountains of waters
>
> And he showed me a pure river of water of life, clear as crystal, proceeding out of the throne of God and of the Lamb. [Rev. 5: 6, 9; 7: 9–17; 22: 1]

The throngs of the blessed converge toward the triumphant white Lamb, who symbolises Christ as the sacrificial victim. As in His spear wound, the blood from the breast of the Lamb flows into a golden chalice on the altar, which displays the text from John 1: 29 embroidered in gold: 'Behold the Lamb of God, which taketh away the sin of the world.' Two semicircles of angels are kneeling round the altar: eight are praying, four are carrying instruments of the Passion (the column of the flagellation, the sponge of vinegar, the lance and the cross) and two are swinging censers. In the foreground, before the altar, stands the Fountain of the Water of Life: a brass column crowned with an angel rising from an octagonal stone basin. The water flows in graceful jets (repeating the arc of the Lamb's blood) from two vases held by the angel and from gargoyles extending from the column; and it issues in a rivulet that flows forward and perhaps into the river that winds through the background, with its verdant hills and visionary buildings.

To the right of the fountain are the twelve Apostles, cloaked and kneeling, and the mitred and resplendent saints; to the left are the Old Testament patriarchs and prophets (Zacarias and Micah are also depicted in ovals above the exterior panels) who believed in Christ before He came. Prominent in the centre of this group, bearded, draped in white and holding a laurel leaf, is the poet Virgil, whose prophetic eclogue led to his virtual canonisation in the Middle Ages and to his companionship with Dante in *The Divine Comedy* (there are many Dantean echoes in the novel). In the background are two groups of saints—virgins on the right, confessors on the left—who carry palms in their hands. These are the martyrs who have affirmed their faith by shedding their blood.

The throngs of the blessed continue towards the Holy Lamb in the wings of the lower register. To the right are the Holy Hermits, led by St Anthony; and on the extreme right the Holy Pilgrims follow the giant St Christopher. On the left are the Knights of Christ, the defenders of the Christian faith in the Crusades; and most important, on the extreme left, the Just Judges: ten richly robed figures on horseback forming a $>$ and riding past a rocky cliff topped with a plateau of grass and through a hill of trees leading upward to three turreted and spired castles. These Just Judges 'may have been intended as the rulers of the Old Testament impersonated by the Counts of Flanders'.[8] They have no hagiological status and 'are admitted to the hierarchies of the Blessed . . . as the ideal representatives of a specific group of living dignitaries who hoped to be included with the Elect'.[9]

The recent history of the painting, as well as its iconography, is closely related to the theme of guilt and judgement in the novel, and particularly to the Nazi crimes of the Second World War, which exemplify the fall and damnation of modern man. After the Great War the panels of Adam and Eve were returned to Ghent from Berlin as stipulated in article 247 of the Treaty of Versailles. On the evening of 10–11 April 1934 the panel of *The Just Judges,* with the *grisaille* John

the Baptist holding a lamb on the reverse side,[10] was stolen from St Bavon Cathedral. The half-panel with John the Baptist was returned for a ransom of 25,000 francs; but the authorities refused to pay the million francs that was demanded for *The Just Judges*. The original has never been found and a copy was put into the empty space.

During the German invasion of Belgium in 1940 the altar-piece was sent to the south of France, and was placed in the castle at Pau the following year. But in August 1942 the Vichy government gave the painting to the Germans and that year it was placed with the personal collections of Hitler and Goering in the salt mine of Alt-Aussee. The Belgians discovered it there after the conquest of the Tyrol in May 1944, and it was ceremoniously restored to the cathedral by the allied armies in 1945.[11] In 1951 it was x-rayed and cleaned, and a rainbow was discovered around the dove. This dove symbolises the Holy Ghost, completes the vertical Trinity of God the Father and Christ as Lamb, and sends its mystical rays over the altar of the Lamb.[12]

Not far from Ghent, in the capital of the Netherlands, Clamence lives in the Jewish quarter 'on the site of one of the greatest crimes in history', where seventy-five thousand Jews were deported to concentration camps or murdered. Clamence calls this quarter the last circle of hell; but in Dante the guilty expiate their crimes, whereas in Camus the innocent are tortured and executed. Just after he mentions this, Clamence relates two other Nazi atrocity stories, which are his bitter equivalent of the parables in the Gospels. In his own village, 'during a reprisal operation, a German officer courteously asked an old woman to please choose which of her two sons would be shot as a hostage?'; and another man, who loved all humanity and welcomed strangers into his home, was disembowelled by the militia. If the symbolic lambs, the Dutch Jews and French victims, are guilty, then the very concept of innocence has been extinguished, as in the case of the innocent Frenchman who vainly protested against his fate at Buchenwald. If the only innocence that exists is of those who confess and forgive themselves, it would appear that everyone is guilty except Clamence (who reserves all his clemency for himself) and perhaps the prelapsarian barman, an ironic Adam.

Both the painting and the novel illustrate Christian concepts by the opposition of the fall of man and the redeeming message of John the Baptist, both are allegories based on 'revelations', and both concern the transference of guilt. But Camus' juxtaposition of Van Eyck and Hitler, of a religious vision and brutal atrocities which negate that vision, suggests that the painting provides an ironic contrast to the godless theology of *The Fall*. For in the novel, where the theological fall of man, the physical fall of the drowning woman and the moral fall of Jean-Baptiste converge, Clamence is an insincere penitent who embodies the collective vices of modern man: selfishness, hypocrisy and moral cowardice. His hatred of judges, a legacy from his days as a lawyer, is really a hatred of

himself, for their verdict is his condemnation. Like the speakers of the ironic confessional monologues in Browning's 'My Last Duchess' and 'The Bishop Orders his Tomb', Clamence gradually and unconsciously reveals his guilt and alienates the sympathy of the reader. He retains the nagging insistence but not the sincerity and anguish of *Notes from Underground.*

Clamence's confession is essentially an attempt to shrive himself by convincing others that *they* are guilty—he even insists that Christ was 'not altogether innocent' of the slaughter of the children of Judea in Matthew 2: 16—while in *The Adoration* the innocent Saviour takes man's guilt upon Himself. In *The Fall* there is guilt but no redemption, 'though people naturally try to get some help from His death'; in the painting redemption washes away the guilt. The richness and brilliance of the pictorial vision is a powerful contrast to the grey, 'negative landscape' of Amsterdam; and Virgil's pilgrimage through the paradise of the painting opposes Clamence's descent into the inferno of the novel. 'The breath of stagnant waters, the smell of dead leaves soaking in the canal and the funereal scent rising from the barges' (34) are the reverse in tone and mood from the precious stones glittering in the pure crystal of the river of the water of life. In the novel Clamence confirms his damnation by passively avoiding a drowning woman and by actively stealing the literal water of life from a dying comrade in a German prison camp.

The ironic contrast between the painting and the novel is subtly established by recreating the 'empty rectangle' through a series of allusions to *The Adoration of the Lamb.* When Clamence calls his companion a Sadducee, one of a sect of Jews who denied the resurrection of the dead and the existence of angels, he not only alludes to the substance of the painting but also exposes his own character by a reference to Christ's condemnation of the hypocritical Sadducees in Matthew 16: 3. 'The tousled hair of palm trees in the wind' suggests the palms carried by the martyrs and confessors on their pilgrimage to the Holy Lamb. Clamence's remark that as a lawyer he was 'shielded equally from judgement as from penalty, and freely held sway bathed in a light of Eden', recalls the prelapsarian innocence of the blessed multitudes. The Dutch doves who fill the heavenly space and are 'invisible because of their altitude . . . wheel above the earth, look down, and would like to come down' is an ironic reference to the Holy Ghost in the painting. And the salvation that was won 'in the sweat of the death agony' is symbolised by the blood of the Lamb.[13]

The megalomanic Clamence ('I am the end and the beginning') parodies Revelation and even imagines himself in divine iconographic poses, just as in the panel above the *Adoration* where God the Father is flanked by singing and musical angels: 'How intoxicating to feel like God the Father and to hand out definitive testimonials of bad character and habits. I sit enthroned among my bad angels at the summit of the Dutch heaven and I watch ascending towards me, as they issue from the fogs and the water, the multitude of the Last

Judgement I could live happily only on condition that all the individuals on earth, or the greatest possible number ['a great multitude, which no man could number'], were turned towards me ['stood before the throne'], eternally unattached, deprived of any separate existence and ready to answer my call at any moment' ('and serve him day and night') (105, 51).

Clamence imagines himself to be god-like in the adoration he receives and the omnipotence he exerts, and like the wrathful god of the Old Testament he must judge and condemn—that is, excuse himself by condemning others. *The Fall* is essentially an ironic discourse on Matthew 7: 12: 'Judge not, that ye be not judged. For by what judgement ye judge, ye shall be judged.' Clamence quotes Christ's words to the woman taken in adultery in John 8: 11, 'Neither do I condemn thee,' but he rejects His compassion and condemns without absolving anyone: there is guilt but no redemption.

Since Clamence believes that 'we lack the energy required for evil as well as that required for good', he feels that modern man suffers from an indeterminate guilt, shares the common guilt for all the cruelty done by human beings, and therefore feels compelled to judge and condemn, to assign guilt to others rather than face his own. Clamence, the self-styled judge–penitent, compulsively confesses his own guilt in order to draw forth the guilt of the listener (and reader) and so condemn him, or even better, provoke him into condemning himself.

Camus employs the Christian topology of *The Adoration* to refute the Christian theology of the Bible. He would agree with D. H. Lawrence that 'Washed in the Blood of the Lamb! always seemed to me an extremely unpleasant suggestion. And when Jerome says: He who was washed in the blood of Jesus need never wash again!—I feel like taking a hot bath at once, to wash off even the suggestion.'[14] For like Lawrence, Camus rejects the soothing idea of redemption as portrayed in *The Adoration*: 'God's sole usefulness would be to guarantee innocence, and I am inclined to see religion rather as a huge laundering venture Don't wait for the Last Judgement. It takes place every day' (83).

But Camus also rejects Clamence's concept of universal guilt, our legacy from the fall. To Clamence the hidden *Just Judges* means 'there is no lamb or innocence any longer' and that justice is finally separated from innocence, 'the latter on the cross and the former in the cupboard' (96–7). Clamence's succinct condemnation of modern man, 'he fornicated and read the papers',[15] applies only to those men, like himself, who submerge the principle of individual conscience and responsibility in the swamp of collective guilt. Because Clamence could not respond to the woman's body striking the water, the river of death, he is pursued by mocking laughter 'coming from nowhere unless from the water', which symbolises his uneasy conscience as well as a chilling reminder of his damnation. Those men who refuse to test their moral principles in moments of crisis and blame others for their own vices are as weak and despicable as those who wait passively for redemption. For Camus man is neither in Van Eyck's

heaven nor in Clamence's hell: he is in purgatory, where his actions define his fate.

NOTES TO CHAPTER TWELVE

[1] Germaine Brée, *Camus* (New Brunswick, N. J., 1959), 131.

[2] Mildred Hartsock, 'Camus' *The Fall:* Dialogue of One', *Modern Fiction Studies,* VII (1961–62), 363.

[3] Jose Barchilon, '*The Fall* by Albert Camus: A Psychoanalytic Study', *International Journal of Psychoanalysis,* XLIX (1968), 388.

[4] Michael Sperber, 'Camus' *The Fall:* the Icarus Complex', *American Imago,* XXVI (1969), 279.

[5] Erwin Panofsky, 'The Problem of the Ghent Altarpiece', *Early Netherlandish Painting* (Cambridge, Mass., 1953), 212.

[6] Leo van Puyvelde, *Van Eyck: The Holy Lamb* (London, 1947), 49.

[7] *Ibid.,* 19. The Cathedral of St Bavon was originally dedicated to St John the Baptist.

[8] Lotte Brand Philip, *The Ghent Altarpiece and the Art of Jan Van Eyck* (Princeton, 1972), 187.

[9] Panofsky, 217.

[10] See Albert Camus, *The Fall,* trans. Justin O'Brien (London, 1957), 64: 'The surface of all my virtues had a less imposing reverse side.'

[11] See F. Claeys Bouuaert, *L'Adoration de l'agneau mystique de Van Eyck* (Gand, 1957), 40–4, and Thomas Howe, *Salt Mines and Castles: The Discovery and Restitution of Looted European Art* (Indianapolis, 1946), 144–8. Camus' insistence on authenticity is confirmed by the actual existence of the Mexico City bar on Warmoesstraat 91.

[12] See Paul Coremans, *L'Agneau mystique au laboratoire* (Antwerp, 1953).

[13] Camus' references to paintings in a theological context are not confined to Van Eyck, for Clamence also alludes to Rembrandt's *The Anatomy Lesson* and *The Syndics* when he says, in a rather strained sentence, 'you take these good people for a tribe of syndics and merchants counting up their gold crowns together with their chances of eternal life, whose only lyricism consists in occasionally, without doffing their broad-brimmed hats, taking anatomy lessons' (12). He also mentions a bare but clean interior like 'a Vermeer, without furniture or copper pots' (89).

[14] D.H. Lawrence, 'Introduction to These Paintings', *Phoenix* (London, 1936), 567.

[15] Camus took this famous phrase from Huysmans' violent and corrosive attack on modern society in his essay 'Gustave Moreau', *Certains* (Paris, 1904), 20. Compare: 'ces trottoirs remplis d'une hideuse foule en quête d'argent, de femmes dégradées par les gésines, abêties par l'affreux négoces, d'hommes *lisant des journaux infâmes ou songeant à des fornications* et à des dols le long de boutiques d'où les épient pour dépouiller les forbous patentés des commerces et des banques' with Camus, *La Chute* (Paris, 1956), 11: 'Une phrase leur suffira pour l'homme moderne: il forniquait et lisait des journaux.'

13 Dürer and *Doctor Faustus*

Et, l'âme d'amertume et de dégoût remplie,
Tu t'es peint, o Dürer! dans ta Mélancholie,
Et ton génie en pleurs, te prenant en pitié,
Dans sa création t'a personnifié
Voilà comme Dürer, le grand maître allemand,
Philosophiquement et symboliquement,
Nous a représenté, dans ce dessin étrange,
Le rêve de son coeur sous une forme d'ange.
[Théophile Gautier, 'Melancholia']

In *Doctor Faustus* Mann recreates the German myth of the artist destroyed by a demonic pact and uses a number of historical and cultural parallels to give substance to his fictional characters. The novel is like an ancient palimpsest with multiple layers of meaning: Faustian myth, Lutheran theology, Shakespearean parody,[1] Nietzschean pathology, Schönberg's music theory, Mann's autobiography and Nazi history all coalesce into the complex totality of the work. Though the focus of the novel is on the doomed Adrian Leverkühn, the artist is placed against the background of the past and present history of Germany, which reveals striking parallels between the Reformation and Nazism. The controlling device of the novel is analogy, which often develops through irony into a complicated and detailed parody. Mann explains his use of analogy when, paraphrasing Lessing's *Laocoön,* he writes, 'although aesthetics may insist that literary and musical works, in contradistinction to the plastic arts, are dependent upon time and succession of events, it is nevertheless true that even such works strive at every moment to be present as a whole'.[2]

In order to understand this extremely difficult novel one must adopt the method of Adrian's music teacher, Wendell Kretschmar, whose passion it was 'to make comparisons and discover relations, display influences, lay bare the interwoven connections of culture'.[3] Mann uses Dürer's art, especially *Melencolia* (1514) (plate XXI) and *The Martyrdom of St John the Evangelist* (1498) (plate XXII), to link the levels of meaning in the novel that are created by different kinds of analogy, and to unite the temporal sequence of events into the representational whole of a plastic art. Dürer's art relates Adrian to Nietzsche and to Luther (and Serenus to Erasmus); it provides the medieval atmosphere of Adrian's life; it influences the physical characterisation of his friends; it relates him to the frenzied world of the German Reformation; and it visualises the themes of artistic sterility, demonic suffering and apocalyptic destruction.

In his essay 'Dürer' (1928) Mann foreshadows the mood and tone of *Doctor Faustus* and writes that Dürer is 'representative of the medieval, German

atmosphere of "passion, odour of the tomb, sympathy with suffering, Faustian melancholia".[4] Mann anticipates his own allegorical treatment of this theme in his description of German art as 'perversely scrupulous, daemonic and ribald at once, sick with infinity Its pedantry, its philistinism, its self-torment, its anxious calculation, its laborious introspection . . . means history as myth.'[5] And Panofsky's description of Dürer's method, which combines the contemporary and the universal, applies to the novelist as well as to the painter: 'He could plunge into folklore and into the news of the day; he could contrive unusual variations on historical or mythological themes and could think up brand-new inventions of a symbolic or allegorical character.'[6]

For Nietzsche, Dürer's allegorical knight is a pictorial representation of the courageous and solitary Zarathustran hero.[7] And Nietzsche states in his first book, *The Birth of Tragedy*:

> One who is disconsolate and lonely could not choose a better symbol than the knight with death and the devil, as Dürer has drawn him for us, the armoured knight with the iron, hard look, who knows how to pursue his terrible path, undeterred by his gruesome companions, and yet without hope, alone with his horse and dog.[8]

Mann writes in his essay on Dürer that 'Nietzsche was the medium through which I learned to know Dürer's world', and to Mann, Dürer's knight symbolises Nietzsche's (and therefore Adrian's) struggle with demonic madness and disease. Mann links Dürer's and Nietzsche's treatment of the Apocalypse theme when he maintains that both artists represent 'the German world, with all its vaulting self-dramatisation, its enthralling intellectualistic climax and dissolution at the end.'[9]

The engraving *Knight, Death and the Devil* (1513) relates Dürer not only to Nietzsche but also to the contemporary adversaries, Luther and Erasmus. Panofsky says that 'Grieved and incensed by the unfounded rumours of Luther's assassination, Dürer jotted down . . . a magnificent outburst against the Papists which culminates in a passionate appeal to Erasmus of Rotterdam: ' . . . Hark, thou *Knight of Christ*, ride forth at the side of Christ our Lord, protect the truth, obtain the crown of the Martyrs.'' '[10] But like Erasmus, who ignored Dürer's invocation and remained hostile to Luther, Mann does not share Dürer's enthusiasm for the great reformer: 'I frankly confess that I do not love him The choleric coarseness, the invective, the fuming and raging, the extravagant rudeness coupled with tender depth of feeling and with the most clumsy superstition and belief in demons, incubi and changelings, arouse my instinctive antipathy.'[11] In the novel Mann uses Luther's letters and table talk for his portrayal of the lecturer in theology at Halle, the crude but popular Ehrenfried Kumpf, who goes so far as to fling a roll at the devil lurking in a dark corner. Kumpf's lustiness offends the refined Erasmian temperament of Adrian's

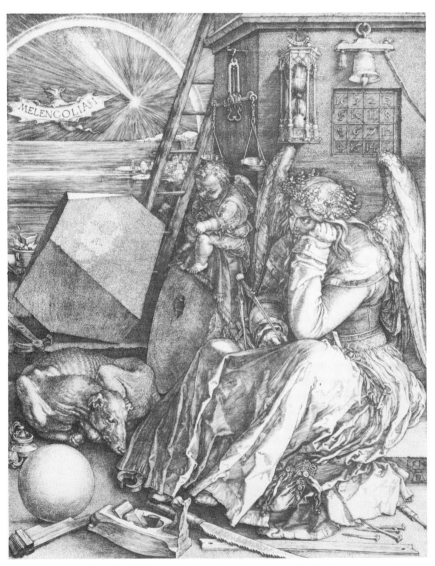

(XXI) Dürer, *Melencolia*, 1514

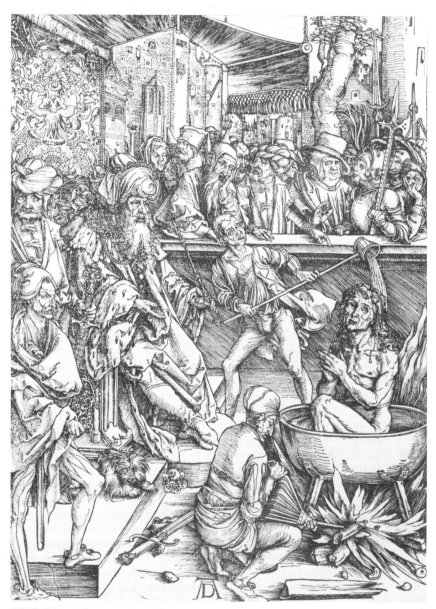

(XXII) Dürer, *The Martyrdom of St John the Evangelist*, 1498

biographer, Serenus Zeitblom, whose first name is a near anagram of Erasmus (whose portrait Dürer drew in 1520 and engraved in 1526), who is descended from sane, noble and harmonious humanists, and who tempers the demonic elements of Dürer, Luther and Nietzsche that are tragically manifested in the subject of his 'biography'.

Like Adrian, Dürer lived in a period of chaotic transition from one age to another, and as Panofsky observes, *Knight, Death and the Devil,* 'a symbol of Dürer's art and mentality—is composed of two disparate elements: one German, Late Gothic and "naturalistic"; the other Italian, High Renaissance, and stylised in accordance with a "classic" canon of pose and proportions'.[12] Just as Dürer moved from the world of Schongauer and late Gothic art to that of Mantegna and the Italian Renaissance,[13] so Adrian's artistic career spanned the epoch from traditional to modern music, from Brahms to Schönberg. Dürer and Adrian also lived in similar historical periods.The great upheavals of the Reformation originated in Dürer's age (1471–1528) and the *Apocalypse* 'had an immense significance at that time. There was a general feeling that the end of the world was near.'[14] Similarly, Adrian's lifetime (1885–1940) saw Bismarck's Prussianism develop into Hitler's demonology, and Adrian's madness and death correspond to the millenarian collapse of the 'Thousand-year *Reich*'.

The town of Kaisersaschern, where Serenus is born and where Adrian receives his early education, retains its distinctly medieval air. It is associated with an atavistic residue of religious mania and even demonic frenzy that originated in 'the last decades of the fifteenth century: a morbid excitement, a metaphysical epidemic latent since the last years of the Middle Ages' (36). As the devil tells Adrian, 'Where I am, there is Kaisersaschern.' Its timeless individual character, its 'Town Hall of mixed Gothic and Renaissance architecture', and its connection with Luther and the Reformation ('superstition and belief in demons') connect the town with Dürer's Nuremberg, which preserved its atmosphere of Gothic churches and steep-gabled houses until the frightful bombardment and destruction of the Second World War brought the Apocalypse directly to the city. During Adrian's decade of insanity (based on the last dark years of Nietzsche's life) the city of art and culture had moved from Hitler's monstrous political rallies, what Serenus ironically calls 'national celebrations so uplifting to unenlightened hearts', towards the last judgement of the war crimes trials.

Dürer's famous house at the Tiergartner Gate in Nuremberg is the model for the imposing medieval house of Uncle Nikolaus Leverkühn. A modern guidebook describes Dürer's Gothic house, which dates from 1450, as having a first floor of sandstone, surmounted by two half-timbered storeys and a gabled roof. And Nikolaus' house also has "three storeys, not counting the lofts of the separate roof, which was built out in bays The foundation storey was unwhitewashed and unadorned; only above it did the ornamental woodwork begin' (39).[15]

In the same fashion, the medieval Abbot's room at Pfeiffering, where Adrian composes most of his works, including his 'homage to Dürer', the *Apocalypsis cum figuris,* is based on the study in Dürer's house as well as on his famous engraving of *St Jerome in His Study* (1514): it was

> nearer 1600 than 1700; wainscoted, with carpetless wooden floor and stamped leather hangings below the beamed ceiling. There were pictures of saints on the walls of the flat-arched window embrasures, and leaded window-panes that had squares of painted glass let into them. There was a niche in the wall, with a copper water-kettle and basin, and a cupboard with wrought-iron bolts and locks. There was a corner bench with leather cushions, and a heavy oak table not far from the window, built like a chest, with deep drawers under the polished top and a sunken middle part where a carved reading-desk stood. Above it there hung down from the beamed ceiling a huge chandelier with the remains of wax candles still sticking in it, a piece of Renaissance decoration with horns, shovel-antlers, and other fantastic shapes sticking out irregularly on all sides. [207][16]

Mann's description of the Abbot's room, like Dürer's engraving, conveys the homely calm and orderly atmosphere of Mother Schweigestill's farmhouse, so necessary to the scholarly Adrian, who, like the translator of the Vulgate Bible, needs a quiet study in which to work. Mann retains the essentials of both rooms and transforms the horn-like stalk of Jerome's pumpkin, suspended from the ceiling according to the custom of German farmhouses, into the antlered chandelier of Dürer's *Arbeitszimmer.*

Some German scholars have found a correspondence between Dürer's portraits and the physical features of Mann's fictional characters. Kaufmann writes that Adrian's 'father bears exactly the features of Dürer's Melanchthon, his uncle those of Dürer's Hieronymous of Augsburg, while his mother . . . is modelled after Dürer's picture of "The German Woman from Venice" (1507)'.[17] Though these resemblances seem more suggestive than exact, it may also be possible that the 'Ecce-Homo countenance' of the bearded Adrian, who (contrary to Mann's practice of 'mythologising' his hero) is described with rare detail at the end of the novel, is influenced by Dürer's full-faced Christ-like *Self-Portrait* (1500) in Munich:

> The change was due to a dark growth of beard, mixed with grey, a sort of chin-beard, with the addition of a drooping little strip of moustache One bore with the unfamiliarity resulting from the partial covering of the features, because it was this beard—and perhaps a growing tendency he had to carry his head on one side—that gave his countenance something spiritualised and suffering, even Christlike. [483]

Adrian's almost divine features seem appropriate for the composer of the symphonic cantata, *The Lamentation of Dr Faustus,* which is the musical equivalent of the last words of the Redeemer.

Like Proust, Mann is fond of aesthetic analogies. The impresario Fitelberg says that Wagner 'set up Titian as the true and the good'; Rudolph Schwerdtfeger's handsome Florentine apparel 'made him look like Botticelli's youth in the red cap'; Adrian writes 'on a slanting surface, like Erasmus in Holbein's painting'; and Serenus likens the composer's bearded, hollow face to 'an El Greco nobleman's'. But almost all the numerous references to art in *Doctor Faustus* concern Albrecht Dürer. Apart from *Melencolia* and *The Martyrdom of St John,* which Mann describes in detail, which form the symbolic cores of chapters twenty-five and thirty-four, and which require extensive analysis and discussion, there are many other cryptic and indirect references to Dürer.

The Esmeraldus-syphilitic Baptist Spengler takes the name of Lazarus Spengler, town secretary of Nuremberg and leader of the Reformation, as well as of Oswald Spengler, the prophet of the twentieth-century apocalypse. Serenus' father, Wohlgemut Zeitblom, bears the name of Dürer's teacher, Michael Wolgemut, whose portrait he painted in 1516; and the theologian Philipp Melanchthon, who, 'to the distress of Erasmus, had gone over from the humanistic camp to the reformers' (88) had his portrait engraved by the master of Nuremberg in 1526. Jeanette Scheurl, 'a woman of peculiar charm and sincerity' and a close friend of Adrian, has the name of a family whose coat of arms was designed by Dürer. Willibald Pirckheimer, who is mentioned with Dürer in Serenus' description of the destruction of Nuremberg, was a member of a rich and patrician Nuremberg family, a political and military leader of that city, and a great scholar. Dürer made a drawing of his best friend's pug-like face in 1503 and another late engraving in 1524. And the art critic and Dürer scholar Professor Gilgen Holzschuher, a member of the reactionary Kridwiss circle that foreshadows Nazi ideology, bears the name of Hieronymous Holzschuher, another Nuremberg patrician who was painted by Dürer in 1526 and who participated in the Augsburg *Reichstag* in 1547. Serenus speaks to Holzschuher about his article on the problems of proportion in Gothic architecture, so that the critic may also have elements of the Dürer scholar, Erwin Panofsky, whose long interest in this field culminated in *Gothic Architecture and Scholasticism.*

Mann uses a number of other works by Dürer to suggest the qualities of Adrian's art. The name of Adrian's great choral work, *Apocalypsis cum figuris,* is taken from the Gothic lettering on the title page of the second edition (1511) of Dürer's series of woodcuts, and Serenus explains that Adrian's work 'is intended to emphasise the visual and actualising, the graphic character, the minuteness' of the Nuremberger's fifteen illustrations. Adrian and Dürer are also similar in their 'intellectual passion for austere order, [and their] *linear* style' (178). In order to emphasise their artistic affinity Mann refers to five of Dürer's woodcuts in his description of Adrian's oratorio: *The Opening of the Seals* (No. 5); *St John Devouring the Book* (No. 9); *The Adoration of the Lamb* (No. 13), which

foreshadows the appearance of Nepo, who is presented with a coloured picture of the Lamb of God when he first arrives at Pfeiffering; *The Four Horsemen of the Apocalypse* (No. 4), the frightful avenging angels who mow down a third of mankind and prefigure the Nazi terror; and *The Whore of Babylon* (No. 14), in which Dürer portrays the devil (as he did in the engraving of 1513) and depicts the 'Woman on the Beast, with whom the kings of the earth have committed fornication' (Rev. 18: 3) by using the portrait study of a Venetian courtesan. This illustration of devil and courtesan suggests Hetera-esmeralda, the demonic whore who infects Adrian with syphilis.

Even the fatal disease that seals Adrian to the devil and has a similar manifestation in both Nepo and his uncle (part of the horror of Nepo's death is that it foreshadows Adrian's) refers to a work by Dürer. In his long conversation with Adrian the devil significantly relates the religious frenzy of the Reformation to madness and disease, and says that the demonic element simultaneously re-entered Europe in two different but connected forms: syphilis and the Reformation.

The devil describes the syphilitic spirochetes in the religious metaphor of penitential Flagellants, who flailed for their own and all other sins and appeared from the West Indies about 1500 when 'the right planets came together in the sign of the Scorpion, as Master Dürer has eruditely drawn in the medical broadsheet' (231). The devil alludes to Dürer's woodcut *The Syphilitic* (1496), which depicts an unfortunate victim in the secondary stage, miserably ragged and completely covered with pustulant ulcers. The arms of Nuremberg appear in the woodcut, and a sphere with the Zodiac is above the syphilitic, with the sun below. In a later conversation with Serenus the saturnine Adrian defends the medieval 'science' of astrology, states 'that diseases, plagues, epidemics have to do with the position of the stars was to those times an intuitive certainty' (274), and reveals that he identifies with the superstition of the Middle Ages. He has compacted with the devil and is aware of his doom.

The Reformation's 'agitation, unrest, anxiety and presentiments' were already familiar to Adrian from medieval Kaisersaschern and from the story that Schleppfuss (an early avatar of the devil, who also represents Goebbels) tells of honest young Klopfgeissel's possession by a succubus. In Adrian's demented mind this bewitching possession is re-enacted in his own union with the Little Mermaid that produced the doomed love-child Nepo: 'Thereupon did Hyphialta get with child and accounted me a little son, to whom with my whole [damned] soul I clung But since the child was flesh and blood and it was ordained that I might love no human being, he slew it, merciless' (501). In Mann, as in Nietzsche, the solitary hero is defeated by death and the devil.

Dürer's three great engravings, *Knight, Death and the Devil, St Jerome in His Study and Melencolia,* form the thematic trilogy of 1513–14 and represent the moral, theological and intellectual virtues. Panofsky relates these works and

writes, '*The Knight, Death and Devil* typifies the life of the Christian in the practical world of decision and action; the *St Jerome* the life of the Saint in the spiritual world of sacred contemplation; and the *Melencolia I* the life of the secular genius in the rational and imaginative worlds of science and art.'[18]

If *St Jerome* personifies the peaceful bliss of divine wisdom, *Melencolia* represents the spiritual tragedy of human creation and the soul's capacity for suffering. The winged Melancholia, whose white eyes stare out of her darkened, saturnine face with a fanatical concentration, sits in Job's unforgettable pose, 'the knees drawn up, the heavy-laden head supported by one hand, the other lethargically resting in the lap'.[19] Panofsky's extensive interpretation is both masterful and convincing, and helps us to understand how the symbols in the allegorical engraving are used in the novel and how Mann establishes the temperamental analogies between Dürer, Melancholia and Adrian. Panofsky describes Melancholia as seated on a low stone near an unfinished building in a lonely spot near the sea, illuminated by moonlight and by the gleam of a comet surrounded by a rainbow. Beside her a gloomy little *putto*, perched on a chipped grindstone, scribbles on a slate, and a half-starved hound lies at her feet.

> She has lapsed into a state of gloomy inaction. Neglectful of her attire, with dishevelled hair, she rests her head on her hand and with the other mechanically holds a compass, her forearm resting on a closed book. Her eyes are raised in a lowering stare.
>
> The state of mind of this unhappy genius is reflected by her paraphernalia whose bewildering disorder offers, again, an eloquent contrast to the neat and efficient arrangement of St Jerome's belongings. Attached to the unfinished building are a pair of scales, an hourglass, and a bell under which a so-called magic square is let into the wall; leaning against the masonry is a wooden ladder which seems to emphasise the incompleteness of the edifice. The ground is littered with tools and objects mostly pertaining to the crafts of architecture and carpentry Two objects seem to be not so much tools as symbols or emblems of the scientific principle which underlies the arts of architecture and carpentry: a turned sphere of wood and a truncated rhomboid of stone. Like the hourglass, the pair of scales, the magic square, and the compass, these symbols or emblems bear witness to the fact that the terrestrial craftsman, like the 'Architect of the Universe', applies in his work the rules of mathematics.[20]

Adrian's interest in mathematics, which 'holds a peculiar middle position between the humanistic and the practical sciences' (45), relates him to Dürer, the author of *A Treatise on Descriptive Geometry* and *The Teaching of Measurements with Compass and Ruler*, in yet another way. For Adrian becomes absorbed in the application of mathematics, 'like a magic formula', to the theory of harmony, and he works out the musical 'unity, interchangeability,

and identity of horizontal and vertical writing' (73). Both in Halle and in Leipzig Adrian pins on his wall above the piano the 'so-called magic square, such as appears also in Dürer's *Melencolia,* along with the hour-glass, the circle, the scale, the polyhedron, and other symbols. . . . The magic, or the oddity, simply consisted in the fact that the sum of these numerals, however you added them, straight down, crosswise, or diagonally, always came to thirty-four' (92). The magic square relates Adrian's art to Dürer's by casting it 'back into a dark, mythological realm'.[21] It is no accident that thirty-four (the number of Hans Castorp's room in *The Magic Mountain*) is the chapter that describes Adrian's *Apocalypsis,* and that its components, three and four, equal the mystical number represented in Dürer's woodcuts by the seven candlesticks, the seven trumpets and the seven seals. In the 'curiously cabbalistic craft' of music Adrian employs the 'magic square' technique to 'develop the extreme of variety out of identical material' and to determine the permutations of the 'fundamental five-note motif' which form the symbolic equivalent of Hetera-esmeralda, the butterfly whore.

In his chilling interview with Adrian the devil places particular emphasis on the hour-glass which is suspended between six graceful Gothic columns and nearly rests on the right wing of the allegorical figure, and which forms a triangular apex with the heads of Melancholia and her *putto.* As Adrian swears his demonic pact the red sand just begins to run through the slender neck and to measure his twenty-four years of creative genius. And when he makes his final public confession before lapsing into total madness, he announces to the astonished audience, 'now the houre-glasse standeth before my eyes, the finishing whereof I must carefully expect: when the last grain runs through the narrow neck he will fetch me, to whom I have given myselfe so dearly with my proper blood' (497).

The sleeping dog, who forms another unifying triangle with Melancholia and the *putto,* is related in one way to the tradition of scholars in their study and to the sedentary dog in *St Jerome,* and in another way to the dog's predisposition to dejection and even madness. But it is related most significantly to Adrian's strange dog, Suso-Kaschperl, the familiar guardian of both Buchel and Pfeiffering, with whom Adrian has a peculiarly intimate relation. As Adrian succumbs to insanity he refers to Suso-Kaschperl as Praestigiar and apologises for his 'hellish yauling and bauling'. The dog Praestigiar belonged to the original Dr Faustus, and the Faustian philosopher Agrippa of Nettesheim 'owned a dog which revealed itself on closer inspection as the devil'.[22] Suso-Kaschperl, then, is a kind of earthly Cerberus, guarding Adrian in his private hell, which is 'only a metaphor for a little normal Dürer melancholia' (236).

The cherubic but cheerless *putto's* industrious scribbling with an engraver's burin provides a strong contrast to the torpid inactivity of Melancholia. 'The mature and learned Melancholia typifies Theoretical Insight [symbolised by Geometry] which thinks but cannot act. The ignorant infant, making meaningless

scrawls on his slate and almost conveying the impression of blindness, typifies Practical Skill which acts but cannot think.'[23] If we transform this iconographic interpretation to the novel, it is possible to see the winged *putto* as Nepo–Ariel, who, though closely related to Adrian, remains childishly innocent, self-absorbed and totally unaware in his uncle's tragedy and of his own implication in the demonic plot. If Adrian represents creating, Nepo stands for pure being.

Melancholia's wreathed head suggests her poetical, or at least creative powers, which have been extinguished. Like Adrian, who is extremely sensitive to light and spends days in total darkness during his severe attacks of migraine, Melancholia seems condemned to a crepuscular, shadowy world, symbolised by the evil emanation of the falling comet and the winged bat. With folded and quiescent wings she appears to be an ironic counterpart to the splendid and dynamic Winged Victory of Samothrace that gives its name to the Nike room at Pfeiffering. Like the Winged Victory, Melancholia is *functionally* headless, for her mental powers are paralysed by her disease.

Doctor Faustus is saturated with the concept of melancholy, and this adjective is used to describe not only Adrian and his works but also his techniques, his age, his friends and his family. The 'profoundly melancholy nature' of Jonathan Leverkühn's experiments with osmotic growths foreshadows the meningitis that penetrates Adrian's brain and Nepo's spine by fluid diffusion. Adrian's predecessor at Pfeiffering, the gloomy Munich painter, and his patron Herr Director Stiglmayer, both share 'a streak of melancholy'. The tragic character of Inez Rodde, the morphine addict, adulteress and murderer of Rudolph Schwerdtfeger, is 'full of melancholy and distinction' and prefigures the dissolution of modern German society. Adrian's adorer, the sausage queen Kunigunde Rosensteil, passionately treasures the composer and his nephew Nepo 'in her melancholy heart'. Even the buoyant and irrepressible Saul Fitelberg describes the relations of Wagner and Lenbach as 'ah, comme c'est mélancholique, tout ça!'

Adrian is attracted to the works he sets to music by their melancholy nature: Shakespeare's *Love's Labour's Lost,* Keats' 'Ode to Melancholy,' Verlaine's 'Un grand sommeil', and of course his own *Lamentation of Dr Faustus*, a counterpart to Beethoven's Ninth Symphony in the 'most melancholy sense of the word', are all described by the same depressing adjective. Adrian's use of the echo in the Faust cantata 'is essentially a lament: Nature's melancholy "Alas!" in view of man, her effort to utter his solitary state'. And his most characteristic technique, parody, is '*melancholy* in its aristocratic *nihilism*', and combines the tragic elements of Dürer and Nietzsche in Adrian's two archetypal German weaknesses. Since parody is so important in the novel, Mann's statement clearly applies to his own method as well as to Adrian's. The whole nineteenth century, even truth and art itself, are called melancholy in *Doctor Faustus*.

Adrian's deep-rooted melancholy is, of course, the most important of all, and his characteristically cold expression is 'Mute, veiled,[24] musing, aloof to the point of offensiveness, full of a chilling melancholy ending in a smile with closed lips, not unfriendly, yet mocking, and with that gesture of turning away, so habitual, so long familiar' (163). The migraine that Adrian inherits from his father is the first symptom that leads to melancholia and madness, and his cold demonic laughter of the damned (an important leitmotif in the novel) is the complement of melancholy and a sign of the manic phase that inevitably leads to the depressive. Adrian's temperament, his 'disinclination, avoidance, reserve and aloofness' are related not only to Dürer's *Melencolia* but to Dürer himself, for the artist 'never became passionate and retained a certain cool reserve in all he did'.[25] Both Dürer and Adrian suffer from the same intellectual disease, for Wölfflin writes, 'From his own experience Dürer seems to have known the depression caused by an evil star gaining power over the soul.'[26]

Mann's characterisation of Adrian is clearly related to Dürer's portrayal of the melancholic condition, which 'was hated and feared as the worst [of the four humours]. When excessively augmented, inflamed or otherwise disturbed, the black gall causes the most dreaded of all diseases, insanity [The Melancholic] shuns the company of his fellow-men and despises the opposite sex; and his only redeeming feature . . . is a certain inclination for solitary study.'[27] Like Melancholia, Adrian suffers from a temperamental condition that makes him extremely vulnerable to madness. A hermit by nature, he becomes more and more of a recluse as he grows older and madder. Though he does not despise the opposite sex, he has no close relations with women, except for his one fatal association with Hetera-esmeralda, and he allows himself to be wooed and 'seduced' by the homosexual attentions of Rudolph Schwerdtfeger, who aroused his 'melancholy preference'. Adrian has a Jerome-like inclination for solitary study; and though 'melancholic derangement could be cured by music', that antidote fails to heal the composer.

Dürer's portrayal of arrested productivity in his allegorical figure is used by Mann to suggest that Adrian's melancholy makes him fear artistic sterility. Before he is driven to a pact with the devil Adrian resorts to the defence of parody, 'the proud expedient of a great gift threatened with sterility by a combination of scepticism, intellectual reserve, and a sense of the deadly extension of the kingdom of the banal' (152). His own proto-demonic characteristics are intensified by his lack of faith and sense of impending doom. Adrian needs the devil to kindle his work. Thus the Faustian theme of the novel—'the flight from the difficulties of the cultural crisis into the pact with the devil, the craving of a proud mind, threatened with sterility, for an unblocking of inhibitions at any cost'[28]—is directly inspired by Adrian's profound fear of melancholia.

The melancholic and Faustian themes are specifically connected in an early

analysis of *Melencolia* by Carl Gustav Carus (1789–1869), a doctor, painter and philosopher, whose significant influence on *Doctor Faustus* is not mentioned by Gunilla Bergsten in her study of the novel. Mann said that he learned about Dürer from Nietzsche, and Nietzsche was familiar with the works of Carus, who influenced the Klages circle. Mann used Klages' book on Nietzsche (1926) as a source for his novel, and he considered Luther, Nietzsche and the anti-Semitic Klages as intellectual precursors of Nazi ideology.[29]

> Basing his interpretation on the engraving *Melencolia I*, [Carus] discovered a Faustian element in Dürer's nature, a restless craving for a perfection never to be attained, and an acute awareness of problems never to be resolved. Carus's statements are not free from exaggerations and positive errors (he went so far as to identify the 'Melencolia' with Dr Faustus in person); yet they do justice to what is perhaps the most significant aspect of Dürer's personality.[30]

Another source, which Mann acknowledges in *The Genesis of a Novel* but is only briefly mentioned by Bergsten, also relates Dürer's engraving to Faust. For Agrippa of Nettesheim's *De Occulta Philosophia*, in which Mann found 'a quaintly denunciatory chapter on exorcism and black magic, and even more, one chapter on music, or rather against it, full of moralistic lore',[31] is 'the predestined mediator between Ficino and Dürer'[32] and the most important literary source for *Melencolia*. Panofsky states that the book published in 1531 seems to come from the study of Dr Faustus, and is full of cabbalistic charms, astrological tables and magical devices. But in the original version of 1509/10, the author

> sets forth the Neo-Platonic doctrine of cosmic forces whose flux and reflux unifies and enlivens the universe, and tries to show how the operation of these forces enables man not only to practice legitimate magic—as opposed to necromancy and commerce with the Devil—but also to achieve his greatest spiritual and intellectual triumphs.[33]

Agrippa also provides a connection between the divinely inspired *Apocalypsis* and the creative agony of *Melencolia*, for he says that 'Homo melancholicus . . . when it takes fire and glows, generates the frenzy which leads us to wisdom and *revelation*'.[34]

Agrippa's statement suggests another significant aspect of *Melencolia* that connects Dürer, Nietzsche and Mann. By Dürer's time the expression *furor melancholicus* came to be synonymous with *furor divinus*, a syndrome first described in Plato's *Ion* and used by Nietzsche in his exposition of the Dionysian–Apollonian conflict in *The Birth of Tragedy*. 'What had been a calamity and, in its mildest form, a handicap became a privilege, still dangerous but all the more exalted: the privilege of genius . . . the hitherto disparaged melancholy became surrounded with the halo of the sublime.'[35] When Serenus

says of Adrian, 'in his neighbourhood sterility, threatened paralysis, arrest of productivity could be thought of only as something positive and proud, only in connection with pure and lofty intellectuality' (189–90), he specifically refers to the concept of *furor divinus* that influenced Dürer's *Melencolia*. When the devil explains to Adrian, 'Alway the pendulum swings very wide to and fro between high spirits and melancholy,' between towering flights and illuminations and a correspondingly deep sinking 'into void and desolation and unfruitful melancholy, but also into pain and sicknesse' (230), he is actually describing the related extremes of genius and madness, of *furor divinus* and *furor melancholicus*.

This painful vacillation reveals the devil's power over Adrian and his threat to terminate the pact before the expiration of the twenty-four years. During Adrian's creation of the *Apocalypsis* 'he lived in fear that the state of illumination with which he was blest—or with which he was afflicted—might be untimely withdrawn. And in fact he did suffer a relapse' (360). And during the composition of the *Lamentation* Serenus once again notes the demonic 'extremes of Adrian's nature, his swing between penitential paralysis and compensating creative release' (454).

Dürer's engraving represents the paralytic phase of Adrian's melancholia: 'Winged, yet cowering on the ground—wreathed, yet beclouded by shadows—equipped with the tools of art and science, yet brooding in idleness, she gives the impression of a creative being reduced to despair by an awareness of insurmountable barriers which separate her from a higher realm of thought'.[36] Panofsky calls the engraving 'a spiritual self-portrait of Albrecht Dürer' and quotes Dürer's own words as a motto for the work: 'Darkness is so firmly entrenched in our mind that even our groping will fail!'[37] *Doctor Faustus* employs an aesthetic analogy with Dürer's allegorical engraving and with the Faust myth to express this tragedy of artistic sterility.

Another of Dürer's works, *The Martyrdom of St John*, provides a second visual representation of Adrian's spiritual anguish, and though Serenus is characteristically put off by Dante's 'tendency to cruelty and to scenes of martyrdom' it falls to him to describe the martyrdom of his friend. For when Adrian is conceiving his apocalyptic oratorio and enduring 'his utmost and torturing sufferings' he compares himself first to Andersen's Little Mermaid and then, in 'a second striking and pregnant comparison', to Johannes Martyr in the cauldron of oil.

> 'You must imagine it pretty much like that. I squat there, a pious sufferer, in the tub, with a lively wood fire crackling underneath, faithfully fanned up by a bravo with a hand-bellows, and in the presence of Imperial Majesty who looks on from close by. It is the Emperor Nero, you must know, a magnificent big Turk with Italian brocade on his back. The hangman's

helper in a flowing jacket and a codpiece pours the boiling oil over the back of my neck from a long-handled ladle, as I duly and devoutly squat. I am basted properly, like a roast, a hell-roast; it is worth seeing, and you are invited to mingle with the deeply interested persons behind the barrier, the magistrates, the invited public, partly in turbans and partly in good old-German caps, with hats on top of them. Respectable townsfolk—and their pensive mood rejoices in the protection of halberdiers. One points out to the other what happens to a hell-roast. They have two fingers on the cheek and two under the nose. A fat man is raising his hand, as though to say: "God save us all!" On the women's faces, simple edification. Do you see it? We are all close together, the scene is faithfully filled with figures. Nero's little dog has come too, so there shan't be even a tiny empty space. He has a cross little fox-terrier face. In the background you see the towers and gables and pointed oriels of Kaisersaschern.' [354]

It is difficult to improve upon Adrian's brilliantly ironic description of Dürer's concise and elemental work, 'the saturation of space with fantastically exact detail' and the first in the series of fifteen woodcuts on the *Apocalypse*, but it is possible to discuss the 'pregnant comparison'.

The traditional story of the martyrdom of St John, the only Apostle to die a natural death, explains the stoic and ecstatic attitude of the dishevelled and muscular sufferer, and relates him to the source of Dürer's and Adrian's *Apocalypsis*. At the command of the emperor Domitian (not of the emperor Nero, whom Mann uses to signify a notorious cruelty and depravity), John 'was brought in fetters from Ephesus to Rome, and by the verdict of the Senate was cast into a cauldron of burning oil, and came forth thence more hale and more hearty than he entered it'. For God 'conferred on him the merit of martyrdom, but suspended the operation of the fire The seething oil was changed into a refreshing bath' and the baffled Domitian banished John to the Greek island of Patmos, where he witnessed the Apocalypse and wrote the Book of Revelation.[38] Adrian's demonic vision is the converse of John's divine vision, and both Mann and Dürer brilliantly combine realistic and imaginative elements in their portrayal of a supernatural event that occurs within the consciousness of the seer.

John pays for his sainthood by martyrdom just as Adrian pays for his creative genius with physical torments, and the audience is indifferent in both cases. The magnificent despot, turbaned, bearded, gowned and bejewelled, toys with his sceptre, lounges on his throne and gazes down at the burning martyr with little more than casual interest. The despot's head is based on a drawing of a Turk that Dürer made during his journey to Venice, and it is related to the several odd Turkish allusions in the novel. When Adrian lives with the Roddes in Munich he plays the soft-toned Bechstein in the ornate salon decorated with a darkened oil painting 'representing the Golden Horn with a view of the Galata'; and when Frau Rodde retires to Pfeiffering she brings 'the Golden Horn in its heavy frame'

with her, just as Adrian brings his Italian rubber bath tub—his martyr's tub—with him on the local train from the city. One manifestation of the Reformation's religious frenzy, which included '*meteors, comets,* and great omens, nuns with the stigmata, and miraculous crosses on men's garments, [was] that amazing standard of the maiden's shift with the Cross, whereunder to march against the Turk! Good time, divellishly German time!' (231). And just before he enters the tram on which Inez shoots Rudolph, Serenus walks along upper Türkenstrasse (an actual street in Schwabing). These precise yet puzzling allusions connect the Reformation with modern German history and the political allegory of the novel in an extremely subtle manner. For Waetzoldt writes that after

> the fall of Otranto in 1480, fear of the Turks had once more cast its shadow over Western Europe It was doubtless the Turkish peril which induced Dürer to publish his book [*Instruction on the Fortification of Cities, Castles and Towns,* 1527] and to dedicate it to the grandson of Maximilian, King Ferdinand of Hungary and Bohemia, 'not only that a Christian may protect us from the others, but that the lands on the Turkish borders may be saved from their violence and bombardment'. Dürer was a good prophet—two years after his death Vienna was besieged by the Turks.[39]

In the sly but meaningful Turkish references Mann suggests that the Nazi threat to twentieth-century Europe, a brutal invasion followed by unspeakable cruelty, is the modern equivalent of the Turkish threat to Reformation Europe. Whereas Dürer's woodcuts emphasise man's salvation and end with John's vision of the New Jerusalem, Adrian's oratorio, 'so far from being a romantic music of redemption, relentlessly confirms the theologically negative and pitiless character of the whole' (360), just as his syphilitic genius revokes and 'takes back' Beethoven's Ninth Symphony in his *Lamentation.* In *Doctor Faustus* culture is overwhelmed by barbarism as Adrian's *Apocalypsis* prophesies the end of the German *Reich* and his *Lamentation* bewails the destruction of the *Festung Europa.*

Mann's multi-layered technique of aesthetic, cultural and historical analogies can achieve both subtle artistic effects and profound insights into the possibility of artistic creation in an age of moral chaos and personal disintegration. But the parallels are so numerous, the allusions so thick, the irony and parody and allegory so complex, that even on a fourth reading the work is not 'present as a whole' and Mann's cultural accretions are not entirely absorbed into the form of the novel. Mann was intrigued with Joyce's use of myth during the composition of his book, and *Doctor Faustus* is Mann's *Ulysses.* The chapter on Kretschmar's lecture, for example, where the ultra-sophisticated technique virtually extinguishes the narrative, is Mann's static equivalent of Joyce's pedantic 'Oxen of the Sun'. Mann takes so long to develop Adrian's background (while Adrian

himself remains deliberately shadowy and elusive) that the novel does not move into high gear until the composer arrives in Munich at about page 200. By contrast, other more 'novelistic' passages like the suicide of Clarissa, the murder of Rudolph and the death of Nepo—inspired perhaps by Mann's own experience—break free from the mythic parallels (the allusions to Christ and Ariel add little to Nepo's characterisation) and have an impressive interest and power.

The 'extraordinarily Dürerish' influence on *Doctor Faustus* is both thematic and structural, and is one of the important ways in which Mann connects the mythic with the 'novelistic' passages and unifies the novel into a coherent work of art. Mann has a special sympathy with Dürer, the archetypal German artist, and he employs Dürer's work and personality in the context of the Reformation as a model for the modern artist, Adrian Leverkühn. By using Dürer's age, his city, his house, his study, his friends, his style, his art, his creative genius, his melancholia and his apocalyptic vision, Mann is able to suggest that in spite of the contemporary barbarity Serenus records there still remains some continuity in our experience and in our relationship to the past, even if history is merely an eternal recurrence of madness and destruction. The work of Dürer, of Adrian and of Mann himself represents the capacity of the artist to persist in his effort to create order and beauty out of experience, even during the 'enthralling intellectualistic climax' and apocalyptic 'dissolution at the end'.

NOTES TO CHAPTER THIRTEEN

[1] See my essay 'Shakespeare and Mann's *Doctor Faustus*', *Modern Fiction Studies*, XIX (Winter 1973–74), 541–5.

[2] Thomas Mann, *The Genesis of a Novel* (London, 1961), 175.

[3] Thomas Mann, *Doctor Faustus*, trans. H. T. Lowe-Porter (London, 1949), 76.

[4] Thomas Mann, 'Dürer', *Past Masters* (London, 1933), 151.

[5] *Ibid.*, 152–3.

[6] Erwin Panofsky, *Albrecht Dürer* (London, 1948), 45.

[7] For an analysis of Nietzsche's concept of the will to power, self-overcoming and creation through suffering see my chapter 'Nietzsche and the Will to Power', *The Wounded Spirit: A Study of 'Seven Pillars of Wisdom'* (London: Martin, Brian & O'Keeffe, 1973), 104–13.

[8] Friedrich Nietzsche, *The Birth of Tragedy*, trans. Walter Kaufmann (New York: Vintage, 1967), 123.

[9] Mann, 'Dürer', 149–50.

[10] Panofsky, 151. Dürer was converted to Lutheranism in 1519.

[11] Thomas Mann, *Germany and the Germans* (Washington, D.C., 1945), 6.

[12] Panofsky, 152.

[13] The influence of Italy had a powerful effect on both Dürer and Adrian, just as it did on Goethe, Nietzsche and Mann himself.

[14] Heinrich Wölfflin, *The Art of Albrecht Dürer* (London, 1971), 59.

[15] A photograph of Dürer's house appears in Wilhelm Waetzoldt, *Dürer and his Times* (London, 1950), opposite p. 216. Dürer's Nuremberg forms the background of his engraving *St Anthony*, 1519.

[16] The last sentence of Mann's description may have been influenced by Dürer's 'fantastic' pen drawing, 'Design for a Chandelier of Antlers', 1500.

[17] Fritz Kaufmann, *Thomas Mann: The World as Will and Representation* (Boston, Mass., 1957), 199. See also W. Holthusen und W. Taubner, 'Dürers "Philipp Melanchthon" und "Bildnis einer jungen Frau" als visuelle Vorbilder für die Eltern von Adrian Leverkühn in Thomas Manns "Doktor Faustus" ', *Die Waage*, iii (1963). My essay has certain similarities to Walther Rehm, 'Thomas Mann und Dürer', *Die Wissenschaft von deutscher Sprache und Dichtung: Festschrift für Friedrich Maurer* (Stuttgart, 1963), 478–97, and J. Elema, 'Thomas Mann, Dürer und *Doktor Faustus*', *Euphorion*, LIX (1965), 97–117, but these articles tend to match Mann to Dürer and do not provide a thorough interpretation of *Melencolia* and *The Martyrdom of St John*, which visualise the dominant themes of Mann's novel.

[18] Panofsky, 151.

[19] *Ibid.*, 93.

[20] *Ibid.*, 156–7.

[21] Mann, *Genesis*, 40.

[22] Gunilla Bergsten, *Thomas Mann's 'Doctor Faustus'* (Chicago, 1969), 47 and note.

[23] Panofsky, 164.

[24] See Keats' 'Ode to Melancholy':
Ay, in the very temple of Delight,
Veil'd Melancholy has her sovran shrine.

[25] Wölfflin, 16.

[26] *Ibid.*, 12.

[27] Panofsky, 158.

[28] Mann, *Genesis*, 28.

[29] Bergsten, 117–18.

[30] Panofsky, 11.

[31] Mann, *Genesis*, 150.

[32] Raymond Klibansky, Erwin Panofsky and Fritz Saxl, *Saturn and Melancholy* (London, 1964), 351.

[33] Panofsky, 169.

[34] Quoted in Klibansky, 355.

[35] Panofsky, 165.

[36] *Ibid.*, 168.

[37] Quoted in *ibid.*, 171.

[38] Butler's *Lives of the Saints*, eds. Herbert Thurston and Donald Attwater, II (London, 1956), 240–1.

[39] Waetzoldt, 221.

Select general bibliography on the relation of art and literature

Benamou, Michel, 'Wallace Stevens: Some Relations Between Poetry and Painting', *Comparative Literature*, XI (1959), 47–60.

Binyon, Laurence, 'English Poetry and Its Relation to Painting and the Other Arts', *Proceedings of the British Academy*, VIII (1918), 381–402.

Blunden, Edmund, 'Romantic Poetry and the Fine Arts', *Proceedings of the British Academy*, XXVIII (1942), 101–8.

Bowie, Theodore, *The Painter in French Fiction*, Chapel Hill, N.C., 1950.

—*Les Rapports entre le littérature et la peinture en France de 1840—1880*, Berkeley, Cal., 1935.

Brookner, Anita, *Genius of the Future*, London, 1971.

Dryden, John, 'A Parallel of Poetry and Painting' (1695), *Essays of John Dryden*, ed. W. P. Ker, II (London, 1900), 115-53.

Finke, Ulrich, ed., *French Nineteenth Century Painting and Literature*, Manchester, 1972.

Fowlie, Wallace, 'Mallarmé and the Painters of His Age', *Southern Review*, II (1966), 542–58.

Giovannini, G., 'Method in the Study of Literature in Relation to the Other Arts', *Journal of Aesthetics and Art Criticism*, VIII (1950), 185–95.

Glazebrook, Mark, 'The Artist in Powell', *London Magazine*, VII (1967), 76–82.

Hagstrum, Jean, *The Sister Arts*, Chicago, 1958.

Hatzfield, Helmut, *Literature Through Art: A New Approach to French Literature*, New York, 1952.

Hautecoeur, Louis, *Littérature et peinture en France du XVIIᵉ au XXᵉ siècle*, Paris, 1942.

Hemmings, F. W. J., 'Zola, Manet and the Impressionists', *PMLA*, LXXIII (1958), 407–17.

Huneker, James G., *Promenades of an Impressionist*, London, 1910.

Hunt, John D., *Encounters: Essays on Literature and the Visual Arts*,

London, 1971.

—*The Pre-Raphaelite Imagination, 1848–1900,* London, 1968.

Jack, Ian, *Keats and the Mirror of Art,* Oxford, 1967.

Keller, Luzius, *Piranèse et les romantiques françaises,* Paris, 1966.

Lessing, G. E., *Laocoön, or The Frontiers Between Painting and Poetry* (1766).

Moore, George, *Impressions and Opinions,* London, 1891.

Noyes, Russell, *Wordsworth and the Art of Landscape,* Bloomington, Ind., 1968.

Pelmont, R. A., *Paul Valéry et les beaux-arts,* Cambridge, Mass., 1949.

Praz, Mario, 'Milton and Poussin', *Seventeenth Century Studies Presented to Sir Herbert Grierson,* Oxford, 1938, 192–210.

—*Mnemosyne: The Parallel Between Literature and the Visual Arts,* Princeton, N.J., 1970.

Rosenberg, John, *The Darkening Glass: A Portrait of Ruskin's Genius,* New York, 1961.

Seznec, Jean, *Literature and the Visual Arts in Nineteenth Century France,* Hull, 1963.

Shapiro, Meyer, 'Fromentin as a Critic', *Partisan Review,* XVI (1949), 25–51.

Souriau, Etienne, 'Time in the Plastic Arts', *Journal of Aesthetics and Art Criticism,* VII (1949), 294–307.

Stein, Leo, *Appreciation: Painting, Poetry, Prose,* New York, 1947.

Stevens, Wallace, 'The Relations Between Poetry and Painting', *The Necessary Angel,* London, 1960, 159–76.

Sypher, Wylie, *Four Stages of Renaissance Style,* New York: Anchor, 1956.

—*Rococo to Cubism in Art and Literature,* New York, 1960.

Tinker, Chauncey, *Painter and Poet,* Cambridge, Mass., 1938.

Wellek, René, 'The Parallelism Between Literature and Art', *English Institute Annual, 1941, New York, 1942, 29–63.*

Woolf, Virginia, *Walter Sickert: A Conversation,* London, 1934.

Index